Graphic Arts Books
An imprint of Graphic Arts Center Publishing Company
P.O. Box 10306, Portland, Oregon 97296-0306
503/226-2402
www.gacpc.com

PRESIDENT	Charles M. Hopkins
ASSOCIATE PUBLISHER	Douglas A. Pfeiffer
EDITORIAL STAFF	Timothy W. Frew, Tricia Brown,
	Kathy Howard, Jean Andrews, Jean Bond-Slaughter
PRODUCTION STAFF	Richard L. Owsiany, Vicki Knapton
DESIGNER	Mary W. Velgos
EDITOR	David Abel
DIGITAL PRE-PRESS	Haagen Printing
PRINTER	Haagen Printing
BOOK MANUFACTURING	Lincoln & Allen Co.

Printed and bound in the United States of America

**Page 1: On his way to his first Iditarod win in 2004 Mitch Seavey kicks as he runs down
the Fish River shortly after leaving the White Mountain checkpoint.**

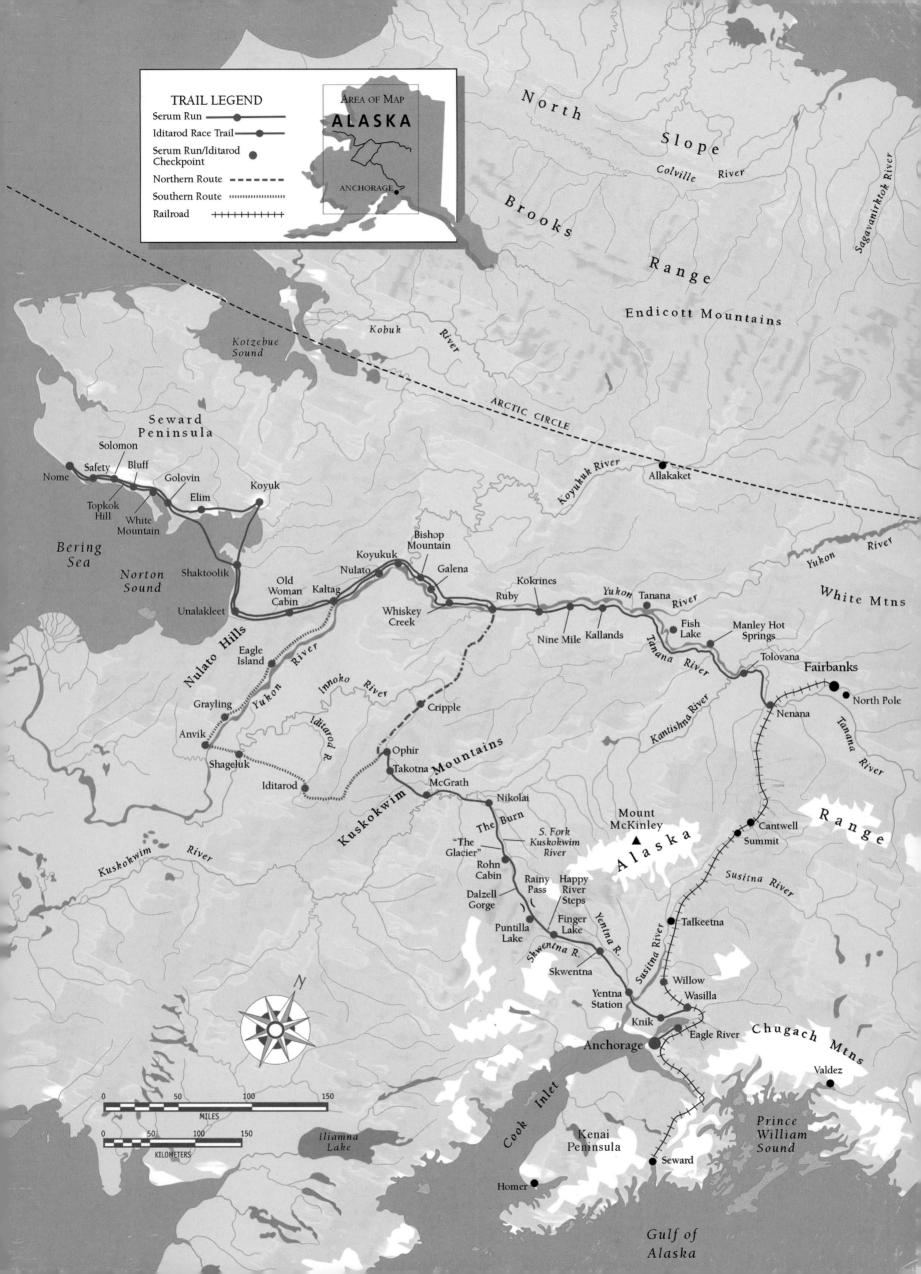

AREA OF MAP
ALASKA

ANCHORAGE

North Slope

Colville River

Brooks Range

Endicott Mountains

Kobuk River

Kotzebue Sound

ARCTIC CIRCLE

Koyukuk River

Allakaket

Yukon River

Seward Peninsula

White Mtns

Solomon
Bluff
Safety
Nome
Topkok Hill
White Mountain
Golovin
Elim
Koyuk

Bering Sea

Norton Sound

Shaktoolik

Bishop Mountain
Koyukuk
Nulato
Galena
Whiskey Creek
Kokrines
Ruby
Yukon Tanana River
Nine Mile Kallands
Fish Lake
Manley Hot Springs
Tolovana
Fairbanks
North Pole

Old Woman Cabin
Kaltag
Unalakleet

Nulato Hills

Eagle Island

Yukon River

Innoko River

Grayling

Anvik

Shageluk

Iditarod

Iditarod R.

Cripple

Ophir
Takotna
McGrath

Kuskokwim Mountains

Nikolai

The Burn

"The Glacier"
Rohn Cabin
Dalzell Gorge
Puntilla Lake

S. Fork Kuskokwim River

Rainy Pass
Happy River Steps
Finger Lake
Skwentna

Kantishna River

Nenana

Mount McKinley

Alaska Range

Cantwell
Summit

Susitna River

Talkeetna

Yentna R.
Skwentna R.
Yentna Station
Knik

Willow
Wasilla

Eagle River
Anchorage

Chugach Mtns

Valdez

Kuskokwim River

N

Iliamna Lake

Cook Inlet

Kenai Peninsula

Prince William Sound

Seward

Homer

Gulf of Alaska

0 50 100 150
MILES

0 50 100 150
KILOMETERS

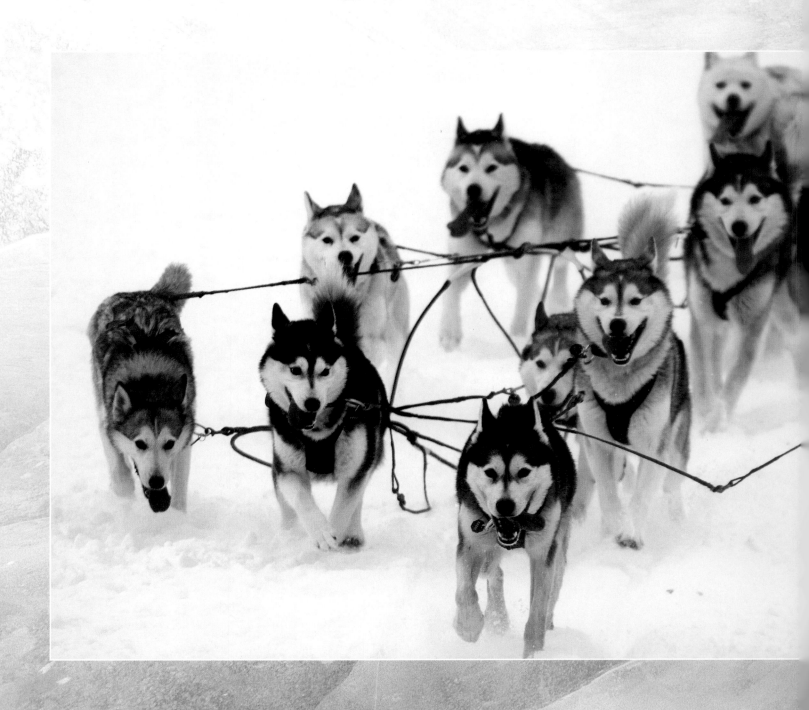

▲ Karen Ramstead's team of registered Siberian huskies takes a turn on Long Lake during the 2005 restart in Willow.

Iditarod *glory*

Contents

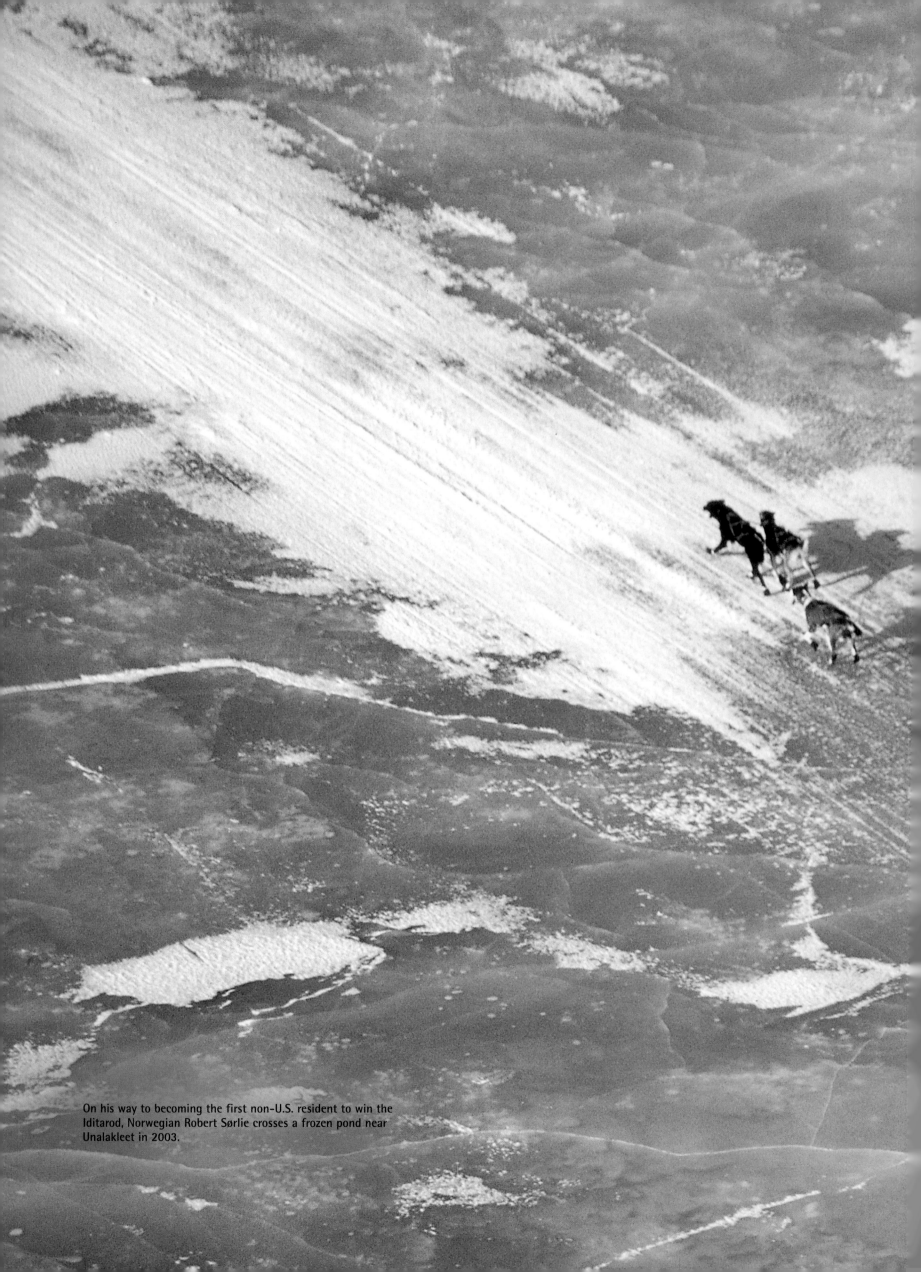

On his way to becoming the first non-U.S. resident to win the Iditarod, Norwegian Robert Sørlie crosses a frozen pond near Unalakleet in 2003.

By the grace of God I am able to make a living at photography and do something that I just simply enjoy. And with the support of my wife, Joan, and children, Ben and Hannah, life is simply wonderful. A huge, heartfelt thanks goes to each one of you and all the others I've met over the years.

—Jeff Schultz

ACKNOWLEDGMENTS

Since photographing my first race in 1981 where I knew very few people and even less about the "real" Iditarod, I've been fortunate enough to meet a huge community of great people who are involved with the race. For that I am very grateful. I could not possibly mention them all here because it would be nearly every musher, volunteer, and staff person. However, a number of people stand out as they have helped me get better images, provided me with access, let me crash on their floor, loaned me their snowmachine, or piloted me along the trail. And without these folks, the pages of this book would be blank and my experience on the trail would be that much less. First a thanks goes to all the mushers who have entered the race over the years and next to my longtime pilots: Dr. Von Mitton, Sam Maxwell, and Danny Davidson. And the others are, of course:

Vi and the late Joe Redington Sr.
Barry and Kirsten Stanley
Ben Schultz
Bill Devine
Bobby Nicholas
Buckey Winkley
Carl & Kirsten Dixon
Charlie Tribbey
Chris McDonell
Debi Trosper

Dick Rudy
Doug Katchatag
Emmitt & Edna Peters
Gina Bringman
Jack Niggemyer
Jan & Dick Newton
Jasper Bond
Jeff King and Donna Gates
Jenna & Dave Squier
Jim Kohl
Jim Brown
Joanne Potts
Joe and Norma Delia
Joe Pendergrass
John Norris
Joy Berger
Laura Kosell
Laurie Campbell
Leo & Erna Rasmussen

Lois Harter
Mark Nordman
Martin Buser & Cathy Chapoton
Maurice Ivanoff
Mike Owens
Mitch and Janine Seavey
Pat Hahn & Sue Greely
Patrick Henry
Paul & Frankie Sayer
Paul & Donna Claus
Peggy & Chuck Fagerstrom
Phillip "Tucker" Semaken
Ralph Canatser
Rich & Vi Burnham
Rick Swenson
Ron & Colleen Halsey
Stan Hooley
Stanton Paniptchuk
Starre Szelag
Steve & Denise Perrins
Steve Nelson
Susan Bramstedt
Susan Butcher & David Monson
Susan Davidson
Willa & Gary Ekanwiler

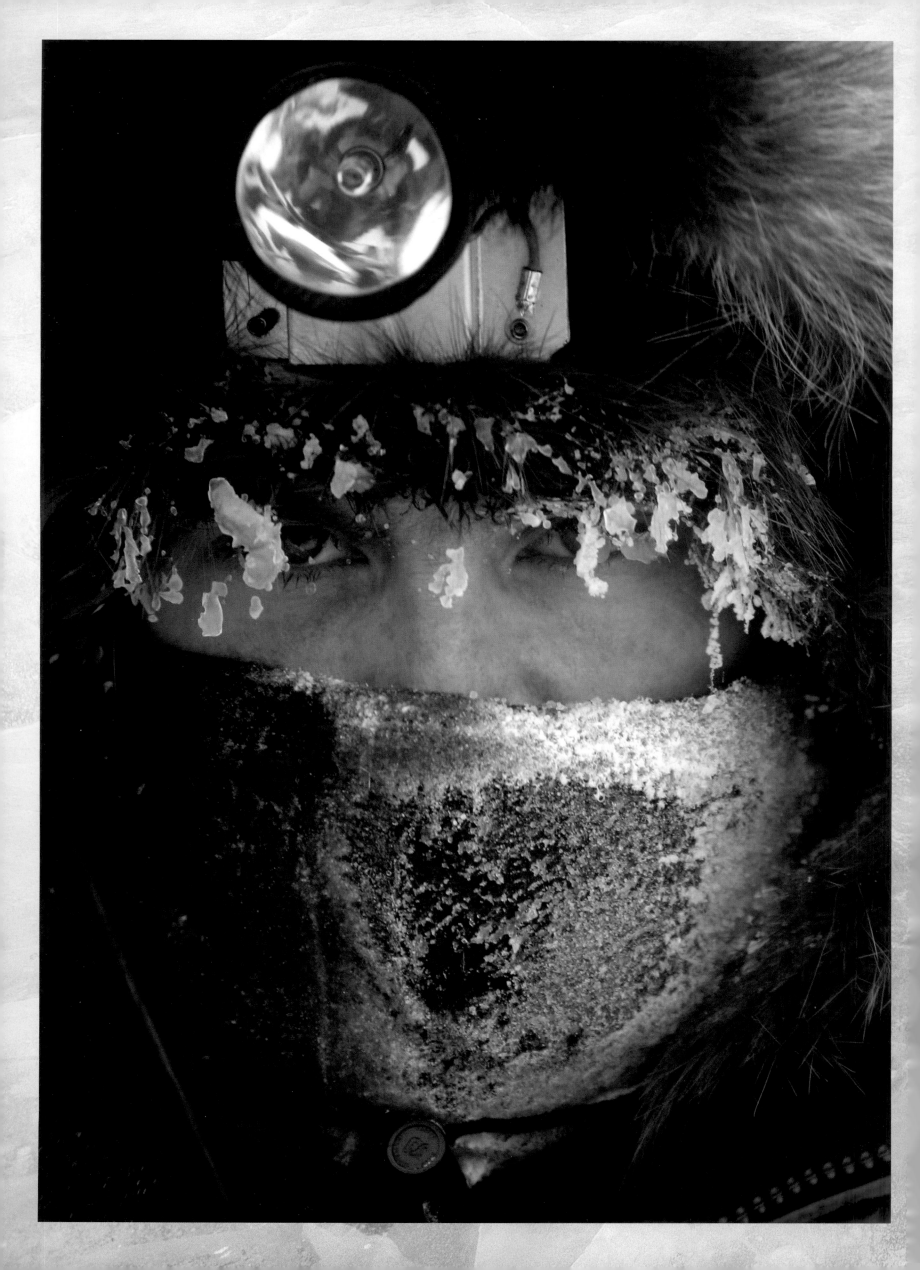

Iditarod *glory*

NEWCOMERS BEWARE: IDITAROD MAY BE HABIT FORMING.

Your first glimpse may come through an intriguing headline, photo, or news clip. You may get a taste by lending a hand as a volunteer pilot, or starting-line handler, or assisting with veterinary care out on the trail. However your introduction to the experience comes about, even fleeting contact with Iditarod tends to lure you farther and farther out the trail.

Take those curious place-names gracing the map: *Knik, Yentna, Skwentna, Finger Lake, Rainy Pass*. From afar, the very names of Iditarod's initial checkpoints herald an event that transcends the normal boundaries of sporting competition.

Your team charges out an old stampede trail and climbs into the Alaska Range, facing challenges that dwarf anything seen on baseball's neatly drawn diamonds, or within the lines of football and soccer fields. The action isn't confined to set periods or innings, and it isn't refereed through called balls and strikes, or a series of downs. The drama showcased in this spectacle stretches over twelve hundred miles of sparsely settled arctic wilderness, and bridges modern urban society and traditional Native cultures.

The Iditarod, the mushing world's ultimate marathon, unfolds in nature's arena. The obstacles that confront you are as unpredictable as the Alaska winter—a harsh season, sharp-edged and fraught with icy menace. Even in the mildest of years, your team is tested crossing snowy mountains, frozen rivers, and by the lashing winds that whip the coast of Norton Sound.

Rohn Roadhouse, Nikolai, McGrath. After descending the Alaska Range through the treacherous Dalzell Gorge, your trail shifts from forests scarred by wildfires to frozen rivers, plunging ever deeper into the Interior. The path through this savage, cold country follows paw prints dating back a hundred years or more, retracing history through yet more checkpoints, and other

▲ An Iditarod sled dog rests at a checkpoint.

◄ Randy Chappel is bundled up against the below-zero temperatures he encountered on the trail leading to Nikolai in 2004.

place-names befitting J.R.R. Tolkien's imagination.

Takotna, Ophir. In odd-numbered years, you take Iditarod's southern route, following the trail southeast into the hills, pushing for the remote ghost town whose spirit embodies the race.

Iditarod. The race takes its name from this forsaken gold camp, which boomed in the early 1900s—and, just as quickly, faded—on the bank of the Iditarod River.

At its height in 1911, Iditarod was a thriving community of ten thousand, boasting electricity and its own newspapers, banks, and hotels. The camp even threatened to eclipse Fairbanks (now Alaska's second-largest city) as the favored destination for boatloads of fortune hunters then pouring into the Interior. For a portion of its fleeting summer, Iditarod was a port of call for steamboats that made the passage via the Yukon and Innoko Rivers. Over the balance of the year, winter's icy grip meant access to the remote camp came overland by trail or not at all, leaving locals dependent on dog teams for mail and supplies.

Those gold seekers of old risked all. Living off scraps of dwindling grub, and stuffing newspapers in their coats and pants for insulation against the cold, the stampeders who mushed dog teams out the trail from Knik toward Iditarod's mines left behind all that was familiar, trading family, shelter, and any promise of security for dreams of claiming the riches locked in the Interior's unforgiving heartland. Today, all that you see is an isolated cluster of sagging storefronts, abandoned cabins, rusting machinery, and other ruins poking through the snow, a reminder of just how far pioneers once chased the whispers of golden opportunity.

Shageluk, Anvik, Grayling, Eagle Island. From the ghost town of Iditarod, the trail swings east, hurling your team at miles of

hills before delivering them to the village of Shageluk. Afterward, you dodge through thick forests, finally bursting onto the immense Yukon River at Anvik. From there, the river dictates life for competitors, canine and human alike. You make for Grayling, then Eagle Island, traveling what amounts to a scratch of man's presence in the Lower Yukon's broad white expanse. Every step of the way, you and the dogs are exposed to the brutal, cutting wind.

In even-numbered years, you follow Iditarod's northern route out of Ophir, blasting across frozen marshes and creeks toward the abandoned mining camps of Poorman and Cripple. The trail eventually spills onto the Upper Yukon at Ruby, the first in a series of riverside village checkpoints.

Galena, Nulato. By this point, "reckless rabbits" are paying the price. If conditions are good, this stretch is hard-packed by village-to-village traffic. Speed here tells whether you are among the mushers who have achieved the right balance between running and resting their dogs earlier in the race.

Iditarod's two routes converge at Kaltag, where the trail leaves the vast Yukon River, and the Interior, for good. Reentering the welcome shelter of trees, you climb toward coastal mountains. This traditional trade route links Alaska's Athabascan Indians with their Inupiaq Eskimo brothers and sisters on the Bering Sea coast. It is, perhaps, the historic trail's oldest segment, predating Alaska's gold strikes and Russian trading posts—indeed most Native villages are newer additions to Alaska's map.

Old, weathered timbers lashed into tripods guide you and other travelers on the drift-caked plateau that separates Native peoples of the river from those of the sea. Descending from the plateau, the trail weaves through forests, crosses frozen streams, and skirts

Speed here tells whether you are among the mushers who have achieved the right balance between running and resting their dogs earlier in the race.

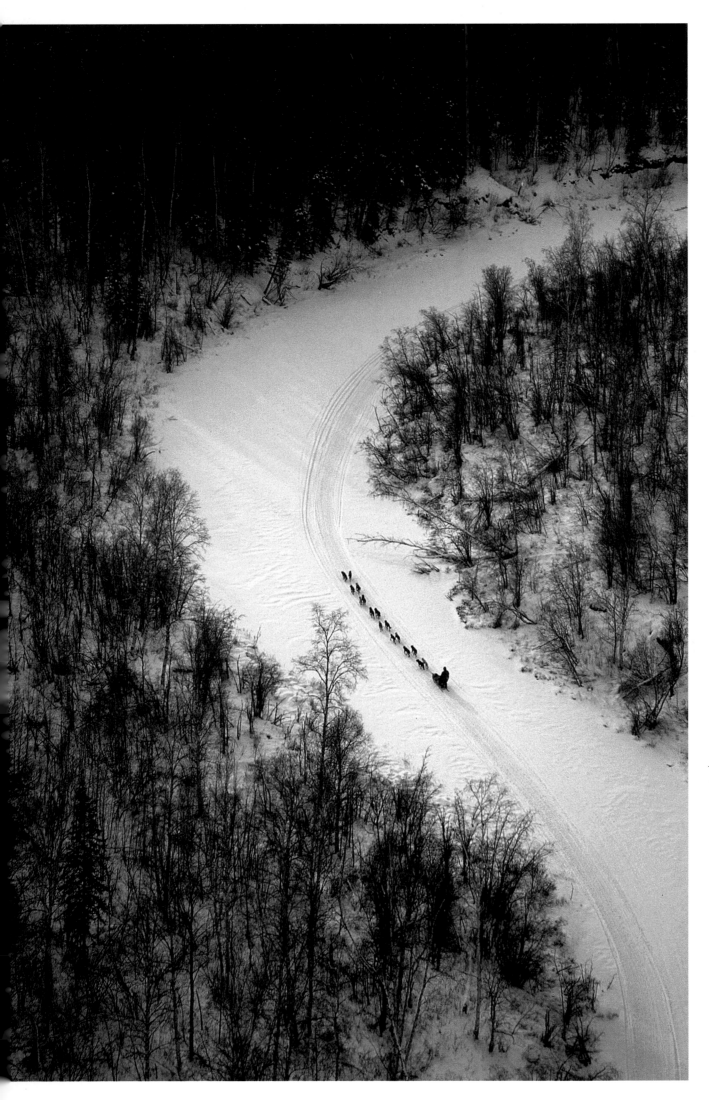

◀ A musher meanders his way down a Tanana River slough during the 2003 Iditarod. The race was the first in Iditarod history that did not cross the Alaska Range. Unusually mild temperatures had kept many rivers and creeks from freezing and the snowpack in Southcentral Alaska was low or nonexistent. Following a shortened ceremonial start in Anchorage, the Iditarod Committee moved the restart of the race north to Fairbanks where conditions were more favorable.

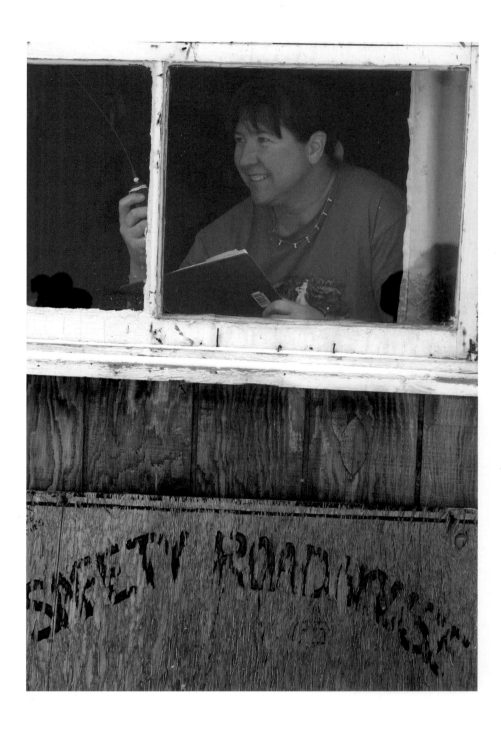

► Volunteer ham radio operator Jan Bullock peers out the window in 2004 toward the horizon looking for signs of the next musher's arrival at the final checkpoint, Safety. With only 22 miles to the finish line, few mushers spend more than the time necessary to sign in and have their mandatory gear checked at Safety so volunteers keep close watch for approaching teams. Each race has over 40 communications volunteers like Bullock spread out at the checkpoints to relay team arrival and departure information to Iditarod headquarters. These volunteers use various forms of communications, depending on available technology, including ham radio at remote sites, or fax, phone, and the Internet.

ever-larger rivers. The air in this stretch carries whiffs of change, explained as you leave behind trees and enter a frozen plain. Ahead waits the coast, seasonal fish camps, and the largest community on the trail, Unalakleet, whose name means "place where the east wind blows."

The starting chute is some 900 miles back; Iditarod's glory hounds still have roughly 250 miles to cover. Exposed to the wind, weaker teams often buckle on this coastal march. For you and the rest, the pace of the race quickens, dogs and drivers moving smoothly in sync, functioning as a unit schooled by shared hardships. Your goals are within reach. Destiny is being written with the rise and fall of each canine paw, and with every boot kick from the player/coach riding the runners.

Shaktoolik, Koyuk, Elim, White Mountain. You trade position with the other racers still in the hunt, alternately leapfrogging into the lead, checkpoint by checkpoint; contending with markers felled

by the wind, battering rides over hardened drifts, and pressure ridges thrusting upward in the sea ice.

The outcome is all but official by the time you reach *Safety*, a roadhouse whose solitude and promise of sanctuary merits its own dot on Iditarod's map. Snow and ice give way to signs of settlement. You pass fish camps locked in drifts. Before long, caravans of spectators honk from a lone roadway overlooking ice-locked sea.

Downtown, a siren sounds and people gather along the street. A police cruiser, lights flashing, sits idling, ready to provide your escort. Out on the beach, a wobbly centipede of paws finally rolls into view, hauling sled and driver over sculpted drifts. Markers and tracks in the snow guide your lead dogs toward a ramp climbing the icy dunes, onto the snow-packed pavement of a hard-living town whose beaches once glittered with nuggets.

The trail behind is no longer a series of place-names on the map. It's a set of experiences, binding those dogs fronting the sled—still pulling for all to see—and a master who's forever changed.

A tall burled arch stands in the center of the roadway downtown. This is the destination etched in every dog driver's waking dreams from one year to the next, through thousands of miles of training. "End of Iditarod Dog Race" proclaim the letters spanning the crosspiece.

"Whoa," you whisper. Those trail-savvy dogs stop on a dime. People are cheering. Someone slaps you on the back. There's a clipboard to sign. Helping hands steady the sled. You hardly dare believe, but it's no hallucination:

At last! *Nome!*

THROUGH THE VIEWFINDER

I first heard about the Iditarod in 1985, while driving a cab in New York. A story in the *Times* had my fares talking—a woman had won Alaska's big dog race. This Libby Riddles character was staying in a posh hotel with one of her dogs. The tall blonde and the dog were freaked out by Manhattan's traffic and urban intensity—so the story went.

How strange, I thought, *driving hundreds of miles over ice fields—with nothing but dogs for an engine!*

A year later, I landed a job in Alaska. A total fluke, believe me. I was ready for a change of scenery, and the recruitment ad from the *Frontiersman*—a Wasilla, Alaska, newspaper—promised adventure.

When the 1987 Iditarod rolled around, I grabbed my camera bag and flew into Skwentna on assignment with sportswriter Tim Mowry. It was quite an introduction to the race. Dozens of teams were camped on the river below checker Joe Delia's cabin. Colorful sleds, heaps of supplies, strings of frisky, excited dogs, and mushers engaged in all manner of checkpoint rituals—it was a press photographer's mother lode.

Still, this was a race; I needed dog teams in motion. Several mushers were fastening little socks on their dogs. I took that as a cue that departures were imminent, so I dashed up the trail on foot, positioning myself to shoot teams rounding a river bend.

Finding what looked to be an eye-catching backdrop framed by trees dipping toward the trail, I gingerly edged across hardened snow toward a higher vantage along the bank. I was about halfway there when the crust gave way under one boot, then the other. I was soon wading through powder up to my elbows. Frantic at the delay, I forced my way though; a musher could be rounding that bend any second!

Near the bank, I stomped out a small platform in the snow and readied my cameras, getting out the lenses I wanted, checking the metering. Then I took aim at the trail snaking down the river. Warm

> "Whoa," you whisper. Those trail-savvy dogs stop on a dime. People are cheering. Someone slaps you on the back. There's a clipboard to sign.

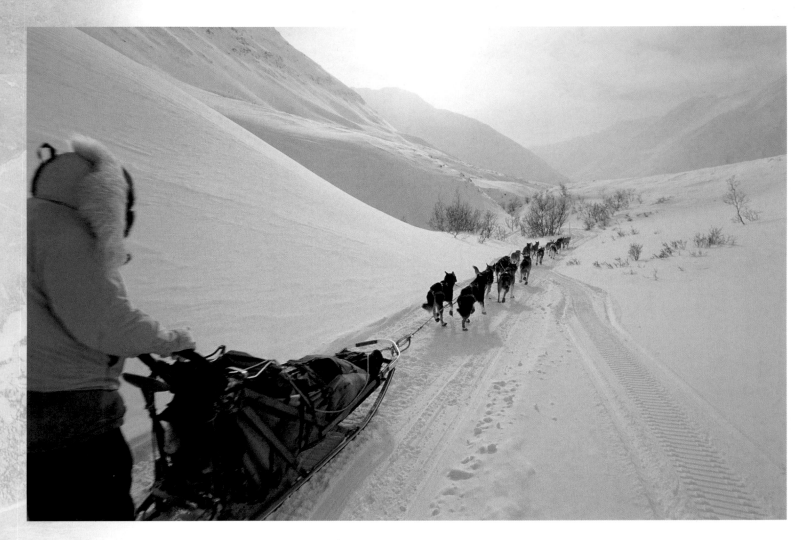

▲ A mile after cresting the 3,160-foot summit of Rainy Pass, in the Teocalli Mountains of the Alaska Range, 2004 musher Charlie Boulding heads down frozen Pass Fork, which snakes its way toward the Dalzell Gorge and the Rohn checkpoint beyond.

afternoon light bathed the scene. Rippling contours added contrast to the snow's glistening sheen. It was perfect—all I needed was a dog team.

Twenty minutes passed. Then another twenty, maybe thirty more. The sun was slipping behind the trees. Blue shadows advanced across my viewfinder, encroaching upon my carefully planned shot. And, though I could only guess at the temperature, cold began nibbling at my spirits. My gloves, pants, and socks were wet from the powdery swim. My boots weren't tied well, which had allowed snow to pack around my ankles. The appeal of this photo op was diminishing as I hopped from side to side, trying to keep my feet from freezing.

A dog team suddenly glided around the corner without warning. By now, my fingers were stiffening and I could hardly operate the cameras. I shot maybe three frames before the advance sprocket began tearing film in one body. The shutter failed in the other. This newcomer's learning curve was

steep. A thousand miles later, similar hardships and camera problems colored my photographs of teams battling their way through a ground blizzard sweeping the frozen beach outside Nome.

A year later, and theoretically wiser, I split the cost of a snowmachine with an AP photographer and together we chased Susan Butcher's team out of Shaktoolik.

The defending champ's dogs were trotting briskly, noses to the wind, fur waving crazily. Their master wore her big fur mitts, gripping the handlebar of the sled as it bounced drift to drift like a spear skimming water. The landscape ahead was stark and surreal, a world stripped of life, yet swirling underfoot. Butcher had to be aware of our presence, but she paid no notice. Her eyes were on the trail; her mouth was set.

It was the sort of moment photographers live for. I blazed away, swapping lenses in the flying snow, adjusting exposures to compensate for motion and light. In minutes, my cameras were dead and my hands felt

crippled. The other photographer sharing the sled soon sported a deadened-white, spreading patch of frostbite on his cheek. Humbled, we retreated to the checkpoint.

The lens switching had allowed moisture into my cameras. By the time I reached Nome, several bodies were unreliable, jamming constantly. I dried them in a kitchen oven set on "low," a method I had once used with success after soaking my cameras while covering a rainy New York marathon. The stove in Nome had a bum thermostat, however; when it cooled, I sadly witnessed just how many heat-sensitive parts three molten Olympus OM-2 bodies contain. Other journalists dubbed me the "meltdown man."

The Iditarod tantalizes, and it torments. My own mishaps covering five Iditarods can only hint at the commitment of photographer Jeff Schultz, who's been following teams up the trail for more than a quarter of a century. It's not uncommon for Schultz to wait an hour and a half in a spot as inhospitable as, say, Rainy Pass on a twenty-below afternoon. "You always wonder if it's going to be worth it," he says.

Hiking down in the Dalzell Gorge, Schultz was once startled to find a lead dog literally at his heels, with an entire team bearing down on him. "Teams can be so quiet you never hear them coming." As is the case for veteran racers, the trail's geography becomes entwined with memories for any journalist who covers the race.

Schultz, for example, on many occasions has sought out the vantage provided by the cliffs overlooking the Yukon at Ruby. "If you haven't got a snowmachine, it's quite a walk climbing that hill," he says. "Then, to get over to the cliff, you're wading through deep snow. By the time you get there, you're totally exhausted. You're covered with sweat." Inevitably, a chill sets in. The sun creeps lower and lower without sight of

the dog team needed to complete that Iditarod picture. As I glimpsed in Skwentna those years ago, this is when the photographer's vigil becomes a cruel labor of love. "It's not a good thing," Schultz says, chuckling.

On another occasion, Schultz was descending the gorge on a sled towed by a snowmachine, when the trail ahead suddenly disintegrated. "The trail just gave out behind the snowmachine," he recalls. "I jumped backwards." The photographer landed on the edge of a new cutbank, with his feet dangling over the water.

FOR LOVE OF THE DOGS

By the mid-1960s, snowmachines were gaining popularity throughout the Alaska Bush, where they proved useful in many roles traditionally filled by sled dog teams.

The machines held considerable advantages over dog teams. A tug on the cord, and you were ready to zip over to a friend's cabin, or make a supply run into town. Not only did a snowmachine take less preparation to operate, it was generally faster than a team. And a machine could simply be parked when not in use; it didn't require a year-round investment in food and attention.

Joe Redington Sr., a homesteader, fisherman, pilot, and freight musher, believed that working dogs still had their place. A well-trained dog team was more dependable in cold weather than any machine. A musher driving a good team could climb steep riverbanks, and negotiate other terrain likely to foil the best snowmachines of the day. The Air Force saw the merits, and employed Redington and his dogs in salvaging military aircraft downed in Alaska's backcountry.

Still, Redington wasn't blind to the signs. In nearly every village he visited, kennels devoted to the burly working dogs favored by trappers and freight mushers were declining. He reckoned that something bold

It's not uncommon for Schultz to wait an hour and a half in a spot as inhospitable as, say, Rainy Pass on a twenty-below afternoon.

was needed to counter the trend, an event calculated to show off the awe-inspiring capabilities of working husky breeds. The obvious answer, as Redington saw it, was a competition borrowing from the past, yet staged in a manner that couldn't help but capture modern imaginations.

In the heady days of Alaska's gold rush, miners looking for a diversion had cheered—and often wagered on—sled dog races. Canine athletes hitched to the sleds came from teams normally used to haul mail and other freight. The competition in that era took place across longer distances and trails far tougher than anything seen in the civilized, twenty- to thirty-mile heats common to modern sprint races.

The most celebrated of these earlier races was the All-Alaska Sweepstakes, a winner-take-all spectacle held during Nome's boomtown days in the early 1900s. The Sweepstakes' trail stretched from Nome to Candle and back, a distance of 408 miles. The 1910 race featured a $10,000 purse and was won in some seventy-four hours, a feat never again equaled, earning lasting fame for John "Iron Man" Johnson. The last sweepstakes took place in 1918; shorter races became the rule afterward.

In the early 1970s, Redington shook Alaska's mushing community from its apathy by proposing a mushing marathon that would dwarf anything ever seen. He suggested sending dog teams racing a thousand miles, on a route seldom used since the stampeders' day. The very concept was audacious; nobody knew whether it was even possible to *drive* dog teams such a distance, much less race them that far!

There's a myth that Redington launched his race as a tribute to the heroic 1925 serum run. Chock that one up to good PR. Sure, the serum run had made headlines in its day. The drama was all but scripted to capture the popular imagination: when extreme weather grounded air traffic, mushers banded together in a desperate relay mission, passing diphtheria vaccine from team to team, on up the trail to Nome, where the medicine quelled a spreading epidemic. But the serum relay had taken off north of the Alaska Range in Nenana. The trail followed the Tanana out to the Yukon River, jumped overland at Kaltag, and continued on up the coast.

Redington lived some 250 miles south of Nenana in Knik, a largely deserted former port that had once served as Cook Inlet's gateway to the Interior. When local historian Dorothy Page approached Redington about staging a sled dog race to mark Alaska's upcoming '67 Centennial, the pair naturally settled on a local trail with suitable lineage: the old supply route to Iditarod.

The Knik-Iditarod Trail had not been used in decades. Local mushers cleared nine miles of brush, reopening the trail as far as Big Lake. This first race was named the Iditarod Trail Seppala Memorial Race—in honor of mushing legend Leonard Seppala, who had died that year. It was run over two days, and featured twenty-five-mile heats. Isaac Okleasik, an Inupiat Eskimo from Teller, won the event, which had attracted quite a field with its eye-catching $25,000 purse. Two years later the race was repeated—with a much smaller purse—and George Attla, an Athabascan sprint-mushing champion, took top honors.

Afterward, Redington began talking up the idea of a sled dog race looping all the way from Knik to Iditarod and back, a distance of roughly five hundred miles each way—more than twice as far as Nome's long-defunct Sweepstakes. The pieces began coming together in November 1972, when Redington collected the first pledges toward what he guaranteed would be a $50,000 purse. Would-be sponsors of the new race, affiliated with a local Democratic Party group, suggested a route change. Instead of mushing for Iditarod, an all-but forgotten ghost town, why not shoot for Nome itself?

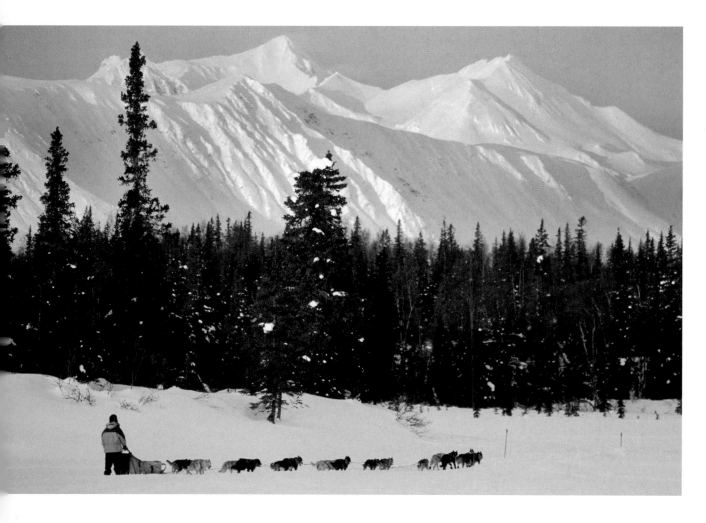

Dick Mackey, a Wasilla musher—who in 1978 would win what remains the closest Iditarod on record—says Redington called him at 2:00 A.M. to test the concept. "It's a great idea," responded Mackey. He promised that if the race ever came off, he'd be the second musher to sign up. He assumed that "Old Joe" himself would be the first.

"WHAT DID WE GET OURSELVES INTO?"

For everyone involved, from the U.S. Army's trailbreakers, who were field-testing snowmachines, to the mushers debating what in the world to pack or feed, the inaugural race of 1973 amounted to a colossal wager on the unknown.

The biggest name entered in the new race was thirty-nine-year-old Attla. The "Huslia Hustler," as he was known—for his competitive spirit and village roots—was coming off a season in which he had swept the big sprint races in both Anchorage and Fairbanks. This Iditarod offered something new. "Most of us who did it we were just curious if we could do it," he told me one afternoon in North Pole.

"It was pretty far out, but the old-timers in Huslia—they said it could be done."

The snowmachines used to mark the trail broke down so regularly that the Army didn't even try to fix them on the trail. "As soon as they broke down they flew in replacements," Rod Perry, one of the veterans of that original race, told me for a story marking Iditarod's twenty-fifth anniversary. "The first few days we had a constant stream of big cargo planes flying over us at Super Cub height."

One of the Army's innovations was equipping the machines to spray-paint trail markers on the surface of the snow. Such marks faded with the arrival of fresh flakes, forcing mushers to painstakingly brush back snow looking for clues, recalled Ken Chase, another '73 veteran.

The thirty-four teams entered in the race chose their gear with a mix of instinct and ingenuity. Nome musher Howard Farley left the starting chute driving a thirteen-foot freight sled, more than double the size of today's Iditarod standard. Okleasik, the Teller

musher victorious in the short '67 test run, brought a Coleman lantern and a four-foot rifle. "Nobody thought to bring a pistol or headlamp," said Herbie Nayokpuk, an Eskimo ivory carver, who was destined to become one of the true legends of the trail—the "Shishmaref Cannonball." Nayokpuk was in Anchorage competing in the Fur Rondy's annual sprint races. The musher from windy Shishmaref on the Bering Sea embraced Redington's new marathon as an adventurous way home. He spent three days building a hefty freight sled for the trip, while his wife stitched together a tent.

Sleds of today glide on various grades of quick-change plastic, color-coded for durability and suited to changeable trail conditions. The first Iditarod featured a wide assortment of experimental "shoes," as the shields protecting runners were then known. "People had wood shoes, steel shoes, some had brass runners or ivory shoes," said Chase, who made a good part of the trip driving a sled riding on PVC pipe.

Most mushers packed hundreds of pounds of dog kibble, dried salmon, and other supplies. Most shipped much more to villages up the trail. At the other extreme, twenty-eight-year-old Raymie Redington, who was subbing as driver for his dad's team, took virtually nothing.

The family plan called for Raymie to mush only as far as Knik, satisfying Redington's sponsors, then quit—but Old Joe's son had other ideas. "I started with nine dogs and they was running good," Raymie Redington told me in 1997. "So I decided to keep going, but I wasn't packed or anything."

No one had dogs trained for such an odyssey. Most came from village traplines or the sprint-racing circuit, where traveling twenty to thirty miles counted as a full day. Seward schoolteacher Dan Seavey probably came closest to the mark, putting what he estimated was fifteen hundred miles of conditioning on his dogs. Many more drivers planned to train their teams on the run.

Bush pilot Dick Wilmarth knew how to drive dogs on the trapline, but he didn't even have a team when he first heard about Redington's great race. The man from Red Devil traded a snowmachine for five dogs, then picked up seven more from a woman he knew from Lime Village. Friends in Stony River gave him several more.

Come race day, Bud Smyth, of Houston, Alaska, hooked up the biggest string and drove twenty dogs out the starting chute. Sprint master Attla deliberately left his faster dogs at home. "I took the big dogs, my old slow dogs," said the Huslia Hustler. The dogs included ten-year-old Blue, a leader from Attla's winning team in the 1969 Open North American. "I just thought in my mind they wouldn't be sprint dogs when I got done with them."

Joe Redington flew air support. When slow progress left mushers stomping out pleas for food in the snow, Old Joe swooped in from the sky, bombing race teams with dog food and emergency supplies. One care package lobbed toward his son included replacement dentures.

Attla borrowed a trick from a sprint rival and fed his dogs a mixture of dry commercial feed and canned horse meat. His team set the pace though the first checkpoints. Four hundred miles into the race, however, Blue and the crew were weakening. An old Athabascan in McGrath pointed out a likely cause: "How far do you think *you'd* get," he asked Attla, "on corn flakes?"

EVENT UNLEASHES REVOLUTION

From its inception, Iditarod's hardships have served as a laboratory, advancing the sport though rigorous demonstrations of what works—or fails—out on the trail. In the early years, mushers from different regions

Most mushers packed hundreds of pounds of dog kibble, dried salmon, and other supplies. Most shipped much more to villages up the trail.

learned from each other. Nayokpuk, for example, used leather booties to protect paws, a concept new to the racer's urban counterparts. Over the decades, leather booties tied with laces gave way to fabrics fastened with loops of electrical tape, which in turn gave rise to tough new synthetic materials and stretch-Velcro straps. Similar advances are apparent in today's sleds, cookers, headlamps, and harnesses.

Take sleds. From the first race onward, the sled used to haul gear and supplies offered an obvious target for improvement. Bud Smyth used twenty dogs to pull his long freight sled in the inaugural Iditarod. After a few trips up the trail, he settled on a bigger-is-better approach more radical than anything seen before or since. At that time, there was no firm limit on the number of dogs in a team. Smyth seized on that opening and started one year with a team of thirty-six dogs. He

brought an extra-wide sled, featuring a built-in cooker and cages for a dozen canine passengers. The musher reckoned on using twenty-four dogs powering across the Alaska Range, while the others rested in those cages. Afterward, the strategy called for jettisoning the big sled, trimming down the crew, and proceeding to Nome driving the best-rested team in the race.

Could it have worked? Iditarod fans will never know. Veterinarians took issue with the cages and halted Smyth's mammoth contraption en route. Subsequent rule changes set the limit at twenty—and, more recently, sixteen—dogs per Iditarod team.

The early 1980s witnessed a gradual shift from traditional freight and basket sleds, fashioned from birch, to more easily repaired, plastic-bottomed toboggans. The latter design, pioneered by mushing inventor Tim White, rode on wooden runners outfitted with

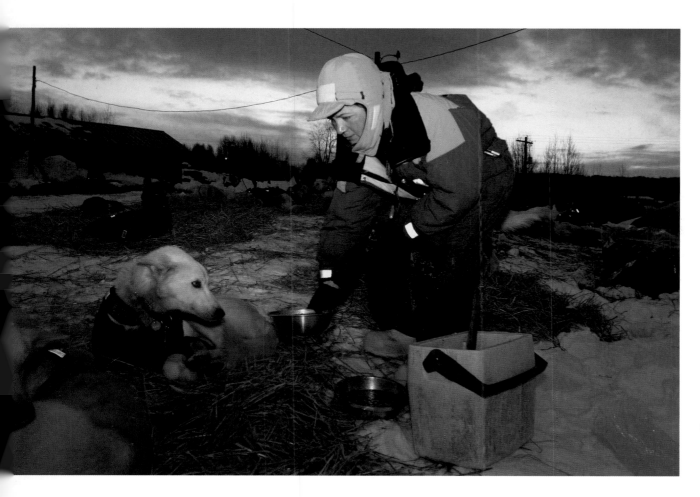

◀ Anna Bondarenko feeds her dogs as the sun rises in the Yukon River village of Ruby. The dogs are fed a variety of foods including beef, lamb, chicken, fish, beaver, and more. High-energy meals are a necessity as studies have shown that dogs in the race burn 10,000 or more calories per day out on the trail.

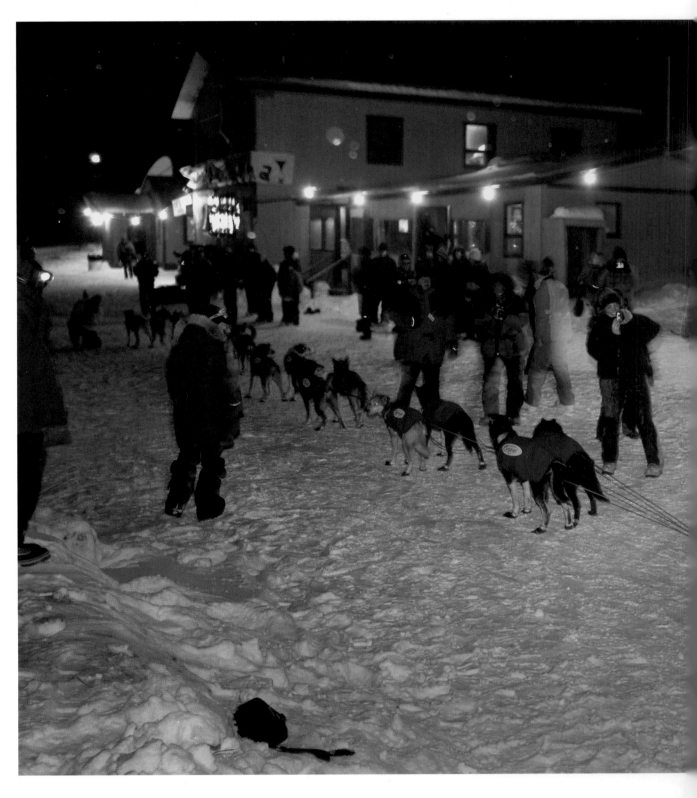

his quick-change plastic. As competition intensified, top drivers began shipping out short, light sleds to the coast. Now, nearly every racer sends out three or four sleds suited for specific portions of the trail. Plastic toboggans with wooden runners have been displaced by (among other designs) high-

riding, flexible, fabric-bottomed basket sleds, cruising on aluminum or composite runners.

Three-time champion Jeff King has raced with sleds that can be shortened for his team's finish-line sprint. Facing a rough passage in a year of poor snow, King unveiled a sled boasting runners equipped

providing more spring in his step during the final miles to Nome.

Over the years, Iditarod mushers evolved from passive riders into player/coaches, doing whatever might boost their team's speed. Most run behind the sled while climbing hills; some have tried harnessing the wind through impromptu sails. Many of today's top drivers thrust with ski poles as they ride the runners, adding what Martin Buser has described as "two extra dogs" to their team.

Schultz finds inspiration in Iditarod's changing accessories. "Adjustments over the years have really helped," the photographer says, citing the graphic possibilities inherent in dog coat designs, colorful booties and blankets, and other innovative gear. "Poling is another one," he says. "Now everybody has ski poles strapped to their sleds."

BLOODLINES REACHING INTO THE FUTURE

When Redington set out to ensure the survival of bloodlines, he had working dogs in mind. As it turned out, his race has not only provided his beloved working dogs with new purpose, it has inspired a way of life structured around racing sled dogs that now bridges generations, and spans international borders.

First came Iditarod's multiplier effect. Redington's classic spawned a host of other long- and mid-distance races, many of which were organized by mushers seeking opportunities to groom teams and hone their own skills for the race to Nome. Among the races that can be directly traced to Iditarod: *The Yukon Quest International*, a 1,000-mile race between Fairbanks and Whitehorse; Norway's 620-mile *Finnmark*; Minnesota's 500-mile *Beargrease*; Montana's *Race to the Sky*; Wyoming's *Rocky Mountain Stage Stop*; Siberia's *Hope* race; and Europe's *Alpirod* and *Odyssey*. Not all of these races have thrived, and each has sported its own set of rules and

Schultz finds inspiration in Iditarod's changing accessories. "Adjustments over the years have really helped," the photographer says, citing the graphic possibilities inherent in dog coat designs, colorful booties and blankets, and other innovative gear.

with retractable wheels—an innovation now banned in the rules. The inventive musher from Denali Park again turned heads in 2004 with a sled that positioned the driver between a forward and a rear compartment. The back section doubled as a seat, a feature the racer credited with reducing fatigue, thus

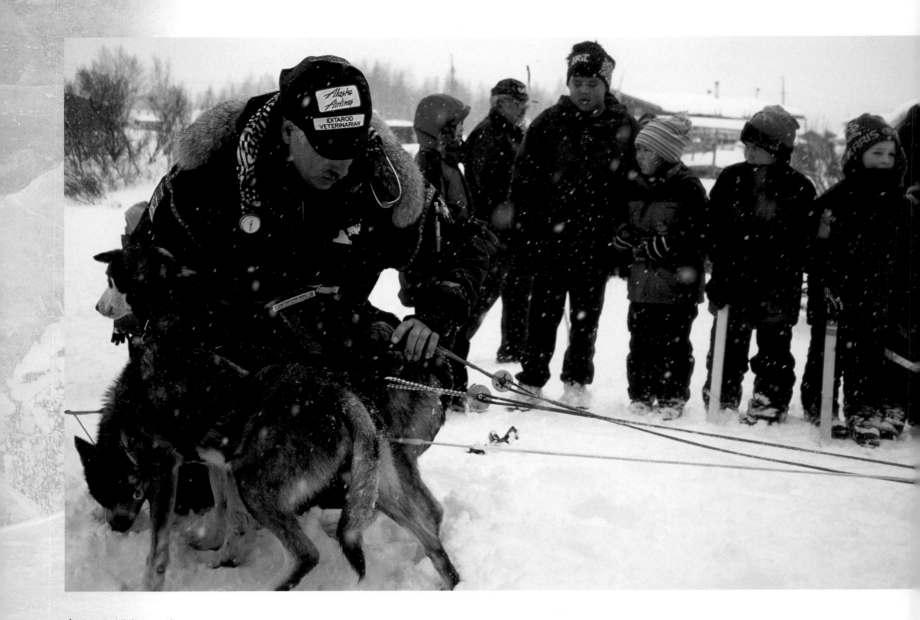

▲ Local children gather around to see dogs arriving at the Athabascan village of Kaltag in 2004. Volunteer veterinarian George Stroberg checks the hydration of a dog shortly after its team reaches the village. Each checkpoint along the trail is staffed by two to five volunteer vets, who check virtually every dog as it passes through. Mushers are all required to carry a "vet book." These are used by trail docs to jot down any veterinary concerns about dogs in the team, allowing colleagues at subsequent checkpoints to monitor their care and better diagnose problems.

challenges. What these and other races share is a common heritage in the evolutionary tree rooted in Old Joe's imagination.

Iditarod's deepening hold is perhaps best measured in the generational transition now well underway. Five years after Dick Mackey edged out then reigning champ Rick Swenson by a lead dog's nose, his son, Rick Mackey, etched his own name on the 1983 winner's trophy. In 2002, nearly thirty years after Dan Seavey mushed the third team across the finish line in the inaugural Iditarod, he was joined on the race trail by his son, Mitch, and a grandson, Dan—the trio went the distance. Two years later, Mitch Seavey finished what his dad started years ago, claiming the big prize in Nome.

Dean Osmar retired after winning the 1984 race, but his son, Tim, remains a perennial contender. Bud Smyth's sons, Ramey and Cim, are among the young guns

bidding for the crown that eluded their father's grasp. Redington's grandson, Ray Redington Jr., is another rising Iditarod star. So is Ramy Brooks, the son of Roxie Wright, a celebrated sprint musher and Iditarod veteran. Eighteen-year-old Cali King joined her father, Jeff, on the trail to Nome in 2004. The list goes on . . . each year, Iditarod attracts more racers from familiar bloodlines.

Technology has expanded news coverage and public awareness of the Iditarod to the point that the progress of teams racing across Alaska wilderness draws worldwide rooting interest. From Scandinavian countries to Japan and Australia, the Iditarod draws entrants from across the globe. Montanan Doug Swingley caused a national sensation in 1995 when he became the first Iditarod winner to reside in what Alaskans refer to as the "Outside." Likewise, the unexpected victory of Team Norway driver Robert Sørlie in 2003 thrilled

fans across Europe, boosting Iditarod's status as a truly international competition. Sørlie's repeat performance in 2005 can only expand the ranks of Iditarod's new Eurofans.

The increasing profile of the race is also reflected in the rewards awaiting top finishers. Iditarod's purse for the 2005 race topped $750,000. Sørlie collected prizes valued at over $100,000, including a new $40,000 pickup. The next twenty-nine racers who followed the champion into Nome all took home considerable paychecks, sized according to their team's order of finish. Other mushers going the distance pocketed consolation prizes of $1,049 apiece, a sum that reflects the ceremonial numbers of a thousand-mile race in the 49th state; the true distance covered by the trail is closer to eleven hundred miles.

Iditarod is relentless. Drivers punch every hour of the clock, adjusting the teams' run, rest, and meal schedules to best suit their dogs. Each of the canine engines sharing the load burns as much as 11,000 calories daily, covering 130 miles or more every 24 hours, for 8 to 14 days straight. It's a physical feat surpassing the energy expenditure of any race horse, or human marathoner.

Yet, despite its grueling demands on every participant, two-legged or four, the Iditarod remains, at its core, a sporting endeavor. Though intense, Iditarod's competition isn't cutthroat; the annals of the race include many examples of racers setting their own goals aside to rescue injured, stranded, or otherwise incapacitated rivals. Teams frequently band together to break trails swallowed by drifts. Though a new champion may be crowned and top spots already decided, joyful jockeying for bragging advantage (if nothing else) continues as successive waves of finishers stream into Nome.

The breadth of its supporting cast distinguishes Iditarod from baseball, football, soccer, and many other similar extravaganzas. Iditarod organizers face logistical and financial considerations comparable to those of a multi-million-dollar business. If everyone involved in the enterprise were on the Iditarod Trail Committee's payroll, employees would easily number in the hundreds. Entering its fourth decade, Redington's great race thrives because it enjoys backbreaking contributions from hundreds of volunteers.

They are the handlers readying sleds and gear. They provide veterinary care on the trail. They distribute supplies at checkpoints, monitor the progress of teams, and ensure compliance with the rules. They pilot the small planes of Iditarod's voluntary "air force," transporting dropped dogs, shifting race officials between checkpoints, and ferrying injured mushers to medical clinics. From the crossing guards in Anchorage to the villagers keeping the stew hot at local checkpoints, Iditarod remains, at its core, a community-driven endeavor.

All of these volunteers and their individual contributions figure in Iditarod's big picture. The deeper one goes behind the scenes, and the closer one gets to the event itself, the larger that picture becomes, encompassing what amounts to a lifestyle. "It's not really about who wins. I don't care who wins," says Schultz. "It's about being out with the people connected with the race," the photographer says. "I always tell people it's not a race, it's an event."

Preparations for the event begin months before teams gather for Iditarod's ceremonial start on the first Saturday in March. And the effort extends for days, sometimes weeks, after the crowning of Iditarod's new champion in Nome. The sporting spectacle isn't over until the gutsy dog guiding the final team into Nome finally pokes its nose across the finish line, and the figurative lantern lit when the race began in Anchorage is finally extinguished. The arrival officially closes the year's record book, and generally draws at least a few appreciative cheers. It's certainly cause for ribbing, albeit kindly, directed toward the sheepish driver of that dead-last, Red Lantern team.

Entering its fourth decade, Redington's great race thrives because it enjoys backbreaking contributions from hundreds of volunteers.

Oh, there's plenty more to say about that luckless Red Lantern's lot.

A SLIPPERY SLOPE

March 1988: There I was, riding out of Anchorage atop Tim "The Mowth" Mowry's bulging sled bag. The sportswriter-turned-musher wore a thousand-miles-to-go stare, but I was a carefree handler, drinking in the cheers for twenty miles, then set to resume my life as a reporter.

Redington's irresistible game had yanked The Mowth from his safe seat in the press box. He was hardly the first: pilots, veterinarians, handlers of all sorts, sponsors, and casual fans from many walks of life have landed on the runners within a year or two of exposure to Iditarod. Why should I be different?

Following Mowry and some fifty other teams up the trail opened my eyes to Iditarod's intoxicating possibilities. Redington, then seventy-years-young, fell behind with

the flu in Skwentna. While he recuperated, front-runners bogged down, slogging through deep wet snow in the Alaska Range. The trail set up while Redington passed his twenty-four-hour layover. Two hundred miles later, Iditarod's founder had rocketed into the lead. "I feel like an old fox chased by fifty young hounds," he told journalists in McGrath.

"Smokin' Joe"—as Redington became known that year—was still ahead of the pack in Ruby, the halfway point on Iditarod's northern route. There I watched Redington and his closest rival, Herbie Nayokpuk, exchange polite waves at a street intersection overlooking the frozen Yukon River. I spent two more days observing the bulk of the field rolling through the village. Kids flocked around the resting teams. The Yukon Fox, '75 champion Emmitt Peters, presided outside the checkpoint sharing stories about Nugget, his famed lead dog, while the sparks from the fire barrel flew high. Racers tended their

▶ A curious sled dog in Dr. Jim Lanier's team is puzzled by the photographer's whining flash at the Ruby checkpoint. The dogs are wearing an insulating coat to enhance warmth as they rest. Lanier's kennel is aptly named "Northern Whites," because he favors dogs with white fur. While few mushers share Lanier's breeding preference, all seek the "super dog," exhibiting traits such as: a coat suitable to the north, a "happy head," hardy constitution, good eating habits, honest effort, tough feet and, of course, speed coupled with endurance.

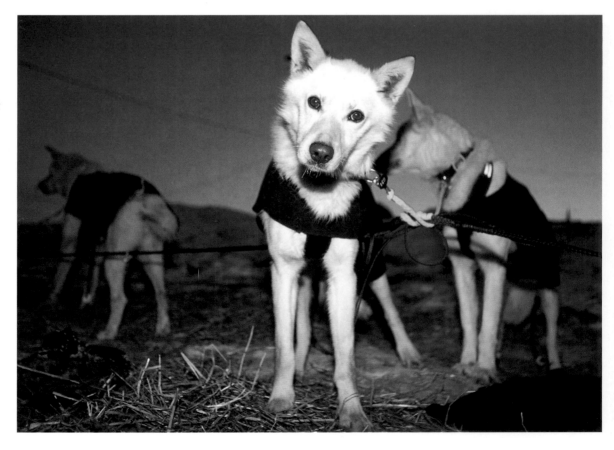

furry athletes, and then headed inside the community hall, where most grabbed a bowl of moose stew and restlessly joked around, analyzing each other's strengths and weaknesses.

It was down on that icy river below Ruby that I saw how close this game strayed toward the edge. An Aussie musher I'd profiled at the starting line, Brian Carver, had stoically pushed through the wee hours on a forty-below night. But he'd neglected to bundle up and eat properly. Hands and feet frozen, sweating feverishly, Carver shivered and moaned as a group of us loaded him aboard an evacuation plane. "Don't you do it, mate," he whispered.

In Nome, I covered Susan Butcher's third-straight win, a feat I was only beginning to appreciate. (Prior to that year, only she and Rick Swenson had won more than one crown.) The cheers were even louder the next day when Smokin' Joe ended his mad dash from Safety seconds ahead of the Shishmaref Cannonball. Redington had matched his personal best, finishing his grand game in fifth place for the fifth time. But this time out Old Joe put a scare in those young hounds. If there had been a decent trail out of Cripple? Well, one could only dream.

The crowds were even larger, several days later, for a musher from the back pack whose progress up the trail had everyone in Alaska watching. Nome schools closed early for the occasion—nobody wanted to miss the arrival of John "Poodle Man" Suter.

Standard poodles had made up half of his team when Suter started, but only three of the curly black critters were still on his string at the finish. Regular village huskies shouldered the real load. It was whispered that the poodle in lead at the finish spent most of the home stretch riding in Suter's sled bag. Not that it mattered—that darn poodle in front looked proud coming down Front Street. And the Poodle Man was a true character. "Five billion people on the planet," he liked to say, "and only one mushes poodles!"

I was catching on: this Iditarod was even crazier than maps and statistics began to suggest. This wasn't simply sport. Bloodlines, lifestyles, history, obsessions, strategies: an entire spectrum of human–canine strengths, and foibles, all found expression in Redington's creation.

CHALLENGE OF THE UNKNOWN

Redington was fond of referring to his Iditarod as the "Last Great Race," evoking a common heritage between his creation and grand point-to-point races of yore. Pioneer aviator Charles Lindbergh would have appreciated the uncertainty confronting participants in the inaugural race. There are fascinating parallels with the Great Automobile Race of 1908, a madcap New York-to-Paris war of attrition between jalopies bouncing the long way 'round the world. The auto marathon, wonderfully chronicled in Dermot Cole's *Hard Driving*, was the inspiration for Blake Edwards's 1965 movie comedy *The Great Race*.

The chief hurdle facing competitors in these and all great races is the unknown. What do the maps foretell? What conditions will entrants face? How will men and machines—or, for that matter, dogs—hold up? Even today, with the chapters closed on more than thirty Iditarods, every edition of Redington's classic presents new challenges. Each year the trail is reshaped by forces beyond man's hand.

Race veterans all recognize that every bend holds potential surprises. The slightest shift in the wind can radically alter the contest. It may seal victory for a front-runner by slowing the trailing teams. Or a stiff breeze may prove the wild card, churning loose flakes into a sea of drifts, robbing a

Bloodlines, lifestyles, history, obsessions, strategies: an entire spectrum of human–canine strengths, and foibles, all found expression in Redington's creation.

front-runner's hard-won advantage as it slams the entire field to a crawl. At such moments, competition takes a backseat to survival; even the fiercest Iditarod rivals understand the wisdom of teaming up when the wind howls with menace.

In 1996, basking in the glow of his second victory, Denali Park musher Jeff King reflected upon the difference a few minutes can make in an event lasting eight days or more and stretching over a thousand miles of wilderness. In that race, Norway rookie Sven Engholm had come upon an angry moose near Rainy Pass. The moose had charged and badly injured three dogs. Only minutes before Engholm's disastrous encounter, King had uneventfully covered the same section of trail. He never spied the moose, though it was surely already in the vicinity. "That's bum luck and good luck right there," King said.

Much of the Iditarod takes place on trails that serve as winter transportation corridors between area villages. These sections are veritable highways through the wild, well packed by snowmachines. The surface makes for a rapid (though bumpy) sled ride.

More remote sections of the trail see little use and are broken out by local residents, many of whom have tended a particular segment for years.

The entire race route is flagged every mile or so using various reflective markers and pickets. As one last piece of insurance, a volunteer party of trailbreakers cruises on snowmachines roughly a day ahead of Iditarod's front-runner, reopening the path through encroaching drifts and re-marking the trail where directions seem unclear.

Regardless, Iditarod teams can and do get lost.

Some of the most experienced drivers in the race have known the dread sensation of traveling a long way, uncomfortably long—too long, in fact—after last passing a bona fide

Some of the most experienced drivers in the race have known the dread sensation of traveling a long way, uncomfortably long—too long, in fact—after last passing a bona fide Iditarod marker.

Iditarod marker. Such moments present racers with agonizing choices: Do I keep going? Should I sit tight and wait to see if others follow? Should I backtrack? If so, how far?

Many an Iditarod driver has experienced the frustration of losing the trail in a storm. In 1988, Martin Buser finally caught and passed Smokin' Joe on the coast. Buser, who trained his houndy-looking huskies in balmy Big Lake, was soon sprinting toward what looked to be a commanding lead over defending champion Susan Butcher when a ground blizzard enveloped his team near Elim. It was daylight, but visibility out on the barren snowpack was nil and Buser became disoriented.

As it happens, the champ's pursuit of the speedy white rabbit was documented from above by a video crew traveling by helicopter. Despite the blinding conditions hugging the ground, the stalled driver and his dogs were readily visible from above. When the helicopter touched down nearby, Buser greeted the video crew with a frantic question: "Which way is the trail?" Granite, Butcher's renowned lead dog, hauled her team through the storm that year to a record-setting third-straight victory.

Another aspect of Butcher's accomplishment was touted on popular T-shirts: "Alaska—where men are men and women win the Iditarod." The slogan was galling for many of Iditarod's male competitors, but the trend was indisputable: combined with Libby Riddles's bold dash through a 1985 storm, Butcher's hat trick gave the women on the trail four straight wins in Redington's great race.

That year Buser sported frostbitten cheeks and a defeated look as he trailed Butcher and Swenson into Nome. It didn't matter that his team's third-place finish represented Buser's best showing in five tries. Glory had been snatched away.

I had my own troubles with markers in 1991, the year I traded in my camera bag

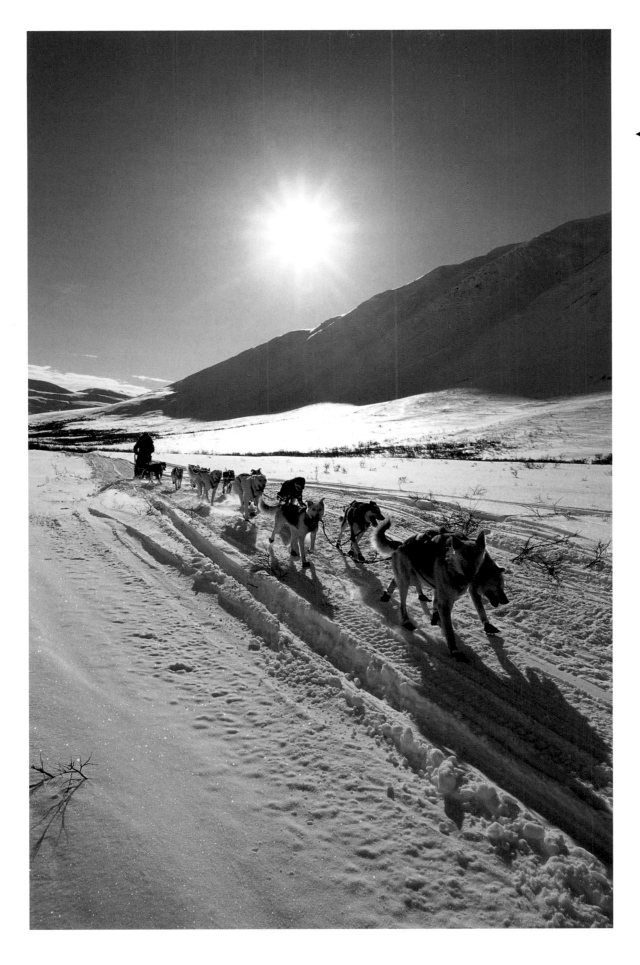

◄ Lynda Plettner and team take in the view during the 2000 race as they travel by a portion of the Alaska Range in an area called "Ptarmigan Flats" on their way to Rainy Pass. Most of the Plettner's dogs are wearing "booties" designed to protect their paws from cuts, pad splits, and abrasions. In the early days of Iditarod, mushers used booties more sparingly because of the time it took to replace them. Back then, a musher would put the bootie on the paw and wrap tape tightly around the top in order to keep it in place. A very time-consuming task. The advent of "hook & loop," or "Velcro," and fabrics more resistant to holes, has made booties easier to change. Most mushers now "boot" the whole team before a run just to be extra cautious. If the dogs go through water, booties must be removed right away before they ice up. They must also be removed shortly after a run in order to allow for better circulation to their feet.

and reporter's notebook and drove the first team out of the Iditarod starting chute. I elected to take my required twenty-four-hour layover in Rohn. The move unexpectedly thrust my team into last place, owing to a time adjustment for our lofty starting position. Afterward, I shot off course following a bison path, and crashed when it came to a dead end. The mishap crushed both of my headlamp reflectors, a

▶ Stan Zuray uses his weight to counterbalance his sled and avoid hitting a spruce tree during the 1996 race as he descends a steep and snaking section of the trail in the Dalzell Gorge. The yellow sign nailed to the tree reads, "Warning steep hill." This section of the trail, after running along a side hill above Dalzell Creek, abruptly descends a nearly 35-degree slope to reach the creek. One of Zuray's tired dogs rides in the basket and stares up at him as if to say "Hold on, Buddy." A musher will carry an injured, or sometimes simply pooped, dog while traveling between checkpoints. Zuray scratched 336 miles later at Ruby.

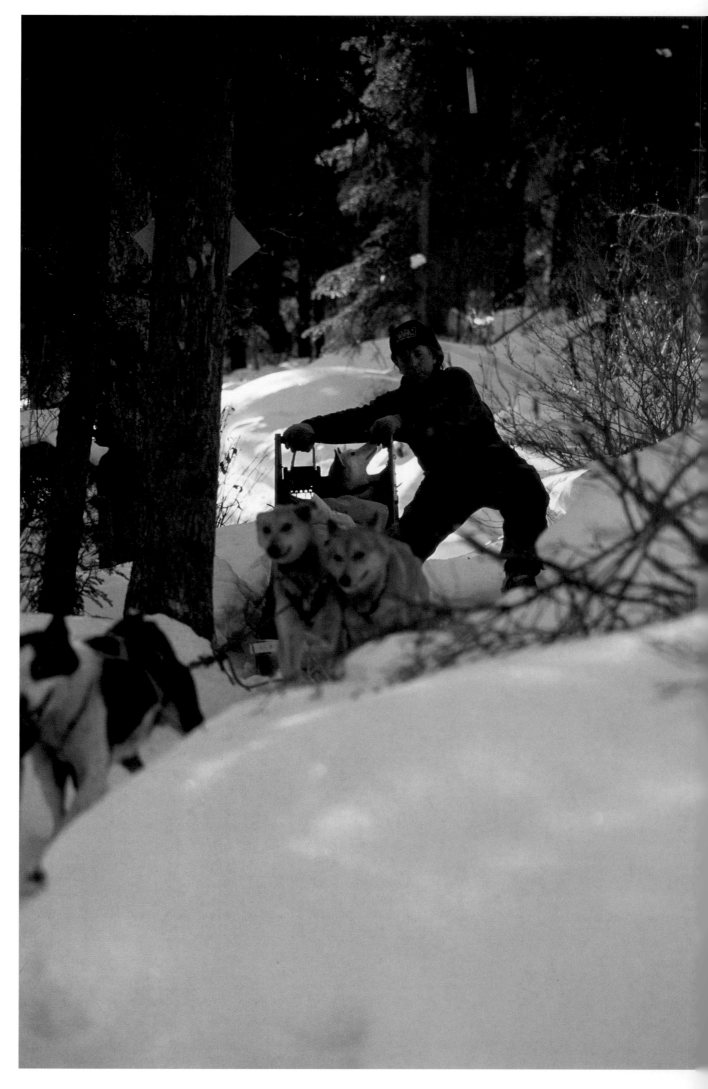

loss that left me all but blind after dark. I backtracked and found runner marks from teams running just ahead of mine. Snow was falling hard. I followed the tracks to the edge of a broad lake, where markers and tracks vanished into seamless white. I camped, counting down the hours until dawn. In the morning, a marker was visible in the distance. Reprieve!

En route to Iditarod, the team climbed a barren dome. Wind or previous dog teams had knocked over most of the markers. I wasn't worried because my leaders were following a wide swath of tracks. Then I realized that the dirt coloring the thin snow appeared churned by hoofs, not paws. The dogs and I were chasing a caribou herd.

The worst turn came as I left Unalakleet. It was blowing snow, of course. I couldn't find the markers and my ever-hungry leader, Harley, took advantage and followed his nose into the village dump. Try to pull a fifteen-dog string free of a mountainous trash pile and you'll have some appreciation for the Iditarod's truly nightmarish possibilities. My whole race was in doubt until a local volunteer showed up on a snowmachine and helped me haul those dogs away from their treasure trove.

OF WEATHER AND SILVER BULLETS

From first-place finisher to the last one through the arch, mushers negotiating the Iditarod Trail all know the feeling of chasing dreams that flutter on nature's whim. The annals of the race show that weather is often the wild card. In 1985, Riddles seized the initiative that eventually spelled victory with her courageous plunge into a storm battering Shaktoolik. Several years earlier, a similar move in that same exposed stretch proved disastrous for none other than Nayokpuk, whose nickname, Shishmaref Cannonball, came from his willingness to charge ahead.

When a storm breaks, the musher often confronts a landscape swept clean of the human hand. A great lead dog will nonetheless find its way, somehow discerning the solid path concealed beneath fresh powder. A savvy musher may take on that job, feeling out the trail with careful steps, perhaps breaking a new one with snowshoes, until markers again reveal themselves. Teams lacking the spirit or resources to find their way are not just stalled, the dogs and driver are living on borrowed time, consuming precious food as they await a rescue that likely signals disqualification.

Decades of effort suggest that there's no "silver bullet" strategy for winning the Iditarod. Mushers have dictated the pace of the great race, or seized what appeared to be a commanding lead, using a variety of approaches. The winners of the first two Iditarods—Dick Wilmarth and Carl Huntington, respectively—took twenty days to reach Nome. Racers were essentially feeling their way throughout those early years, trusting instinct on where and when to camp. Long breaks early in the race were common, as mushers applied the lessons of the first miles, jettisoning gear no longer seen as essential, as they repacked for the long haul ahead.

In 1975, Ruby musher Emmitt Peters pushed all the way to his village on the Yukon River before taking his required twenty-four-hour break. Ruby is roughly halfway to Nome, and Peters, then a rookie, came off the layover driving a well-rested team that went on to shave nearly a week from Wilmarth's finishing time. The fourteen-day, fourteen-hour record set by the Yukon Fox, as Peters became known, stood for five years.

But Peters's accomplishment pales compared to the dog setting his team's pace. The victory procession down Front Street in

Try to pull a fifteen-dog string free of a mountainous trash pile and you'll have some appreciation for the Iditarod's truly nightmarish possibilities.

Nome was actually Nugget's second straight. The year before, Peter's lead dog, then on loan, had guided Carl Huntington's winning team. Four years before Rick Swenson would become the first musher to claim the honor, Nugget reigned as Iditarod's only two-time champion.

Unusual moves that pay off with a victory inevitably invite imitation; for a time, many top teams will embrace a particular winner's formula. In the late 1970s and early 1980s, Swenson emerged as the musher to beat in Iditarod (and virtually any mid-distance race). In a span of six years, the master musher won Redington's classic four times, and lost another Iditarod to Dick Mackey by one second. Swenson's schedule—which called for balanced four-hour runs and rests, and taking the twenty-four-hour break at an early checkpoint such as Rohn—became standard for most competitors.

In the late 1980s, Joe Runyan, a tall,

thoughtful trapper who learned to drive dogs from Athabascan neighbors in Tanana, experimented with pushing beyond Rohn and the fire-scarred Farewell Burn before taking his long layover. In 1989, the formula yielded an Iditarod crown for Runyan, and what happened to be the first victory for a male musher in five years. A year later, Susan Butcher reasserted her team's dominance, claiming her fourth victory, an accomplishment that, briefly, placed her on equal footing with Swenson as Iditarod's all-time best.

Preparing for his first Iditarod in 1992, Montana musher Doug Swingley trained with Runyan. He, too, adopted the strategy of pushing farther than most before giving the dogs their restorative daylong break. The formula yielded a ninth-place finish for Swingley, a showing good for "Rookie of the Year" honors. By then, Iditarod's front pack were routinely speeding across the Burn

► With a crowd gathered in the finish chute, Joe Garnie is about to cross under the burled-arch finish line in 32nd place after being on the trail 11 days and 42 minutes in the 2004 race. Musher Nils Hahn, under the arch, finished just 30 seconds earlier. Even after 1,150 miles of trail, differences in finishing position are sometimes determined by mere seconds. Lifetime Iditarod volunteer finish timer, and former Nome mayor, Leo Rasmussen can be seen on the far right side clocking the team's arrival time. In 2001, this arch replaced the Iditarod's original burled arch finish-line monument, which had succumbed to dry rot. The first arch was built and donated by Red "Fox" Olson in time for the 1975 race. Olson, who mushed the last place "Red Lantern" team a year earlier, figured a race of Iditarod's magnitude needed a substantial finish line.

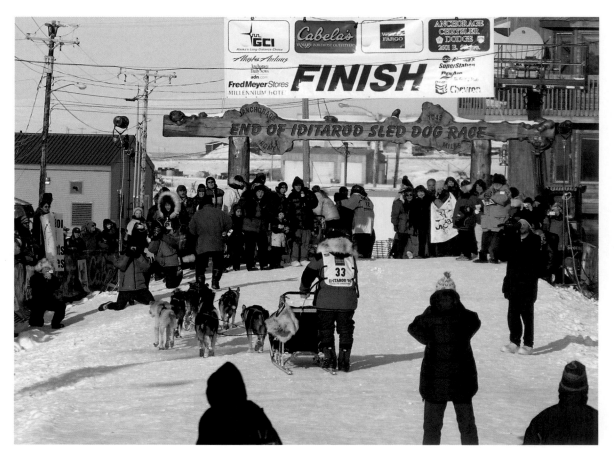

before taking the layover in Nikolai, McGrath, Takotna, or Ophir.

Iditarod's third dynasty was foreshadowed in 1995, when Swingley and a lead dog named Elmer followed the trail blazed by Peters and Runyan and won the Iditarod in a shocking 9 days, 2 hours, and 43 minutes. The record stood until 2000, when Swingley, by then knocking on the door of Iditarod's all-time greats, chopped nearly two hours off his own speed record, collecting his third victory. Driving to Iditarod's halfway point or farther before taking the twenty-four-hour layover became the game to beat as Swingley opened the new millennium with three straight wins, 1999–2001.

A year later, Iditarod's third dynasty ended mysteriously. Even as his team recorded hot times through early checkpoints, Swingley suddenly bowed out of the chase for a fifth crown. Savoring what he described as his retirement run, the Montanan continued to Nome, but at a leisurely pace, resting ten hours or more at checkpoints, showing blistering speed in between. He placed fortieth.

Martin Buser, long known for his own swift hounds, entered the same race on the rebound. In 1992 he'd finally joined Iditarod's hall of champions, becoming the first to win Redington's mad marathon in less than eleven days. He again won the race in 1994 and 1997, before tumbling all the way to twenty-fourth in the 2001 final standings. Afterward, he spoke of retirement. But Swiss-born Buser owed far more than a career to Iditarod.

Buser was still in his early twenties when enthusiasm for sled dogs drew him to America in 1979. Within a year, he was driving for Nome. The musher from the Alps married an Alaskan, Kathy Chapoton. He named his sons, Rohn and Nikolai, after checkpoints on the trail that had become his life.

The tragic events of September 11 awakened many in the nation to the opportunities and sacrifice America represents. That message sounded as clearly across the frontier as it did in Manhattan.

Thrusting aside thoughts of retirement, Buser turned the 2002 race into a glory ride. His dogs shattered the 9-day barrier, completing the race in 8 days, 22 hours. Their driver entered Nome waving an American flag. Twenty-two years after his rookie run, four-time Iditarod champ Buser completed a memorable journey—taking the oath of U.S. citizenship under a flag waving from Iditarod's burled arch.

"Now I'm legal," Buser declared, drawing cheers from the crowd.

PAYING DUES

In some respects, mushers competing in Iditarod have the safest job on the trail. Dog teams are perfectly suited to the challenges of Iditarod country. Race officials, fans, and the press following teams up the trail have no choice but to resort to less optimum means of transport.

After closing down the checkpoint at Iditarod in 1991, ham radio operator Rich Runyan set forth alone on a snowmachine hauling a sled loaded with heavy electronic gear. The volunteer's ride became a 350-mile ordeal, colored by difficulties finding the trail, getting stuck in deep drifts, and a hero's role assisting several faltering mushers and a bicyclist caught out in storms.

The small planes that make up Iditarod's unofficial air force contend with the variables of weather in a region where forecast information is spotty, as well as the risks of landing and taking off from remote checkpoints without improved runways. Even the most veteran Bush pilots can be fooled, according to pilot Ted Mattson. For instance, the most benign-looking frozen river or marsh can imprison a ski plane for

Thrusting aside thoughts of retirement, Buser turned the 2002 race into a glory ride. His dogs shattered the 9-day barrier, completing the race in 8 days, 22 hours.

hours, possibly even days, if fresh seepage (a phenomena known as "overflow") lurks under a concealing layer of snow. Such hazards are covered in excruciating, and sometimes hilarious, detail in Mattson's book *Adventures of the Iditarod Air Force.*

As the official photographer for the race since 1982, Schultz has experienced the full range of frustrations and perils inherent in tracking dog teams from above. He's seen the effects of landing in soupy powder. "You'll spend half a day just to get out." He's passed days in limbo at a remote checkpoint, grounded by weather, miserably contemplating the images escaping up the trail. But Schultz also knows, far better than most, that delays—even stretching for days on end—beat flying the Iditarod Trail in poor weather.

Crossing Golovin Bay aboard a Super Cub in 1992, Schultz and Iditarod pilot Chris McDonnell flew into a whiteout, creating disorienting conditions that the photographer later compared to flying "inside a milk

bottle." They crashed on the ice, seriously injuring both men. The plane was equipped with an emergency beacon, which alerted other aircraft in the vicinity to a problem below. But the men's fate—and their exact location—were hidden by a ground storm. Fortunately, Schultz was carrying a handheld VHF radio, and was able to help guide a rescue party to the wreckage.

The photographer still wears the scars. "I have five metal plates in my face. My left eye waters. And my nose looks like a boxer's," Schultz says, as casually as one might describe yesterday's weather.

In 1980, noted Alaska pilot Warren "Ace" Dodson and three members of a Spanish TV crew died when their plane crashed near Shaktoolik. Considering the wreck that he and McDonnell survived, Schultz counts himself fortunate. "It's a blessing just to be here."

A KINGDOM RULED BY DOGS

The dynasties that helped define Iditarod's

▶ A week prior to the 2002 race, Iditarod volunteers load straw into Iditarod pilot Joe Pendergrass's Cessna 180 at Merrill Airfield in Anchorage. The straw, paid for by a portion of each musher's entry fee, provides a bed for dogs out on the race. One bale per musher is flown out to checkpoints by the team of 27 volunteer pilots. Considering only four to five bales will fit a Cessna and there are typically 60 to 70 mushers per race, it can take 15 or more plane trips per checkpoint just delivering the straw. Beginning two weeks before the race and continuing throughout, these volunteers load plane after plane with up to 1,100 pounds of supplies, including the straw seen here, food for the volunteers, tents, camp gear, and team "drop bags," which contain each musher's dog food, extra socks, batteries, plastic sled runners, and personal food.

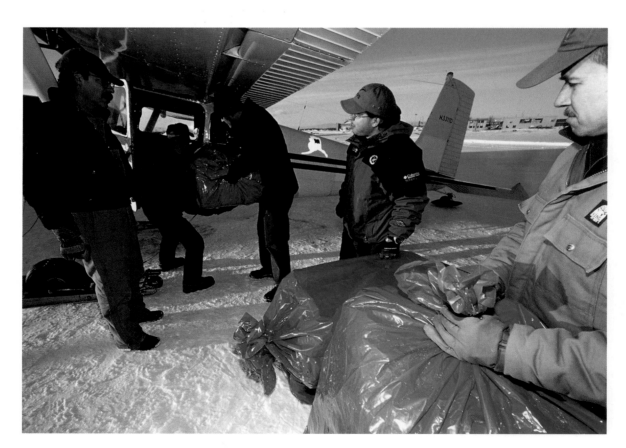

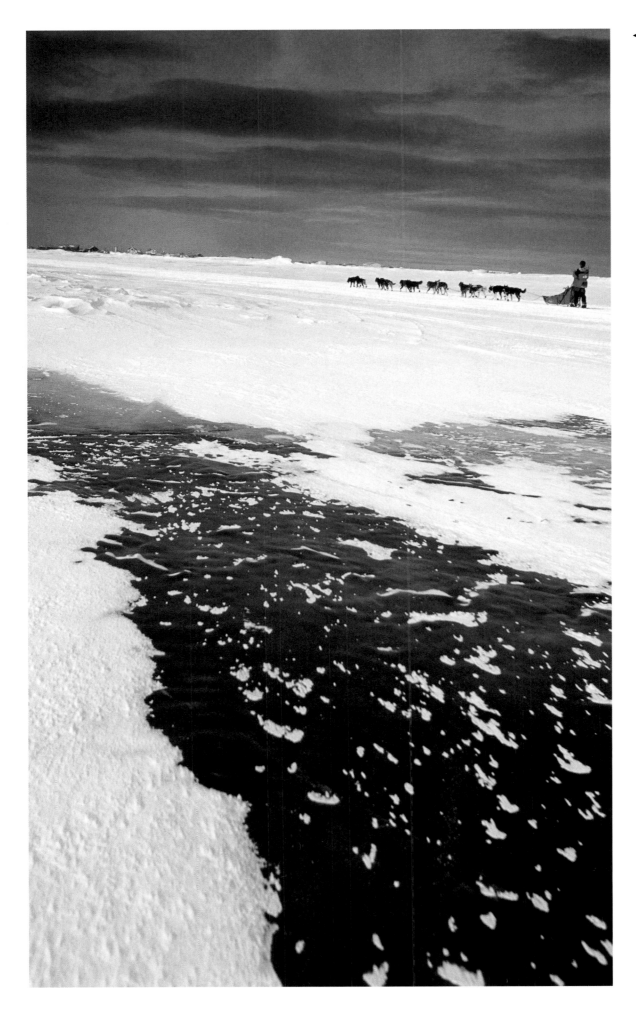

◀ Norwegian Kjetil Backen, in first place after 851 miles during the 2004 race, glides along the Unalakleet River as he nears the Bering Sea coast checkpoint of Unalakleet. The name of the village, Unalakleet, means "Where the east wind blows." The power of that wind shows on this polished stretch of river ice where the snow has been blown out to sea. Backen's hold on first place slipped away on the final 261 miles to Nome. He finished third.

first two decades were each associated with powerhouse lead dogs. Swenson's four victories, between 1977 and 1982, came with a dog named Andy running up front when it mattered most. Butcher's era of near-complete dominance, 1986–1990, featured mighty Granite in the lead.

Entering the 1991 race, Iditarod's keenly competitive king and queen each possessed four crowns. Andy was by then enjoying a sleepy retirement in a shop on Swenson's property, and his master hadn't won a race of consequence in nearly a decade. Butcher, meanwhile, radiated a confidence that a thousand miles of racing at the front of the field did nothing to diminish. Trailing Butcher into White Mountain by over an hour, Swenson griped to a TV crew that it would take a "lightning bolt" to foil Butcher's glory ride.

Regardless how dramatic the image filling his viewfinder may be, Schultz is always haunted by what's happening elsewhere. "I feel like I'm missing photos all the time," he says, observing that action is always taking place around the next bend in the trail. "You could have a hundred photographers out there and not capture all of it."

The night that Swenson's lightning bolt arrived, I was five hundred miles south, hunkered down in my sled bag, nibbling oily salmon while the wind piled drifts over my tightly curled dogs. It had been a brutal day for Iditarod's back pack: Tom Daily, Tom "Doc" Cooley, and I. The trail was buried under waist-deep powder, and our progress had slowed to a crawl as Cooley and Daily took turns breaking trail through a series of rolling storms. I'd offered to put on snowshoes, since my leaders weren't up to the task. Doc Cooley looked horror-stricken. "God no," he cried, "we'll be here forever."

No journalist was on hand as Swenson's lead dogs cut a line across a dog team that was parked straddling the trail. Visibility was terrible. The bulb in his headlamp was

apparently dead. It wasn't until he neared the other team's sled, and Butcher sat up, that Swenson grasped the situation. She had been waiting for him.

Only the two champions know what was said in the swirling snow. Butcher apparently fixed her rival's headlamp, and suggested that it would be safer for them to stick together. Swenson agreed. But soon he was alone again.

After losing Swenson in the storm, Butcher retreated toward White Mountain. On the way, the defending champ encountered Runyan and several others. She persuaded them that there was no sense even attempting this storm. Buser, still hungering for his first win in Redington's great race, wouldn't listen, and continued on. Back at the checkpoint, Butcher told reporters Swenson and Buser would never make it. She feared for them.

Indeed, Swenson's leaders balked. He got off his sled, tied a rope to the front pair, and guided his team on foot, advancing marker to marker through the blinding wind. At the finish line, Swenson was asked what had kept him going. "I wanted to win the Iditarod," shouted the five-time champ, drawing cheers.

That same day, the group I was traveling with caught eight other teams stalled at Eagle Island. Together we formed a convoy and battled though the successive storms, snaked our way up the Yukon and, eventually, dashed between the storms whipping the coast. We called ourselves the Kaltag 11, taking the name from a cozy checkpoint where we passed the first day of spring laughing at a TV report describing Daily as lost out on the ice.

Within the group, competition simmered. While the others were relaxing inside the checkpoint at Golovin, Kenai musher Jon Terhune and I bolted for White Mountain. Any hope of making a quiet getaway was dashed when my dogs smelled meat as we passed a parked team's sled. By the time I

"He didn't have a big team, but he always had feed, and his dogs were real happy, happy-go-lucky dogs," Attla said wistfully.

pried my team loose, other mushers were rushing after us.

A few miles down the trail, I realized that my parka was back in the Golovin checkpoint bathroom. Nome was still a hundred miles away; without that heavy coat, I might not make it. I turned the team around and backtracked. The move cost me a precious hour or so, opening a gap we never did make up.

That's my Red Lantern–winning formula. Feel free to copy it.

The stormy showdown of '91 added to the legends of Redington's Last Great Race. Races yet to come will surely be decided by developments as dramatic, or moves as bold. Records will fall. New strategies will evolve. What won't change is the magic that powers Redington's vision: merry, tail-wagging athletes barreling across Alaska's frosty landscape.

Attla glimpsed as much in 1973. The sprint champ led much of that first race, before stalling with sick dogs in Galena. Though he came roaring back and passed many teams on the coast, Attla had to settle for fourth place in the first great race. The crown went to the man from Red Devil, Dick Wilmarth.

Decades later, the Huslia Hustler was still talking about the attitude of those dogs harnessed to the victor's sled. "He didn't have a big team, but he always had feed, and his dogs were real happy, happy-go-lucky dogs," Attla said wistfully.

"They were in their glory, those dogs."

▼ Keith Aili's dog rolls on his back for a good scratch at the Takotna checkpoint in 2002.

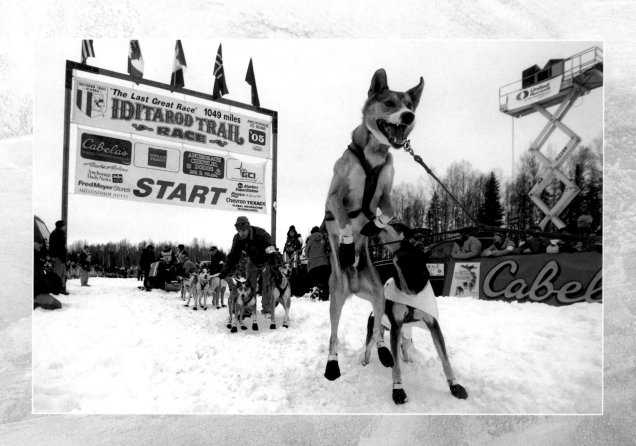

▲ Michael Salvisburg's team dog Pluto jumps with excitement to start the race at the 2005 Willow restart line.

Iditarod glory

the Start

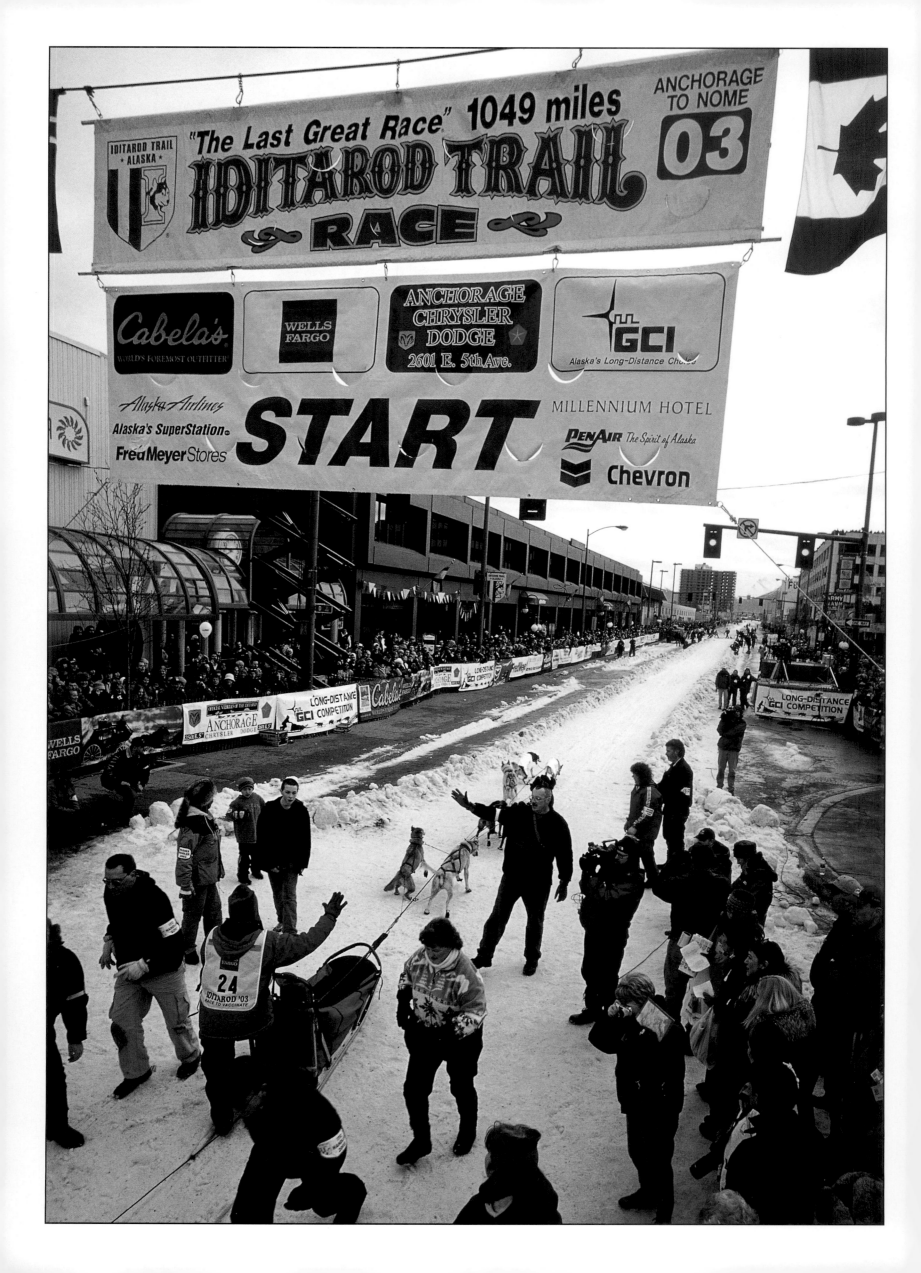

► A sled dog waiting patiently in the Anchorage staging area gets affection from a volunteer dog "handler." Each team relies upon a group of handlers, usually comprised of the musher's friends, to control the team as the dogs are moved down the street toward the start line. Volunteers maintain their grips on the sled and gangline into the chute, where they keep the team from bolting during the countdown.

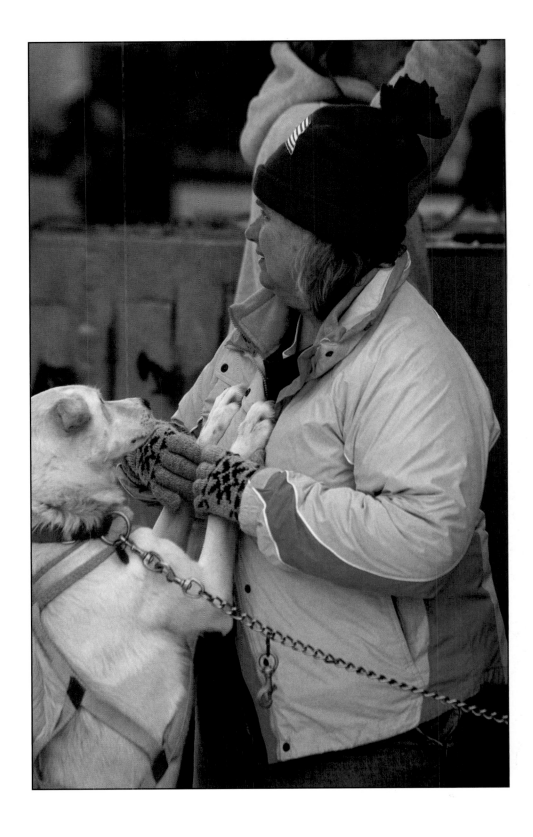

◄ Cindy Gallea readies for a high-five with a handler as she leaves the start line on Fourth Avenue in Anchorage. Thousands of spectators line the downtown streets to watch the teams, which leave at two-minute intervals, begin their 1,150-mile journey to Nome. Departures are staggered to avoid canine congestion and ease passing along the trail. Adjustments for the starting-time differential are made during the mandatory 24-hour layover each musher takes at the checkpoint of their choice.

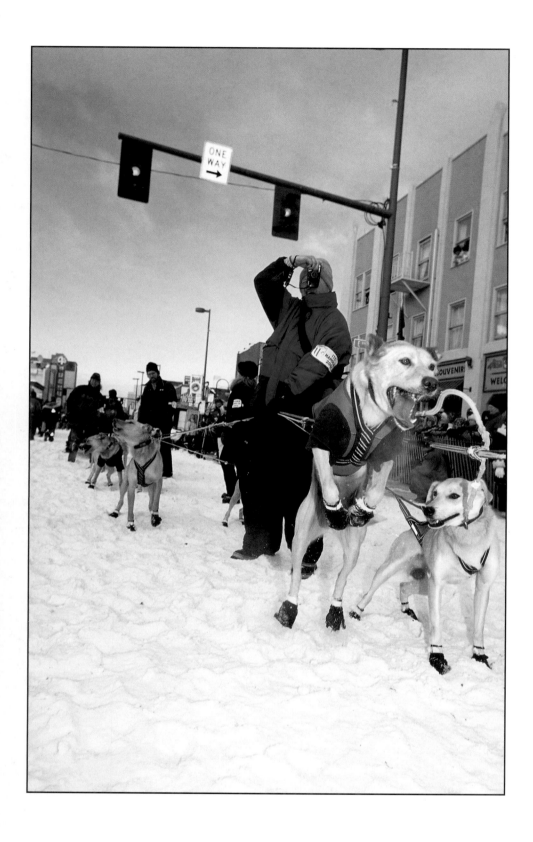

◄ In the middle of Anchorage's Fourth Avenue, one of Sam Perino's dogs jumps with excitement as handlers restrain the team a few hundred feet from the 2004 start line. The Iditarod always begins with this ceremonial dash on the first Saturday in March. Teams leave downtown Anchorage and run the 20 miles to Eagle River, where dogs are loaded back in trucks for a ride to the restart in Wasilla the next day. Sled dogs are bred to run and simply can't wait to get on with it. During the start of the race, with over 700 dogs in downtown Anchorage, the noise of energized, barking dogs is astounding. Once they start running, most fall silent and devote their energy to pulling. Spectators view the commotion from the windows of a local hotel.

► Perry Solmonson waves to the crowd after leaving the 2003 start line in downtown Anchorage. In Perry's basket is Jon Winkle from New Jersey. Winkle bid $1,100—auction style—for the privilege of being an "Iditarider" allowing him to ride in the sled basket for the first 11 miles of the race. Begun in 1994, the Iditarider auction raises money for the purse, a portion of which is earmarked to ensure that every musher who crosses the finish line, after the top 30 paying positions, receives a check for $1,049. A bid of $7,500 guarantees the first bidder a ride with the musher of the rider's choice. Though mushers take up to 16 dogs on the actual race, they are limited to 10 or 12 dogs for this ceremonial run through Alaska's largest city. The team limit depends on current snow conditions and takes into account various urban factors (turns, streets, bridges, people, pets, etc.), which make controlling a larger dog team that much more difficult.

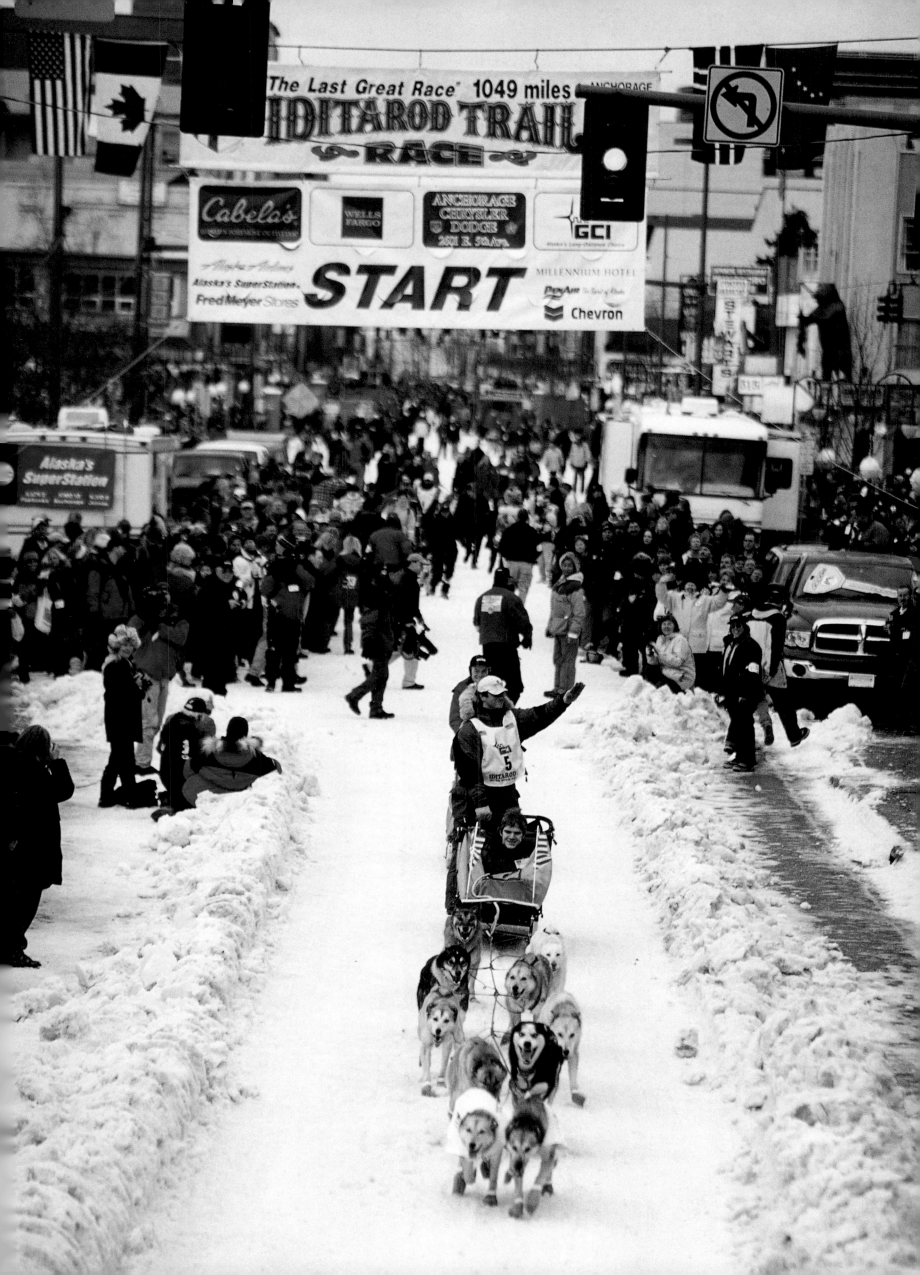

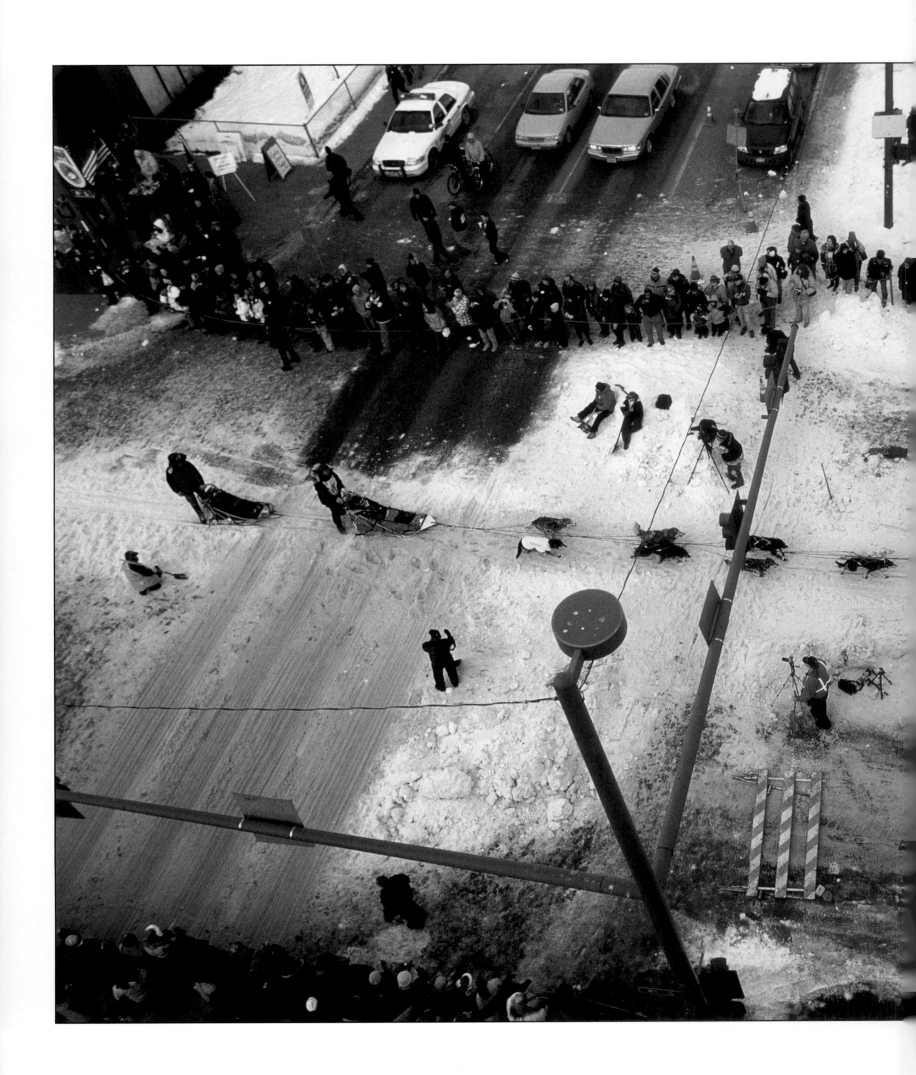

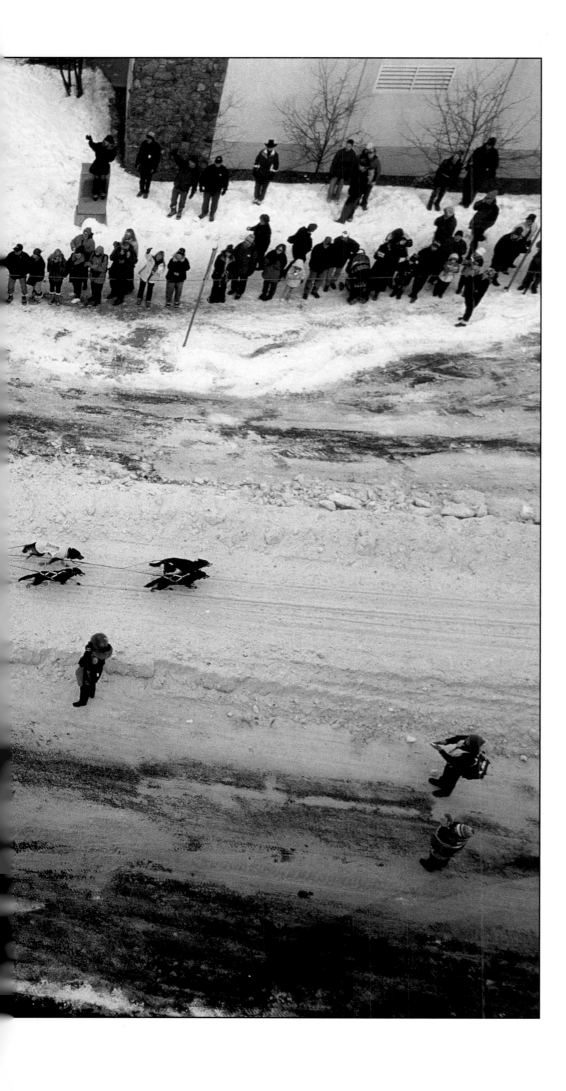

◄ An aerial view shows Ben Stamm's team crossing the Fourth Avenue and C Street intersection a few hundred yards into the 2004 race. Fourth Avenue is closed to traffic for the race. C Street is narrowed to two lanes and police officers direct traffic, allowing dog teams and vehicles to safely cross. Volunteers with shovels keep just enough snow on the two traffic lanes to allow both canines and autos to pass. Race rules require each musher to bring a "handler" traveling the trail from Anchorage to Eagle River, hence the second sled Stamm is towing. In case of a dog tangle or other mishap, either the musher or handler can anchor the team while the other jumps from a sled and sorts out the situation.

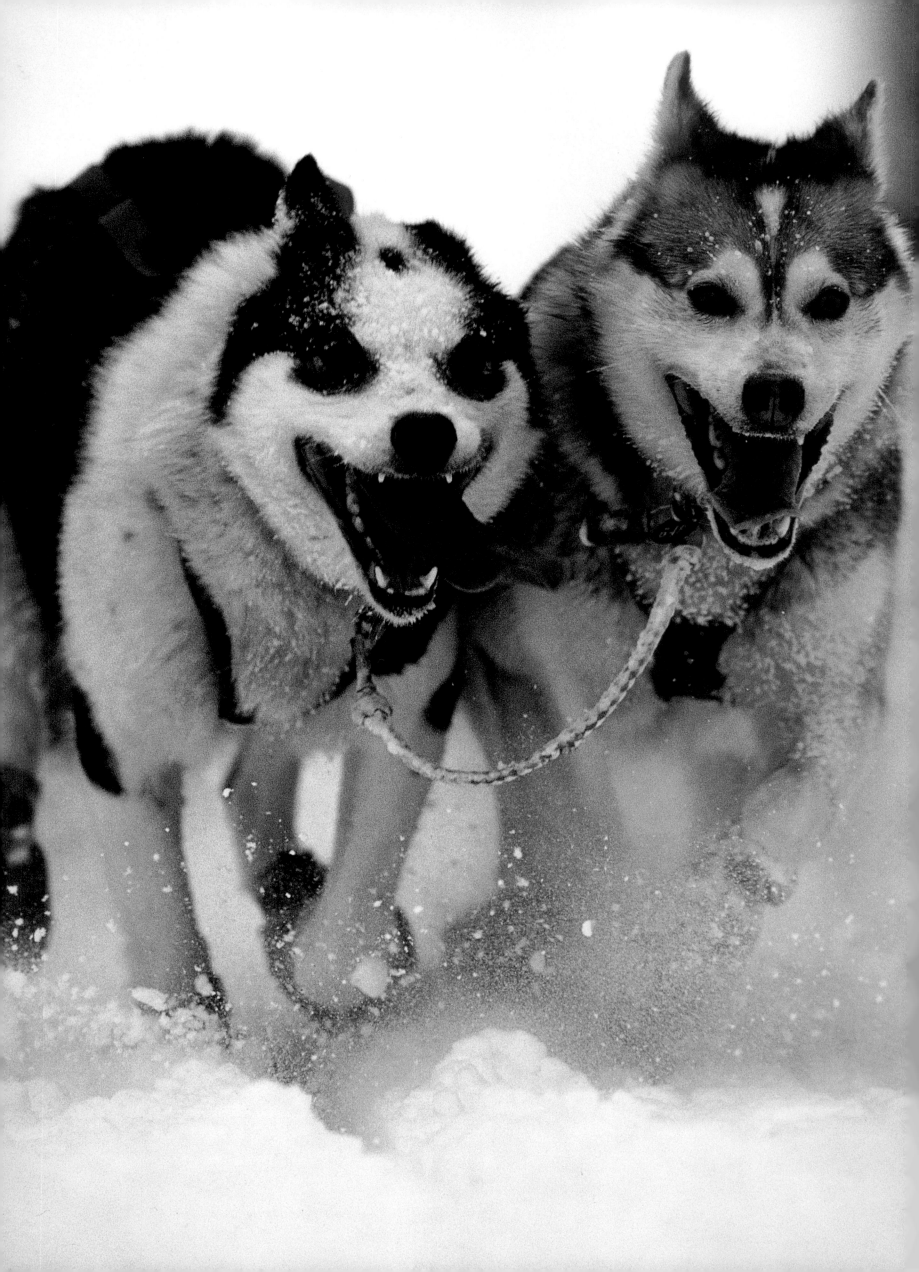

▲ During the 2004 race, spectators watch Ramey Smyth's team as it runs down Fourth
Avenue. A musher can typically tell if any of the dogs are not pulling their fair share
through observation. Tension in the "tug line" connecting a dog's harness to the gangline
is one telltale sign; if the tug line is loose, the dog isn't pulling. Tails provide another
measure. Dogs running with their tails up in the air may be happy, but they're probably
not working as hard as they could. Municipal workers take snow gathered up earlier in the
season and lay it back down on the street creating a trail for the dogs. A berm is created
on either side of the artificial trail to keep the dogs from wandering off into the crowd.

◄ Sled dogs simply love to run as these two lead dogs enthusiastically demonstrate during the
Anchorage start. Because dogs don't regulate their body temperature by sweating, as humans do,
their tongues have an important cooling function. When exercising hard like this, a dog's tongue
becomes enlarged with extra blood. The exchange of air over the enlarged tongue cools down the
canine's body. In this photo, the musher is using two lead dogs, hooked together with a "neck line."
Mushers will run leaders solo, or in double lead, with our without necklines, depending on the dogs'
dispositions and the current trail conditions.

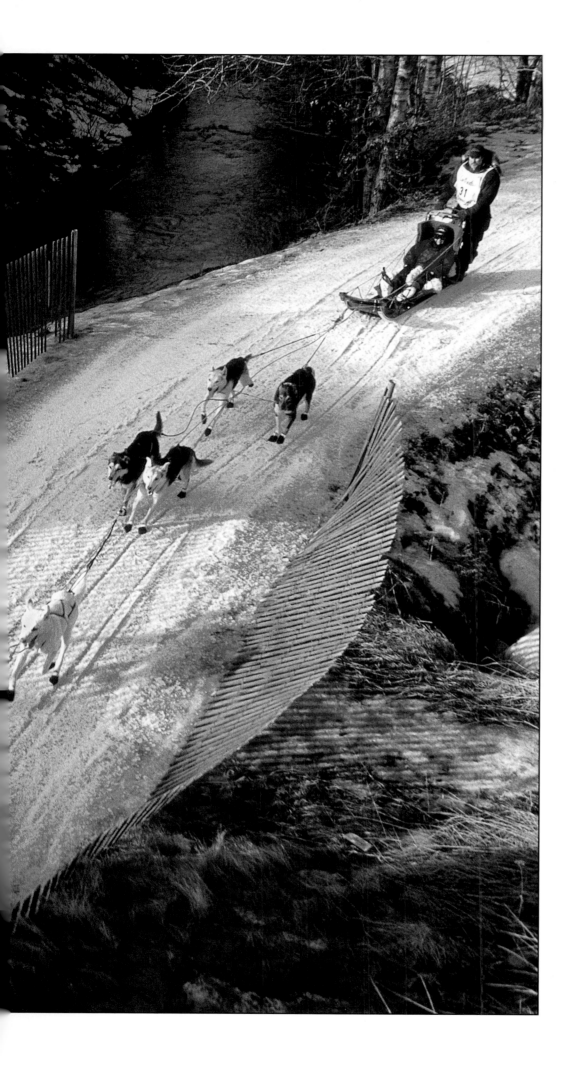

Spectator Robert Cudney takes a photo of Jack Berry in 2003 as his team follows the midtown Anchorage bike trail into a culvert road tunnel crossing Gambell Street. Some dogs balk at tunnels, which are seldom encountered outside urban areas during training; this is one of the reasons mushers take along a handler during Iditarod's ceremonial opening downtown.

▲ Fairbanks residents David Miller (back to camera), Kelsi Evans, and Joy Miller watch musher Ramy Brooks from their backyard hot tub during Iditarod's unprecedented restart on the Chena River in 2003. Needless to say, the juxtaposition of hot tub and dog team made the Miller family a target for any press that happened by.

▼ Jeff King waves to well-wishers along Knik Road after leaving the Wasilla restart in 2002. Whenever the race passes through populated areas, spectators line the trail and encourage the teams. Among these well-wishers is Vi Redington, the widow of Iditarod's founder, dressed in her normal purple attire, and other friends.

The Iditarod brings out the best in people like this group of "K-9 Fairies" posing for a photo as they "bless the mushers" near the Willow restart in 2001. Formed in 1996 as a part of the Martin Buser Booster Club by the late Bettina Williams, who subsequently died of breast cancer, and other Big Lake schoolteachers, the fairies turn out each year and entertain mushers, as well as participate in fund-raising events for cancer research.

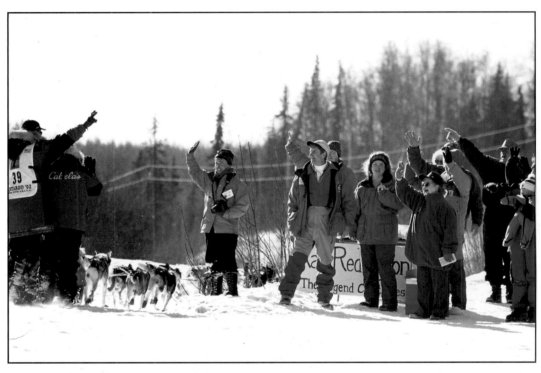

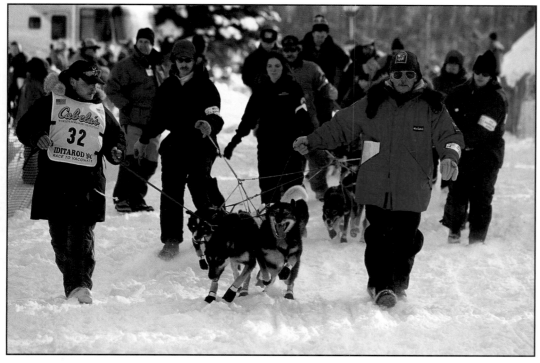

◀ One of three Mackey brothers to compete and finish the Iditarod in 2004, Jason Mackey and handlers walk the team to the restart line at Willow. Some mushers give handlers leashes to hold back the team, instead of having them simply hold the gangline, to reduce chances of freak injury from a helper stepping on one of the surging dogs' feet. It also gives the handlers a better stance to hold the dogs back. Leading the handlers on the right side is Jason's father, 1978 champion Dick Mackey.

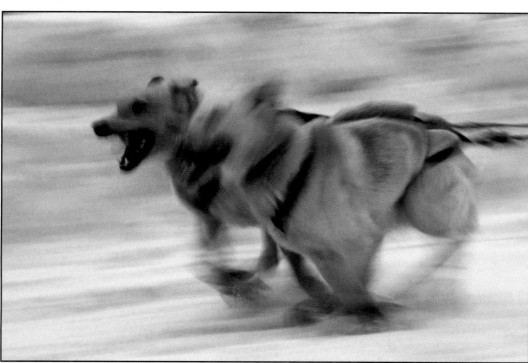

◀ A pair of lead dogs shows their speed at the start of the 2000 Iditarod in Anchorage. Frisky Iditarod dogs can lope at 15 miles per hour or more departing the start line, but most mushers will employ a drag brake to slow their teams to a safer pace. Winning teams today average about 11 mph over the entire race.

▶ Ross Adam uses everything he can to hold on as his team whips his sled around a tight turn from a campground road onto Eagle River during the 2000 Iditarod. The first thing a musher learns is "never let go." A loose team can mean two things: It can cause injury to the dogs as there is nothing to keep the dogs from running too fast or taking a wrong turn, or it can mean a long and potentially life-threatening walk for the musher. More than one musher has lost his team during the 30-plus years of Iditarod. Fortunately none have ended up seriously injured.

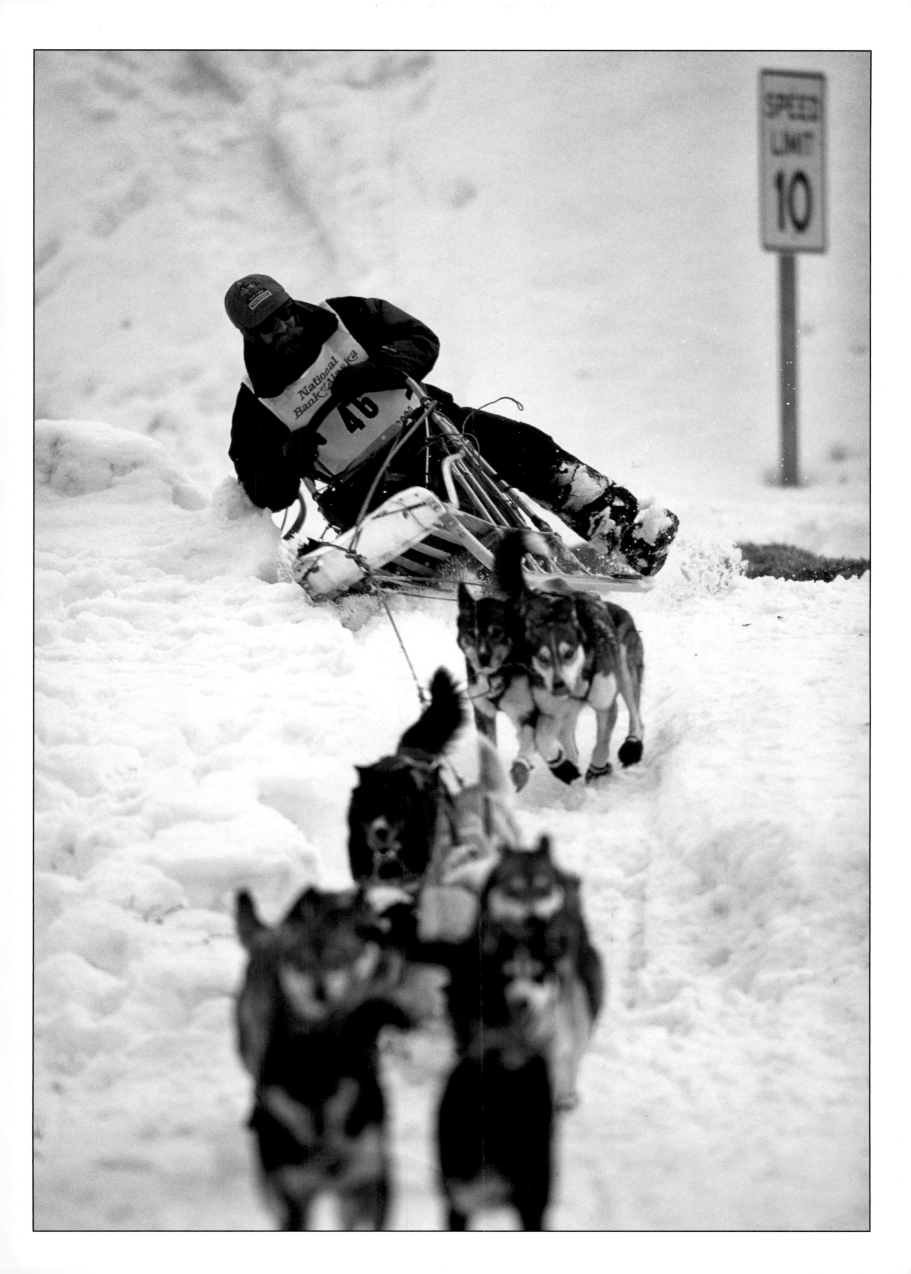

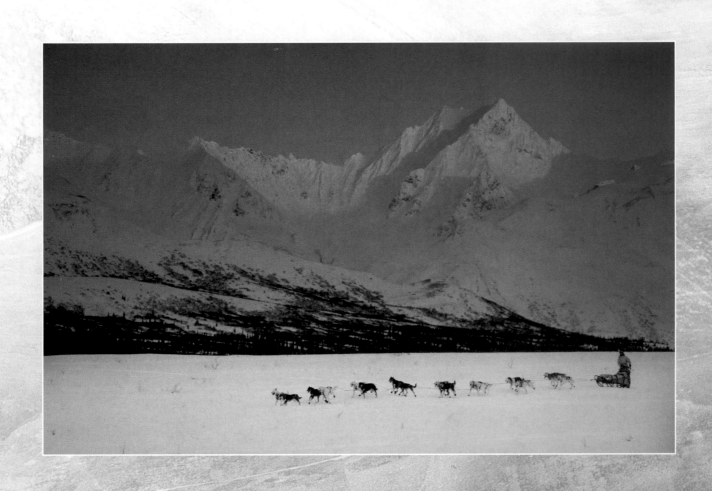

▲ DeeDee Jonrowe and team run in the Ptarmigan Flats area of Rainy Pass and the Alaska Range just five miles after leaving the checkpoint.

Iditarod *glory*
over the Alaska Range

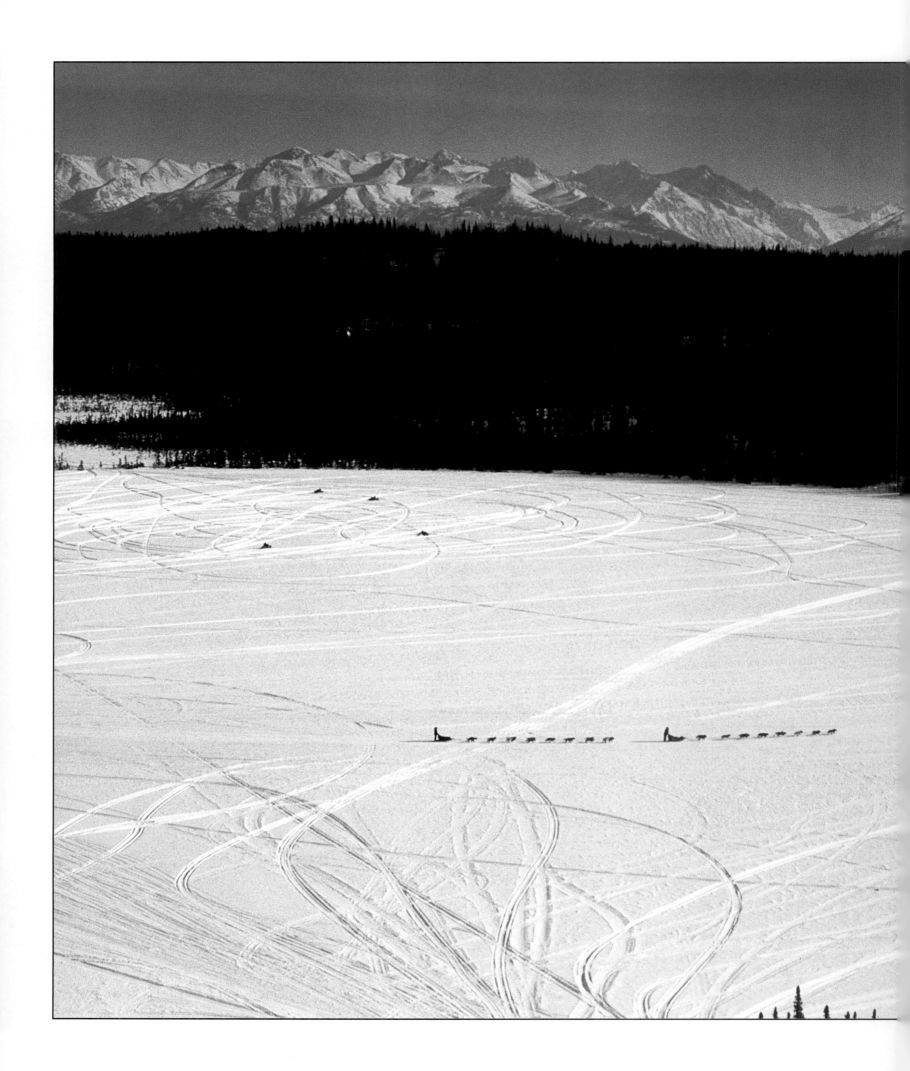

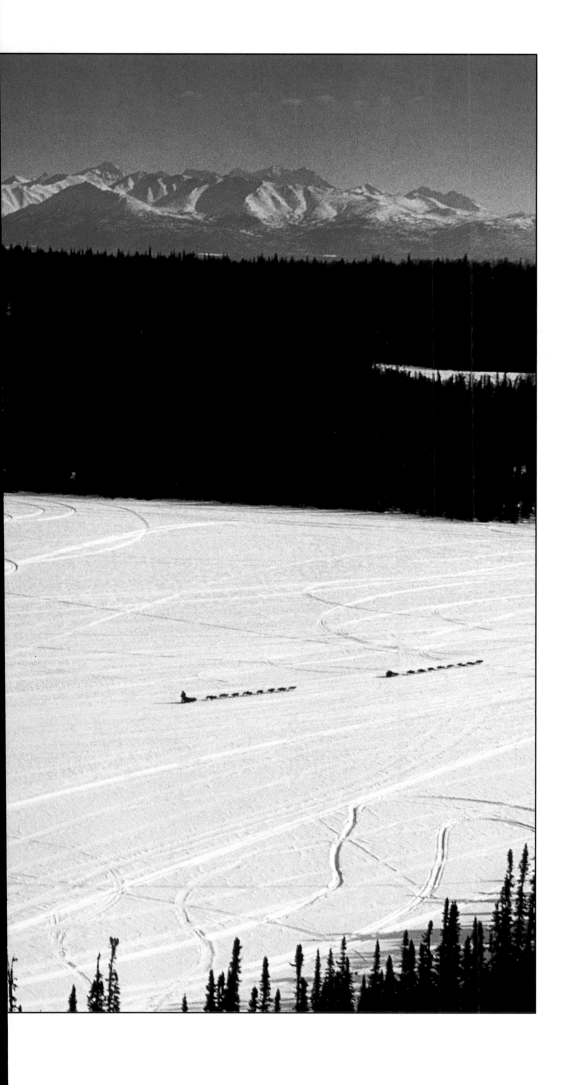

◀ With the Chugach Mountains in the background, four teams mush across Sevenmile Lake after leaving the Knik checkpoint in 1999. Spectators on snowmachines need to be kind enough to stay off the trail here. In these first few days of the race, teams often travel within sight of each other and passing is frequent as faster teams advance to the front. Race etiquette maintains that slower teams must give way upon request. When a trailing musher catches up and calls "trail," the driver ahead stops and lets the faster team pass by. Often times, when the trail widens like on this lake, passes are simply made on the fly. Conditioning dogs to pass without incident is a necessary step in race training. As the days go by, the field spreads out. Toward the end of the race, a half day or more may separate teams traveling in the back of the pack.

▼ Volunteer Dan Gabryszak taxis spectators and volunteers in 2002 using his snowmachine at the first "off-road" checkpoint at the "Big Bend" on the Yentna River. Gabryszak and his family host the checkpoint set up at their river lodge. Iditarod could not function without volunteers like the Gabryszaks. Over 1,500 volunteers are registered with the trail committee and countless others unofficially pitch in to help. Many don't care who wins. To them, Iditarod is an "event" much larger than the actual race. Some don't even pay attention to which mushers are running in a given year.

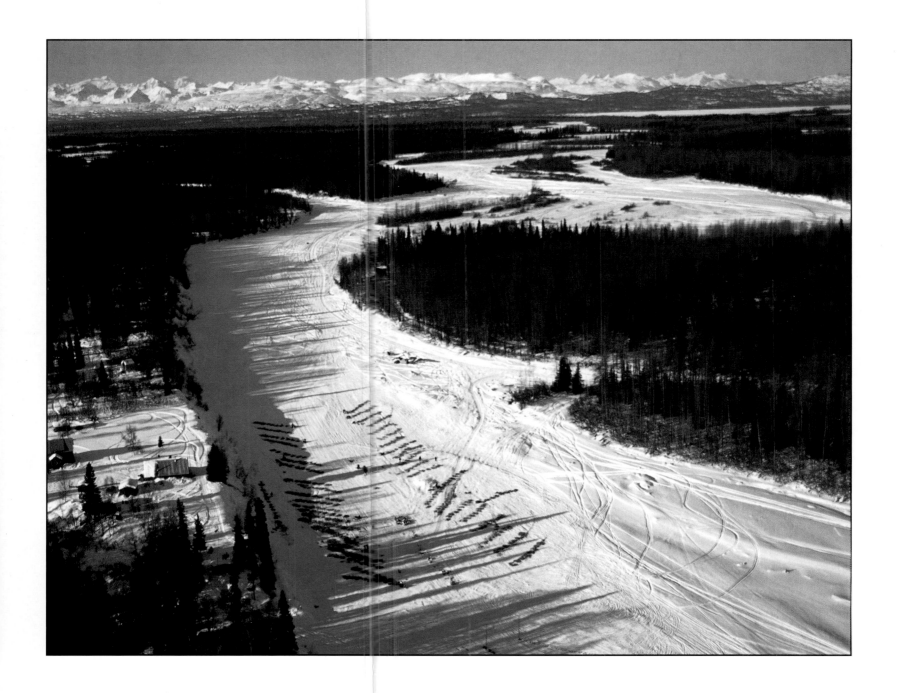

▲ In an aerial view of the Skwentna checkpoint during the 2002 race, teams look like resting centipedes sleeping on beds of straw along the Skwentna River. Though they may have arrived during the night, veteran mushers will choose a parking spot likely to catch morning sun in order to give their dogs a warmer rest. Some would say that's a slight advantage. Skwentna boasts a population of 111 spread out over a wide area. Local postmaster Joe Delia has served as official checker dating back to the very first race in 1973. Delia and his wife, Norma, coordinate the "Skwentna Sweeties," a group of local women who lovingly and unselfishly cook meals for the mushers and volunteers at all hours. The trail to Nome continues up the river toward the Alaska Range in the background.

◀ As the moon rises in 1999, a communications volunteer uses a satellite phone at the Finger Lake checkpoint to contact Iditarod headquarters. Information, collected by volunteers and relayed back to Iditarod headquarters, is often the only means of sharing the progress of teams on the trail with the outside world. Headlamps are a necessary item for all involved as mushers and volunteers alike are going day and night. The race never stops.

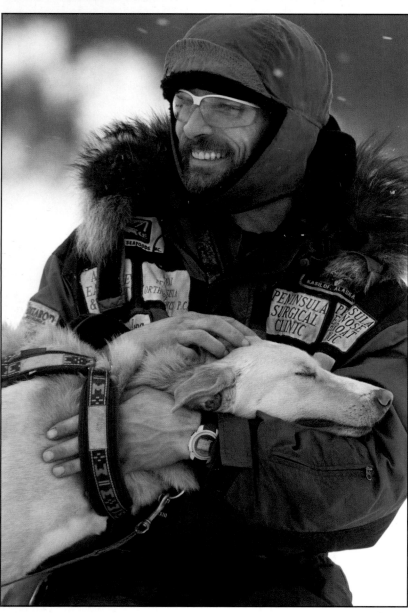

◀ Lance Mackey hugs his lead dog "Scotch" as he takes a break at the Rainy Pass checkpoint in 2005. Iditarod dogs are just "part of the family" and treated as such by mushers. At birth, this dog resembled his mother, "Butter." He was given a name easy to remember . . . "ButterScotch."

▶ Under the ominous Alaska Range Mountains, volunteer veterinarians, checkers, and communications personnel reside in temporary wall tent accommodations on Finger Lake's ice. These tents house the six to eight volunteers needed to run the checkpoint for three to five days as Iditarod teams pass through. Camps are needed at remote checkpoints, such as this one, located between villages and other settlements. Straw bales are strategically placed in line with team parking spots stomped out by snowshoe-equipped volunteers.

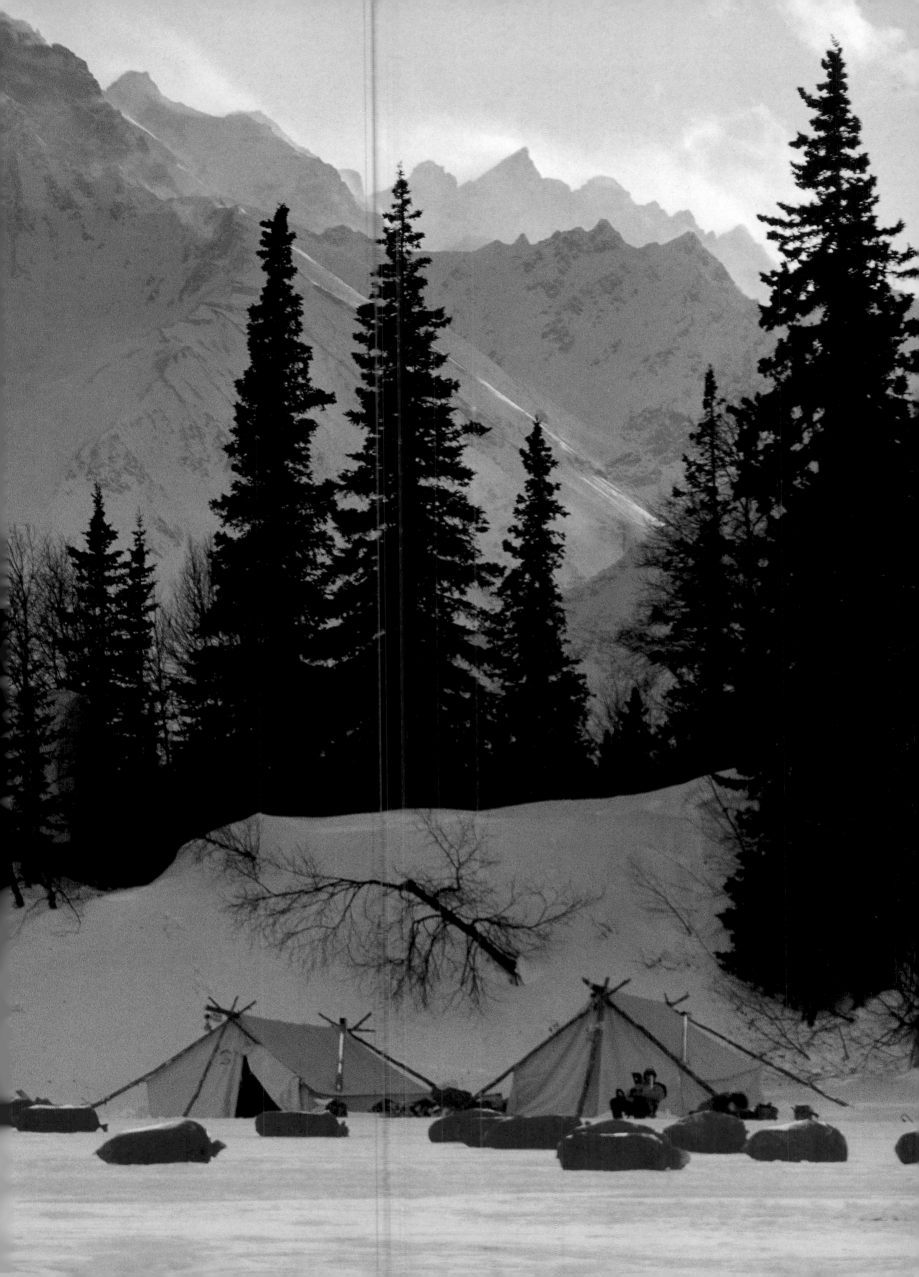

► Two teams snake their way over ice bridges and past open water holes along Dalzell Creek descending the infamous Dalzell Gorge, one of the most treacherous and feared sections of the trail. From year to year, the terrain in the gorge differs depending on snowfall, creek water level, and fallen trees. Trail breakers going through a week or so prior to the race must typically build bridges in spots using trees, branches, and snow. The portion of the trail that goes down the heart of the gorge is only a few miles but may seem an eternity, especially for a rookie musher.

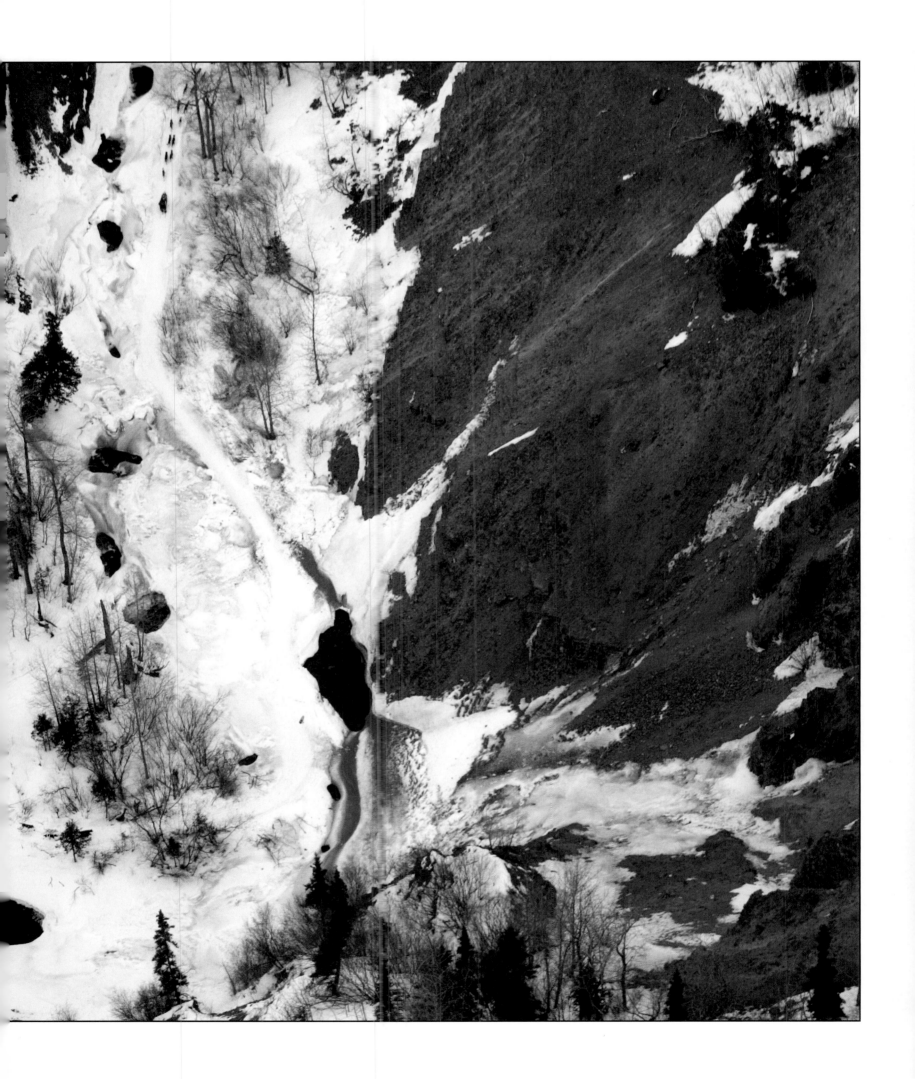

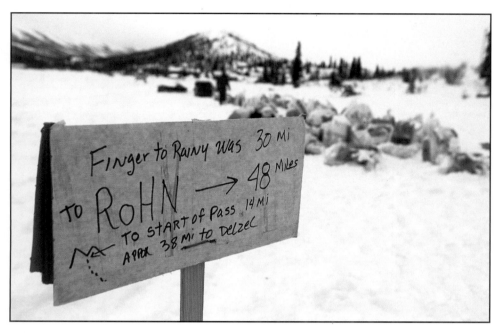

A handmade sign at the Rainy Pass checkpoint reminds weary mushers where they just came from, where they're headed, and what's in store. Iditarod's mountain checkpoint is actually located on Puntilla Lake at the Rainy Pass Lodge, some 18 miles before the actual Rainy Pass summit.

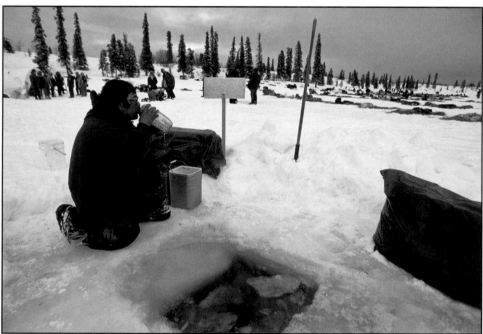

During the 1994 race, Mike Williams drinks water from a hole chopped into Puntilla Lake at the Rainy Pass checkpoint. Mushers appreciate it anytime they find water readily available, sparing them the effort and time required to melt snow.

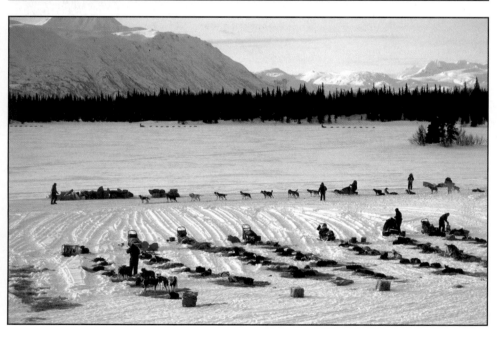

Teams arrive at the Finger Lake checkpoint on each other's heels during the 2004 race. Bill Pinkham and Peryll Kyzer check in with race officials in the foreground as two other teams skirt the lake. Depending on where arrival falls in the dogs' run/rest schedule, or how the musher is feeling at the time, some teams will pause only long enough to check in, then continue. Others will rest at the checkpoint. Along with signing in, a musher must show upon arrival that he has the mandatory gear in his sled including a hand axe, snowshoes, eight pairs of dog booties per dog, a cook pot, fuel, dog food, cold-weather sleeping bag, veterinarian book, and promotional material.

▼ The Alaska Range is bathed in moonlight as headlamps streak the shadows around teams resting on Puntilla Lake in this 1996 time exposure made at the Rainy Pass checkpoint.

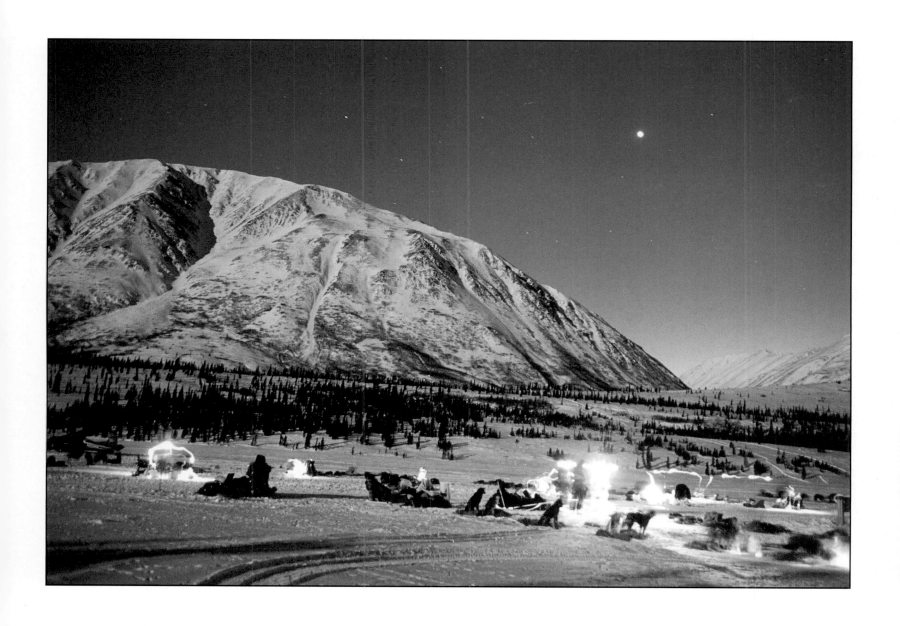

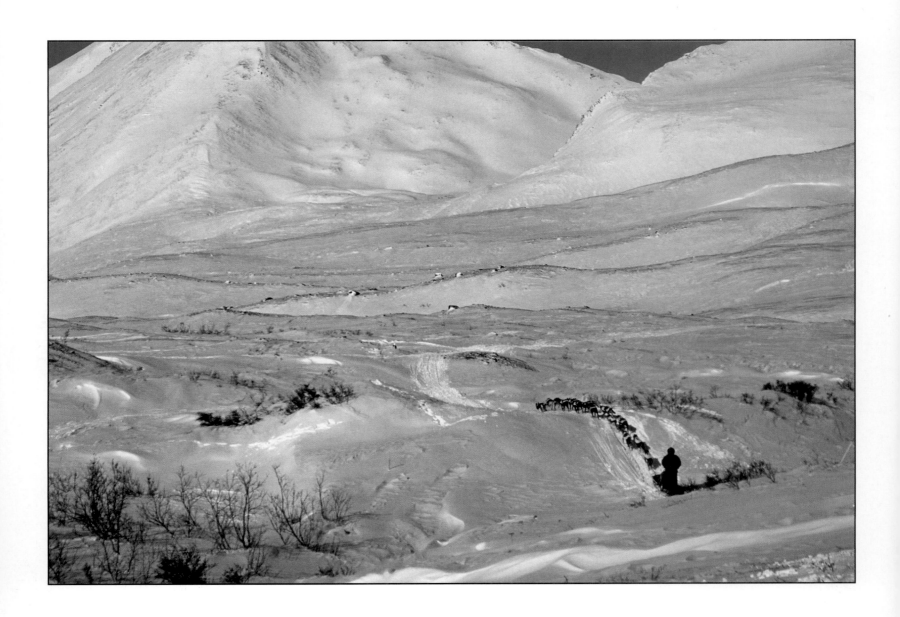

▲ Rick Swenson and team mush uphill within sight of the 3,160-foot summit of Rainy Pass less than a mile ahead during the 2004 race. Well above tree line, the Rainy Pass area is by far one of the most picturesque on the trail.

► Martin Buser winds his way through willows along one of the narrowest sections of the trail in the Rainy Pass area on top of frozen Pass Creek. The trail continues down the left side of this photo and then turns right to follow the Dalzell Creek drainage toward Rohn. In narrow sections like this, mushers driving a full team of 16 dogs often lose sight of their lead dogs as they snake through the terrain.

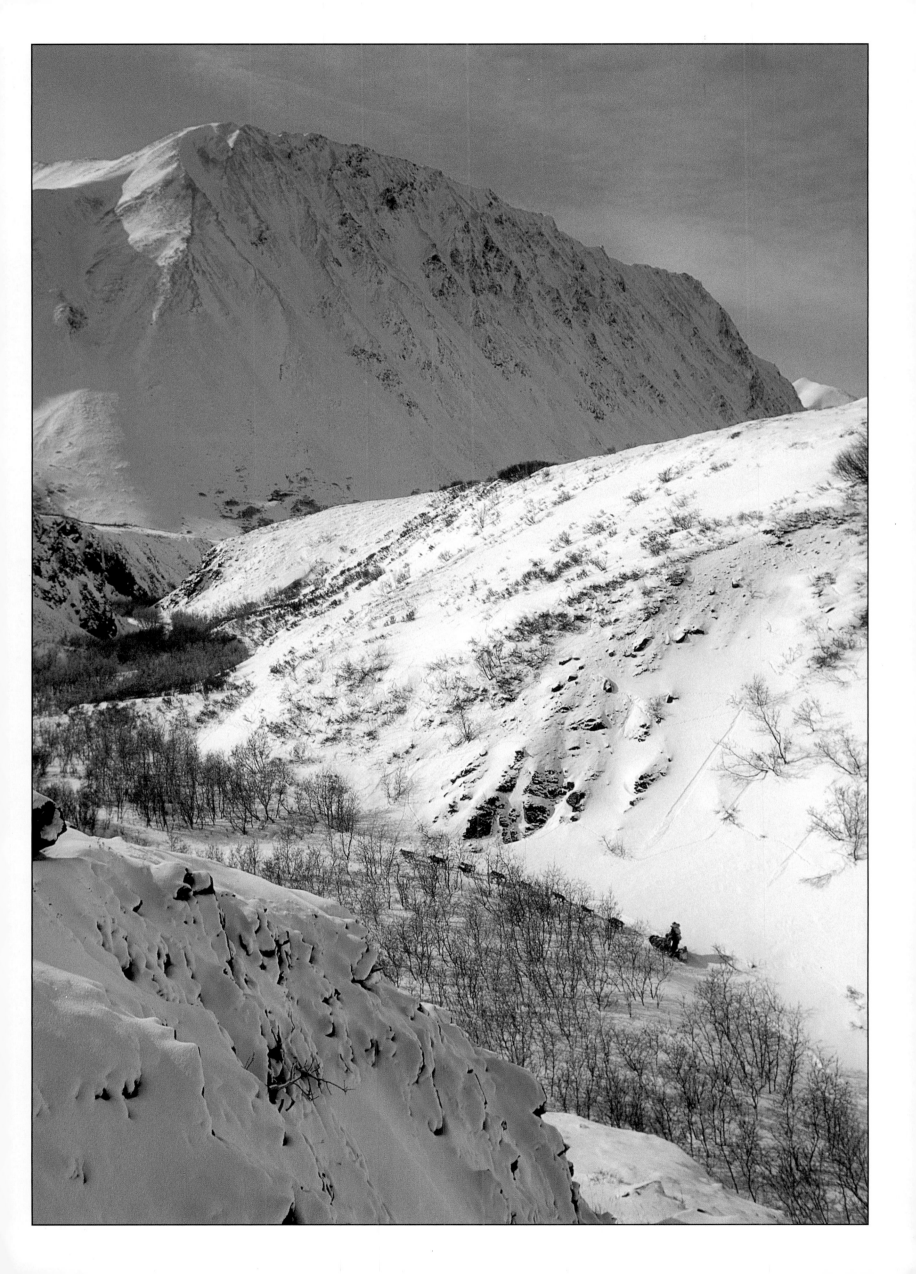

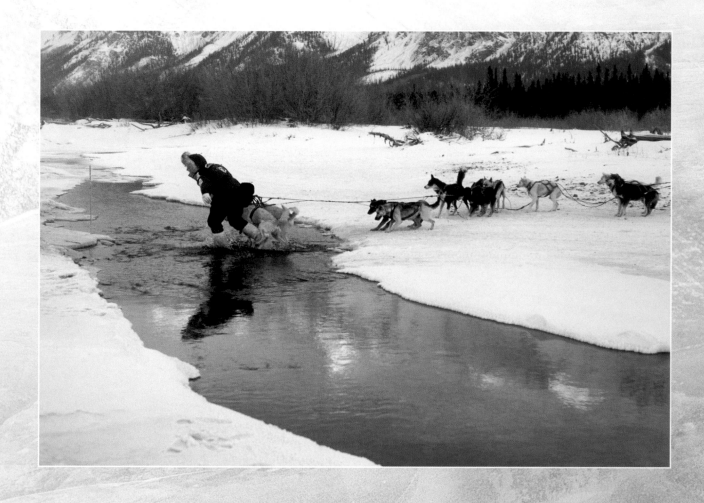

▲ Sonny King guides reluctant leaders across open water near Rohn as they cross the South Fork of the Kuskokwim River in the 1999 race.

Iditarod *glory*

the Interior

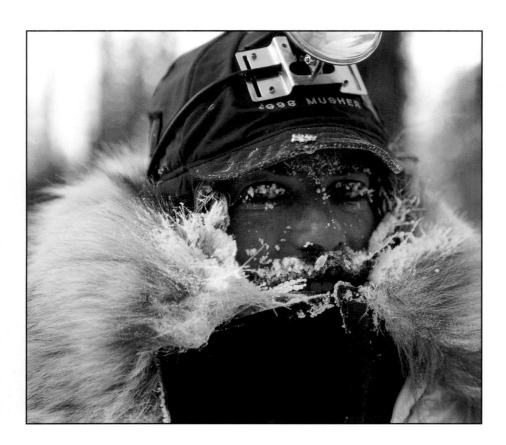

▲ Steve Carrick sports frost on exposed hair shortly after arriving at the Rohn checkpoint in 30-below conditions during the 1999 race. Mushers must prepare for every possible weather condition on the trail. Temperatures can be 30 degrees above zero in the daytime sun and plummet far below zero as teams move through other areas. Packing correct clothing, especially footwear, for whatever comes is imperative.

▼ With no one around to enjoy it, the campfire simmers late in the evening at the Rohn checkpoint where Christmas lights await the next team to arrive. Mushers' food bags are sorted alphabetically and stacked awaiting pickup. The cabin, though not the original Rohn Roadhouse as it was known during the gold rush era, has been in use by the race since 1973. It's owned and operated by the federal Bureau of Land Management. Because of its remoteness and wildness, Rohn is one of those special places on the Iditarod attracting few spectators. The airstrip at Rohn is not only short and narrow, but the winds are often cross.

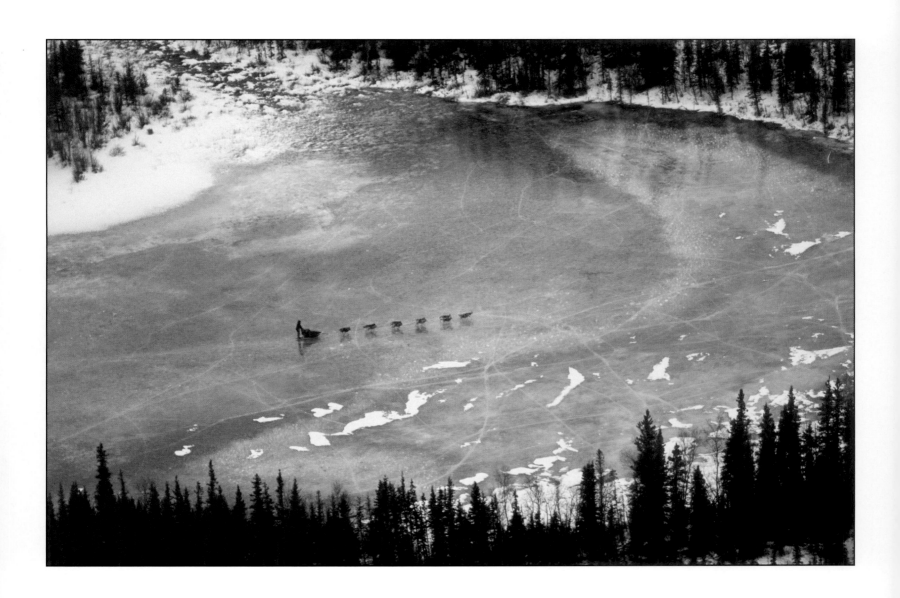

▲ Down to 12 dogs from his original 16 he started with three days and 300 miles earlier,
Wayne Curtis runs his Siberian husky team across glare ice in the Farewell Lake area
between Rohn and Nikolai. Ice stripped of snow makes dogs and mushers nervous
because of the inherent risk of falling on its slick, smooth surface. Pressure cracks show
in the lake because of expansion. Ice on such lakes can be more than two feet thick.

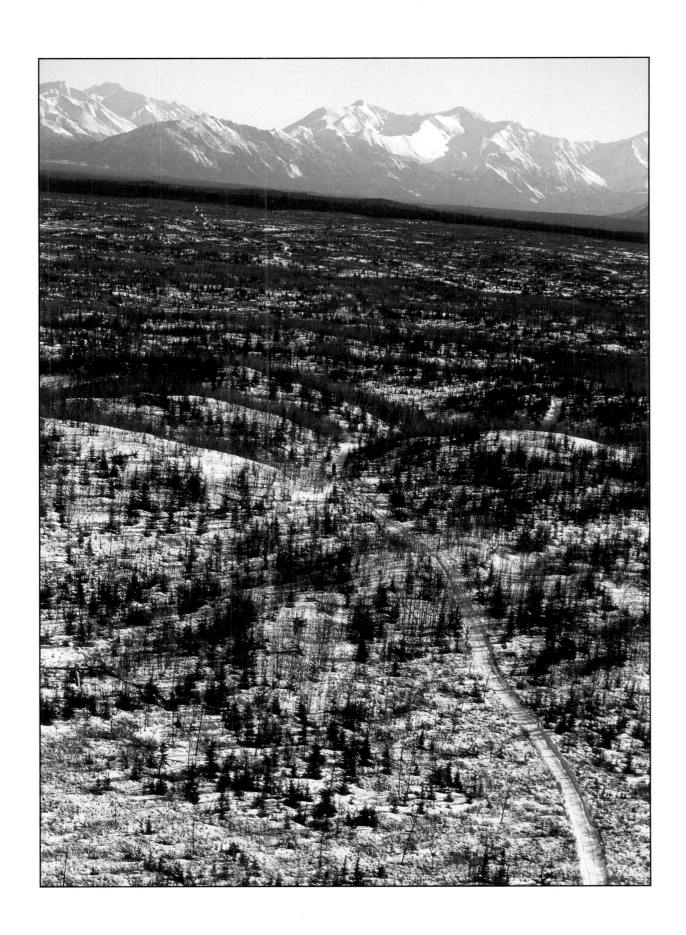

▲ A team cruises on the ribbon of trail cut through the infamous Farewell Burn between Rohn and Nikolai. A 1976 forest fire burned over 360,000 acres in this area. "The Burn," as it has since been called, is notorious for chewing up sleds as they crash over downed trees and smack stumps and rocks. Every year there are stories of broken sleds and mushers injured crossing this desolate 40-mile stretch. High winds in the area often sweep the trail clean, leaving teams passing along rocks and frozen dirt. Amazingly the dogs don't hesitate at all. It can be tougher on the musher, running and pushing, fearful of the bump just waiting to deliver a shattering blow.

▼ Trine Lyrek's team doesn't skip a beat running across bare frozen ground near Egypt Mountain, 16 miles down the trail from the Rohn checkpoint. This area is known for its snowless ground cover each year. Dogs don't mind, but running on barren trails can be harder on sleds, runners, and the musher.

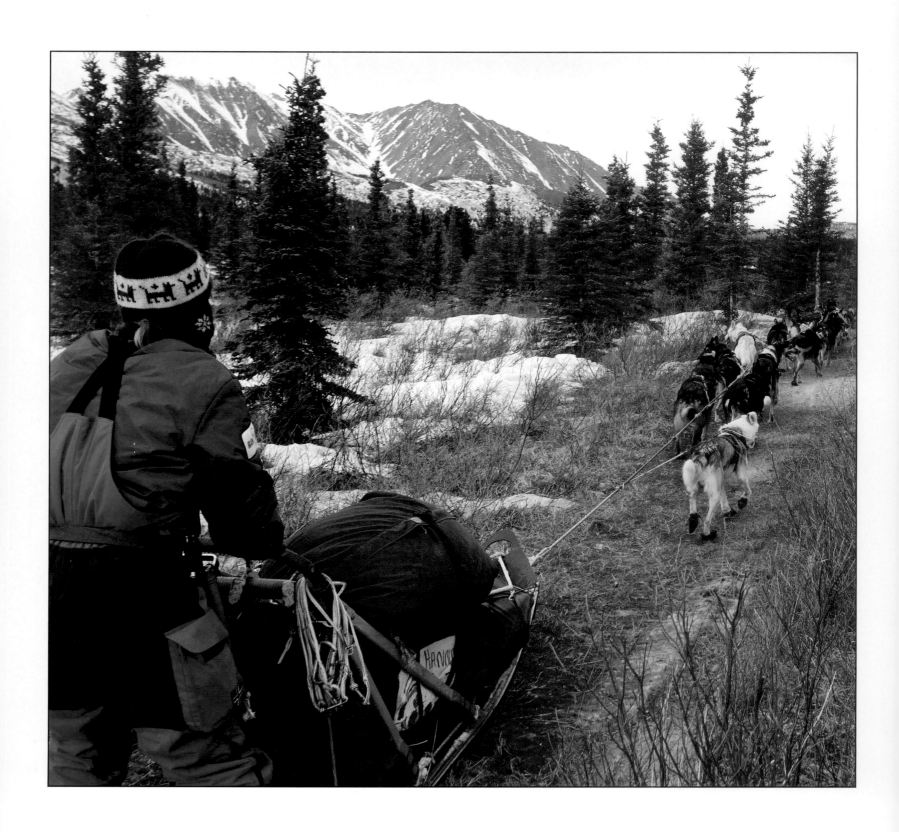

▲ Even though the breed is an Alaskan husky, the piercing blue eyes of the Siberian husky bloodline shine through clearly in Charlie Boulding's dog as he intently looks for the musher's next command.

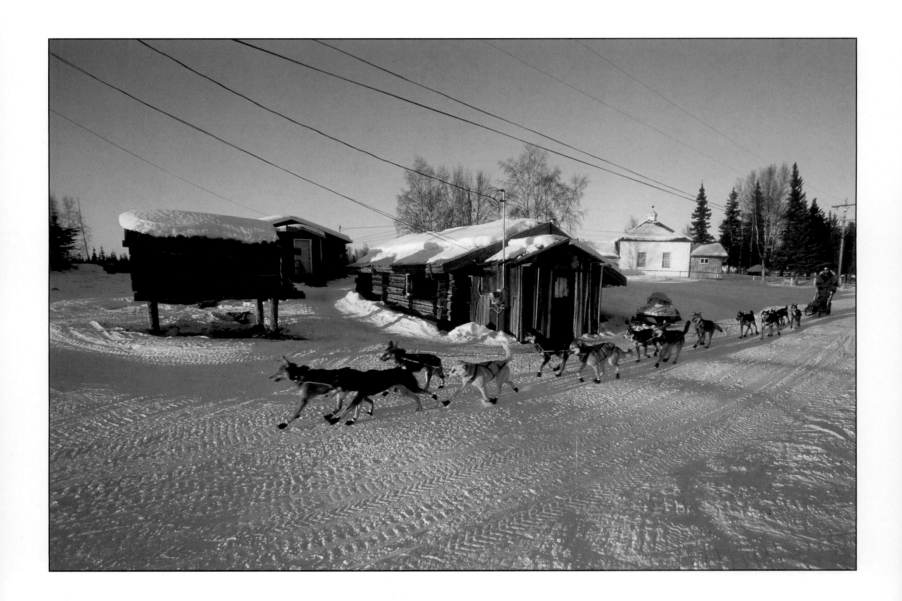

▲ Jon Little and his 15 huskies mush down a street past houses and the Russian Orthodox church departing the Nikolai checkpoint during the 2002 race. Nikolai, located 350 trail miles from Anchorage, is the first Athabascan Indian village mushers encounter on the race.

▶ One of Jeff King's wheel dogs jumps in anticipation of leaving Nikolai as the musher hooks up other dogs in the team. You can tell a strong dog team when you see one. When dogs still jump to go after 350 miles you have a well-trained and rested team. The dogs are parked around the school yard in the village. Mushers can eat or sleep for free at the school. The press and other Iditarod visitors can rent a warm spot on the floor, get a shower or homemade food. Any extra money raised goes back to the school.

▼ Nikolai resident Jeremiah Ticknor walks a "dropped dog" to chief Iditarod pilot John Norris for a ride back to McGrath in 2002. Dogs that are sick, injured, or causing problems for any reason may be "dropped" with volunteer veterinarians staffing the 20-plus checkpoints out on the race. Dogs left behind are cared for by the vets until an Iditarod "air force" plane such as this Cessna 180 arrives. The dogs are tethered down on a leash inside the airplane to avoid excessive movement and when the engine starts up. Most canine passengers lie down for the entire ride. Paperwork from the attending checkpoint vet accompanies the patient through its entire journey assuring that the next caregiver provides proper treatment.

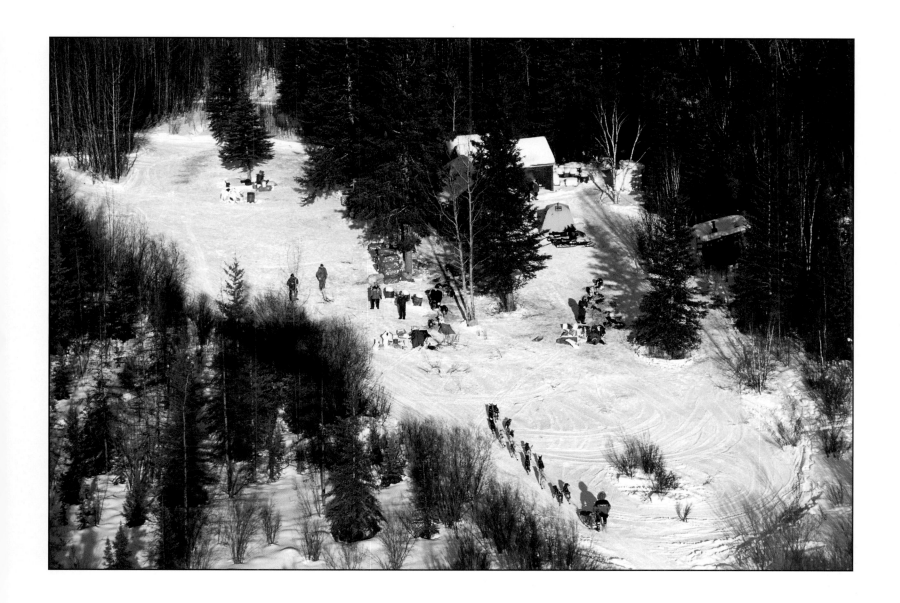

▲ A handful of volunteers wait to check in a team as it pulls in to the Ophir checkpoint in 2002. The gold rush ghost town of Ophir is one of the more remote checkpoints, and harder than most to reach by plane. Cabins used as the checkpoint during the race are generously loaned by Dick and Audra Forsgren, who have participated as volunteers since the first race.

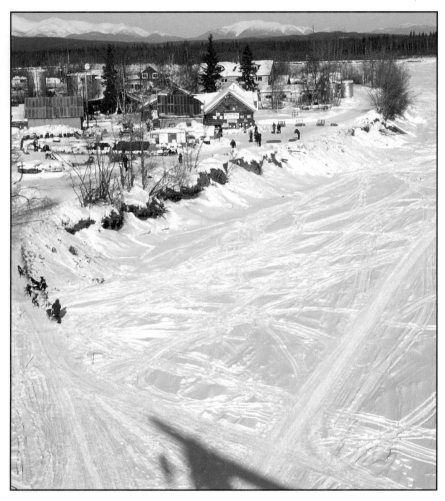

◀ David Straub mushes up the bank of the Kuskokwim at McGrath after running the 48 river miles from Nikolai. McGrath is one of the largest towns on the race with more than 400 people. Straub went on to finish the 2002 race in last place, earning Iditarod's Red Lantern.

▼ Nikolai schoolchildren always help out during Iditarod as these four demonstrate in 2001. When a team arrives, the musher's bale of straw, fuel, food and gear bags are happily loaded onto a sled and pulled to wherever the dogs are parked, saving their master precious time and energy.

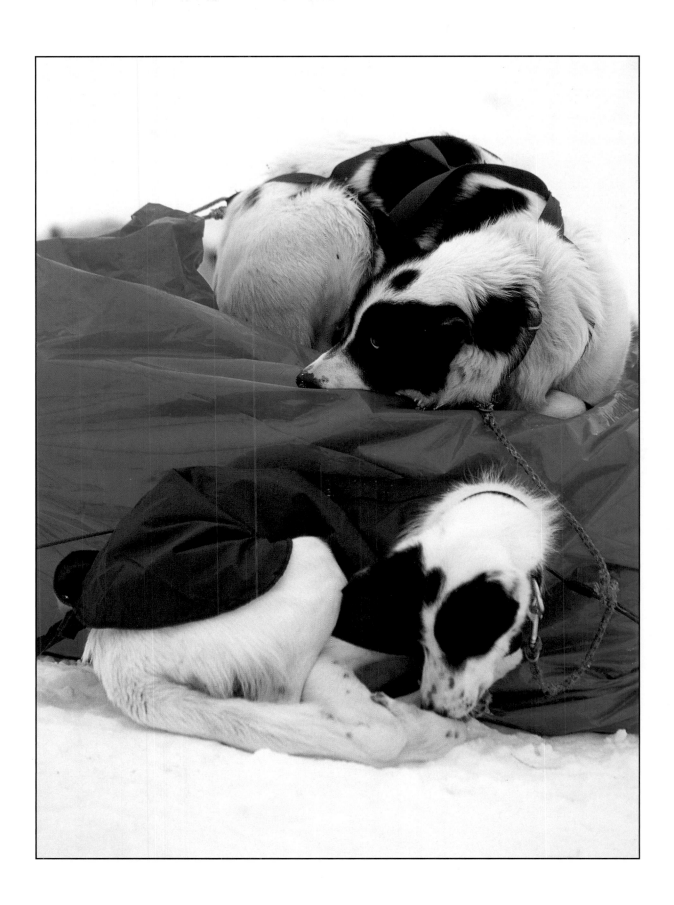

▲ After arriving in Nikolai in 2004, Jerry Sousa's dogs don't wait for the straw to be unpacked; they simply pile atop the unopened bale for a snooze. Mushers typically do not take the dogs out of harness during rest stops, though they do unhitch the "tug line" stretching back to the gangline, freeing tired dogs to comfortably curl. Those harnesses will come off during the team's 24-hour layover so the musher can dry them out. An Iditarod team's typical run/rest cycle has dogs pulling for five hours, then resting five. Six on, six off, is another common schedule. Resting dogs at least as much, if not more, than they run is the accepted recipe for success.

▼ Replacement sleds await the arrival of their owners at McGrath, the first major "hub" checkpoint. The cost of airfreighting sleds to the Kuskokwim village runs $100 or less. Most mushers send a spare sled to McGrath, figuring the chances are great some essential part will by then be broken during the treacherous passages down the Happy River Steps and Dalzell Gorge, and across the Farewell Burn. McGrath is the first of two major villages along the race that receives daily flights from air-cargo and passenger airlines. Given their awkward shape and size, sleds are difficult to bring in to most other checkpoints. A musher who needs a sled back at Nikolai, for example, must enlist the help of a local willing to haul the sled behind a snowmachine on the 48-mile trip.

▲ Lisa Frederic's dog Houston arrives in the basket at McGrath. Part way into the run from Nikolai in 2002 Houston was simply too tired to continue. Frederic loaded him in her basket where he rode the rest of the way. The sign in the background, made by local schoolkids, welcomes the mushers to the village. Schoolkids love the idea of getting autographs from the mushers, pilots, and others coming though town. Some cash in on Iditarod traffic by selling food and offering snowmachine taxi rides.

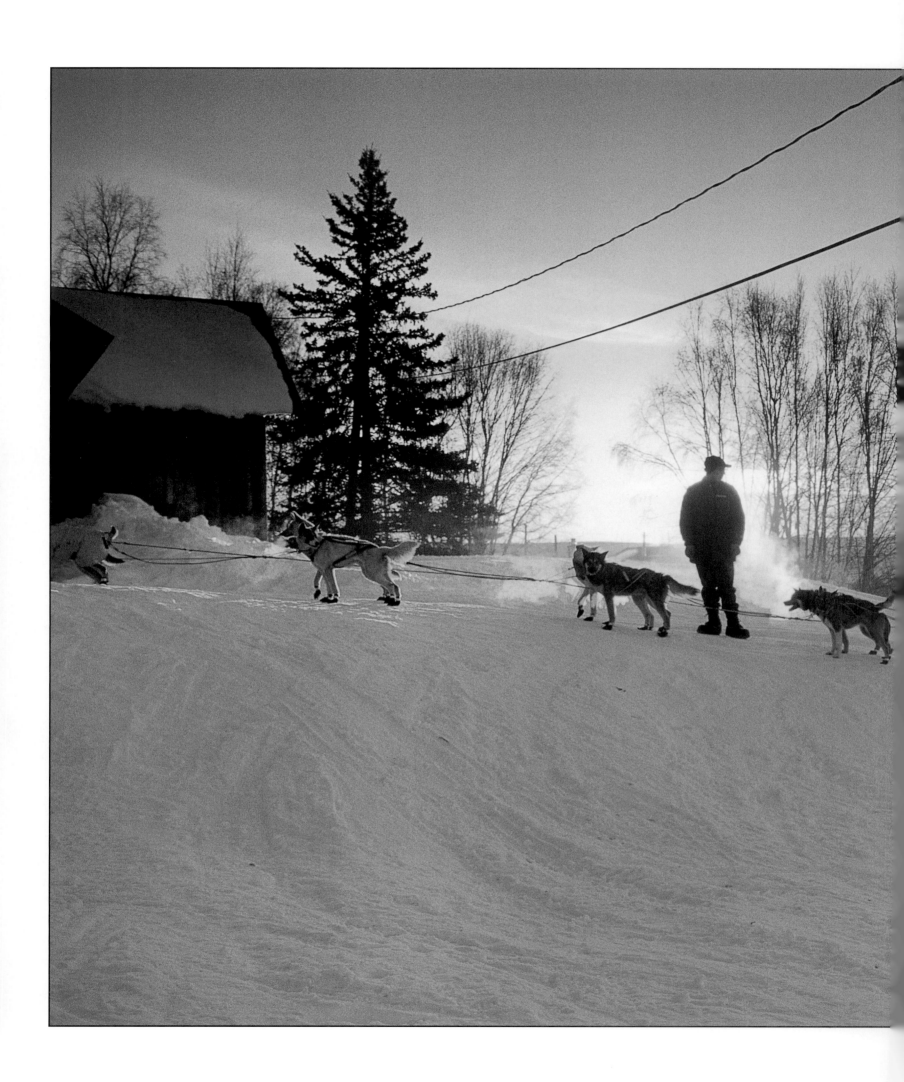

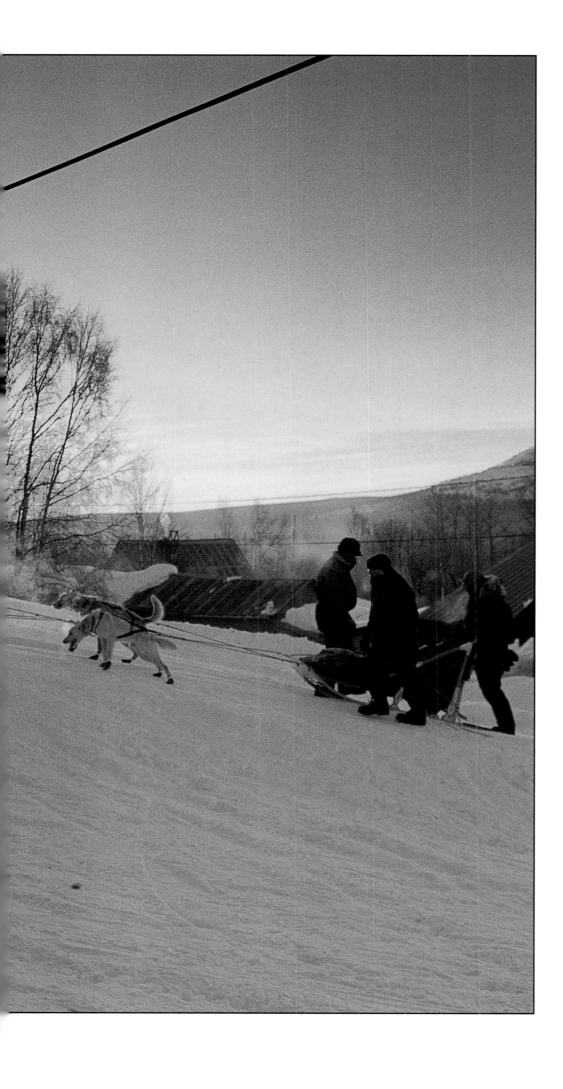

◀ As dawn breaks over the horizon in 2000, Shawn Sidelinger and team pause while looking for a parking spot at the Takotna checkpoint. Volunteers are generally available to assist parking teams. Most often the helpers will hold the gangline and guide dogs around obstacles and tight turns toward a good rest spot.

▼ As one team arrives, rookie Todd Denick mushes his dogs away from the Takotna checkpoint in 2004. Checkers, vets, and communications volunteers scramble 24 hours a day at checkpoints supporting the rhythm of the race. Unless they are completing required layovers, mushers don't need to sign out when departing checkpoints. Serious racers will sometimes conceal their team's movements and leave competitors in the dark. Many vigilant checkers nonetheless take pride in noting departures so they can pass on that news to the Iditarod-watching world.

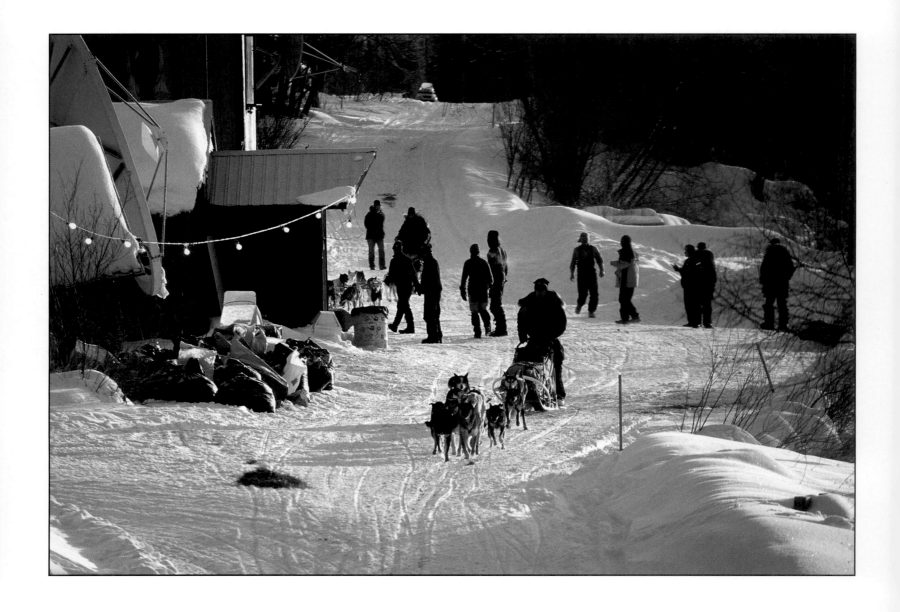

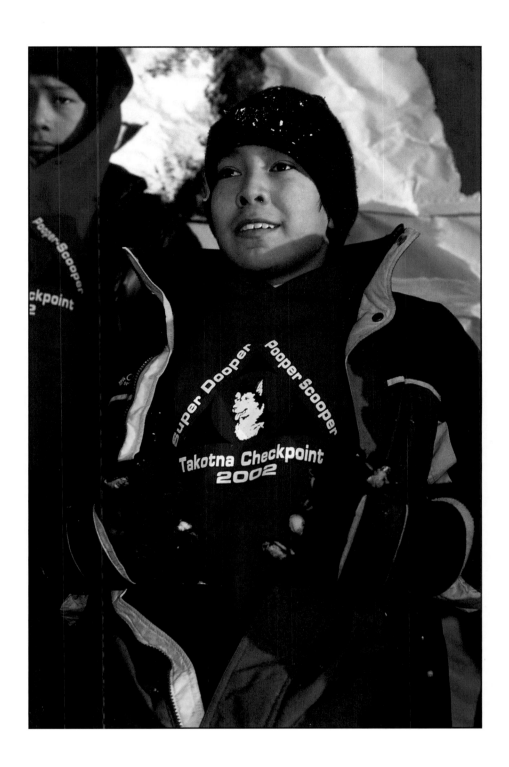

▲ Then 10-year-old Alfred Perkins, one of the 2002 official "pooper scoopers," poses with the group for a photo in their uniforms at Takotna. Most mushers enjoy the Takotna checkpoint and many prefer it for their 24-hour layover because of the hospitality afforded by the residents. Each musher is treated to a steak dinner, a hearty breakfast, and a sack lunch to take with them on the trail. Homemade pies are available 24 hours a day. Older schoolchildren are put to the task of keeping two 30-gallon trash cans full of hot water, which the mushers use preparing their dog food. After teams leave, younger children, like Alfred, get to clean up straw and dog droppings.

► Rick Swenson applies a "wrist wrap" to one of his dogs at the Takotna checkpoint in 2002. Besides being the "brains" of the outfit, a musher is also the "team trainer" as well. When dogs are running, the driver constantly watches each athlete's performance. If any dog's behavior or gait changes, the musher scrutinizes it to see if it might be a sore foot, a hurt back, or something else. It's up to him to diagnose problems and administer proper care, such as this wrist wrap. If a dog shows signs of developing a sore wrist, or has a history of such things, the musher will massage the joint with an anti-inflammatory ointment to increase circulation and promote healing. The wrist is then covered with a neoprene wrap, which acts as an insulator, keeping the wrist warm.

◄ In the early morning at Takotna during the 2000 race, veterinarian John O'Connor begins his rounds by examining Pasvik, one of Norwegian musher Harald Tunheim's dogs. The 35 volunteer veterinarians who work the race each year come from throughout Alaska and many parts of the country, even from overseas. It's a coveted position to be a member of the Iditarod veterinarian team.

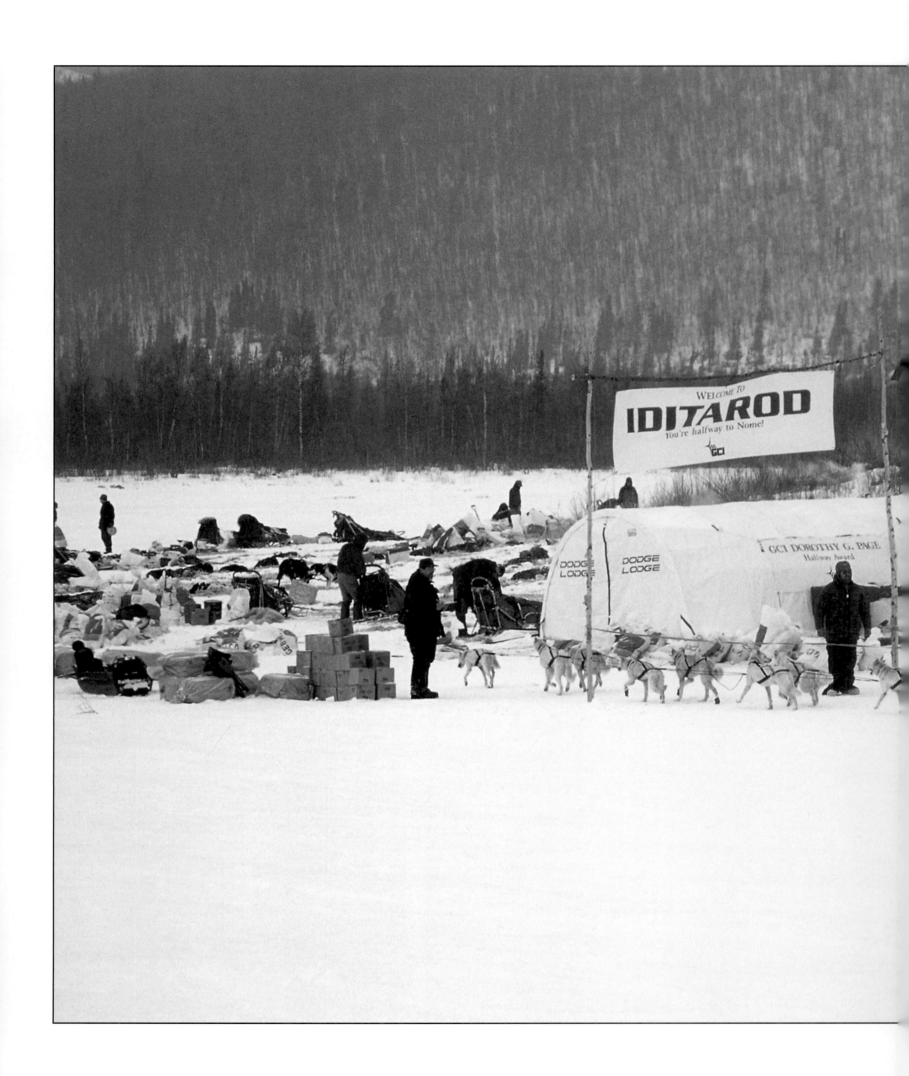

◄ Perennial Iditarod musher Dr. Jim Lanier arrives at the halfway checkpoint of Iditarod, the race's namesake. Iditarod, now a ghost town with only a handful of buildings still standing, was a thriving gold-mining town of 10,000 in the early 1900s. The abandoned town comes alive for more than a week during the race, with racers and other visitors staying at the "musher bunkhouse" built recently by volunteers, and in temporary shelters set up for race officials. An Alaska-owned communications company, GCI, sponsors the "Dorothy G. Page" halfway prize of $3,000 in gold nuggets to the first musher to reach the checkpoint. Lesser prizes await the second- and third-place teams. The late Dorothy Page was known as the "mother of the Iditarod" because of her involvement getting the first races going on the historic Iditarod Trail.

▼ While on his 24-hour layover during the 2002 race, four-time winner Martin Buser puckers up for a kiss from one of his team dogs at the Cripple checkpoint. Mushers treat their dogs like the best of friends as this gesture shows. Buser's hat sports the names of some corporate sponsors. As in many sports, support from sponsors can make or break a competitive team. A newcomer to the sport wishing to lease, outfit, train, and qualify a team for the Iditarod can spend $50,000 to $100,000 dollars making the trip to Nome.

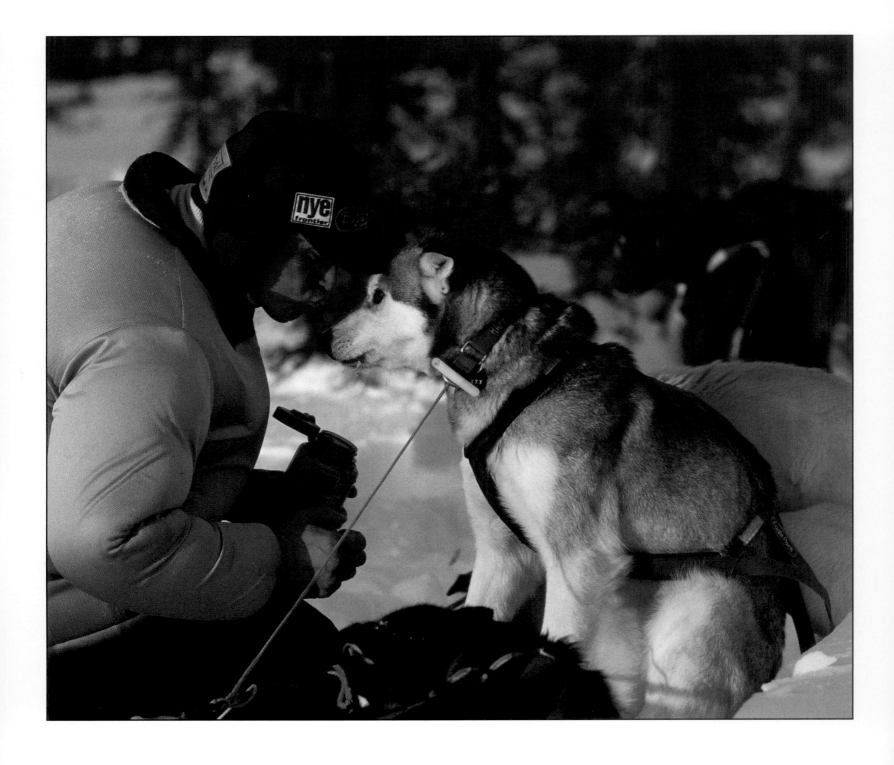

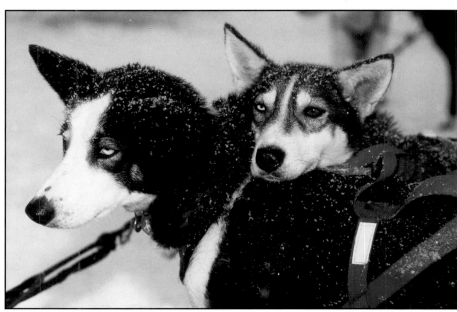

▲ Volunteer "Iditarod air force" pilot Jim Kintz checks on his canine passengers before leaving the Cripple checkpoint. These dropped dogs will be flown by Jim 60 air miles back to the main hub at McGrath. Typically a Cessna "air force" plane will accommodate 8 to 10 dogs. The pilots ferry the dogs from smaller checkpoints to the closest main "hub," such as McGrath, Unalakleet, or Nome, where dogs are then put on a commercial jet for transport back home. In Anchorage, another team of volunteers cares for dogs dropped during the race until the musher's handlers pick them up.

▶ Two of Andy Moderow's dogs rest upon arrival at the Iditarod checkpoint in 2001. The dog on top shows the "bi-eye" trait, with one blue and one brown eye. The blue eye is considered an original Siberian husky bloodline trait.

► Dropped dogs are tied to a plane at Cripple before being loaded for a trip back home. Cripple is one of the most remote checkpoints on the trail, located 100 trail miles from the nearest organized town on Iditarod's northern route. Though the inaugural 1973 race and a few subsequent races followed the trail through the town of Iditarod, the race now alternates between the even-year northern route and the odd-year southern route, allowing more Yukon River villages to participate as checkpoints. The northern route's Yukon River villages all served as stopovers for the famous 1925 diphtheria serum run.

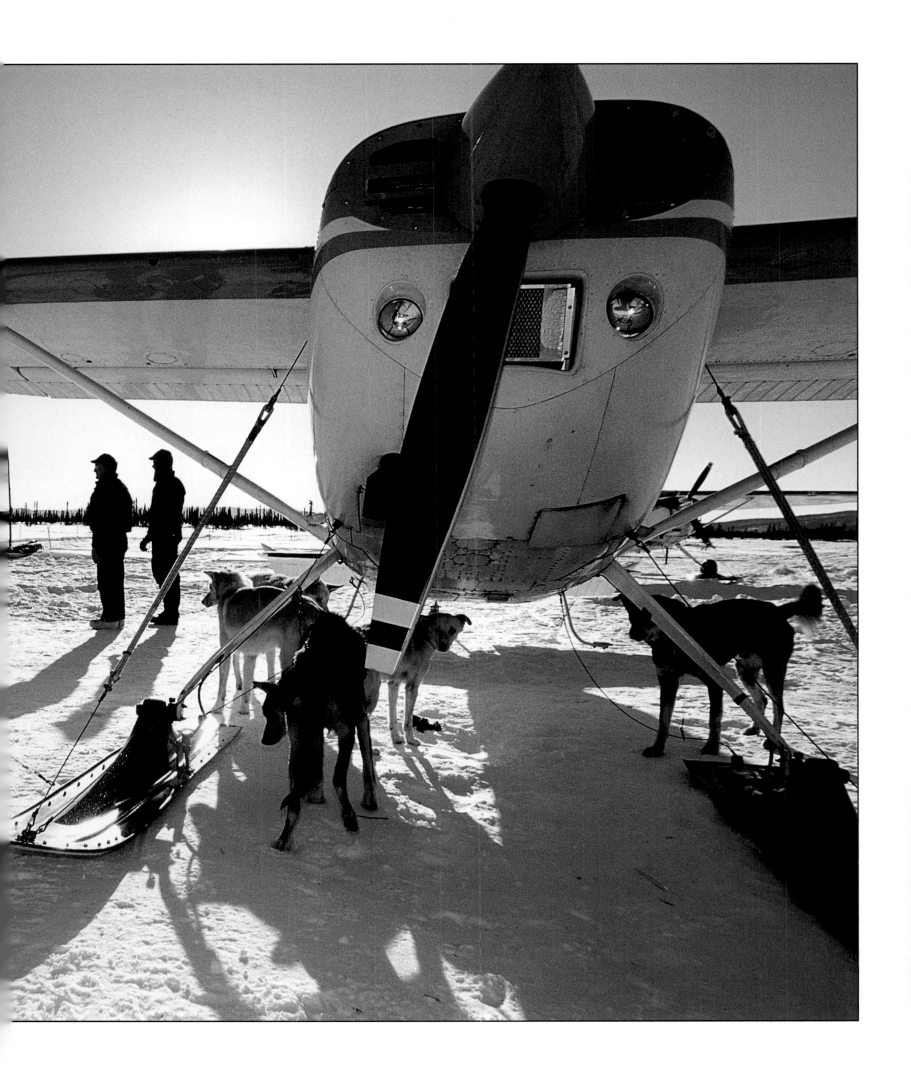

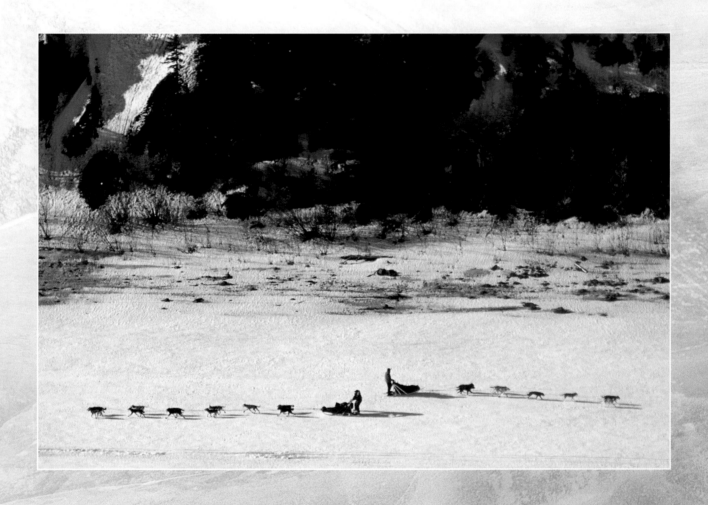

▲ Linwood Fiedler and Bruce Lee pass each other head-on as they travel on the Yukon River between Anvik and Grayling during the 2003 race.

Iditarod *glory*

the Yukon River Routes

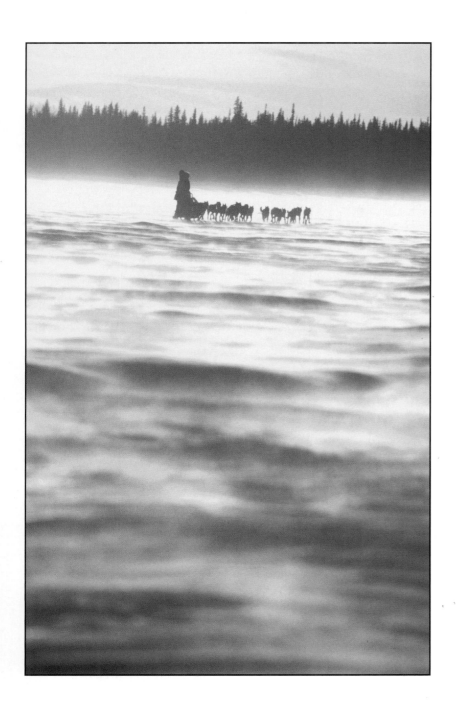

▲ With 25-mile-per-hour winds kicking up snow on the Yukon River, Paul Gebhardt looks back to see if any teams are following him from the Ruby checkpoint. Running the northern section of the Yukon River can be one of the most challenging portions of the race for a musher, not because of the trail's difficulty, but rather the mental boredom it produces. The 150-mile trip is very flat and, generally, uneventful. Many mushers outfit their sleds with seats for this section. Music piped through headphones offers another means of keeping up spirits.

► Uma and Grit, two of Jim Lanier's dogs, bask in their fleece coats during a sunny 2004 rest stop in Galena.

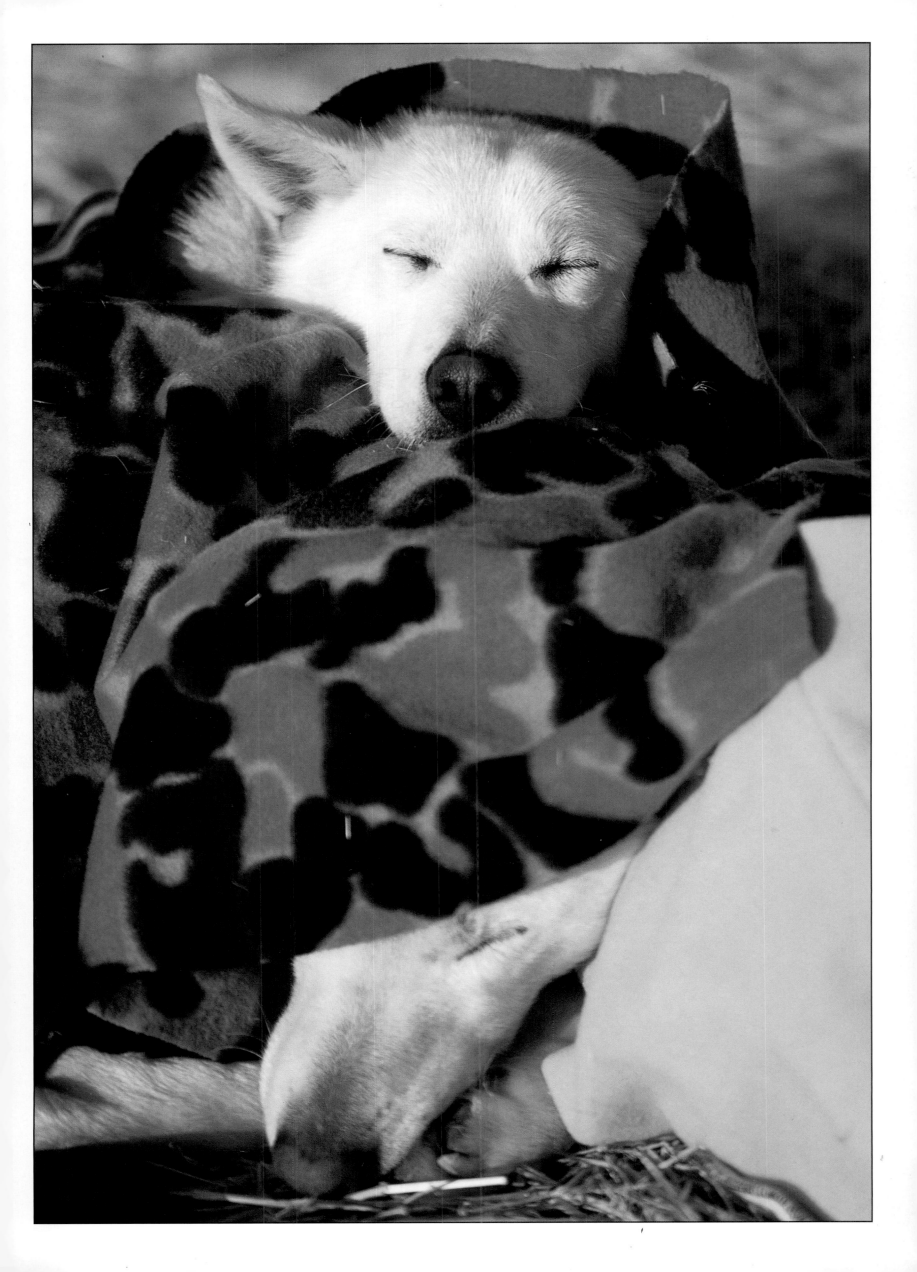

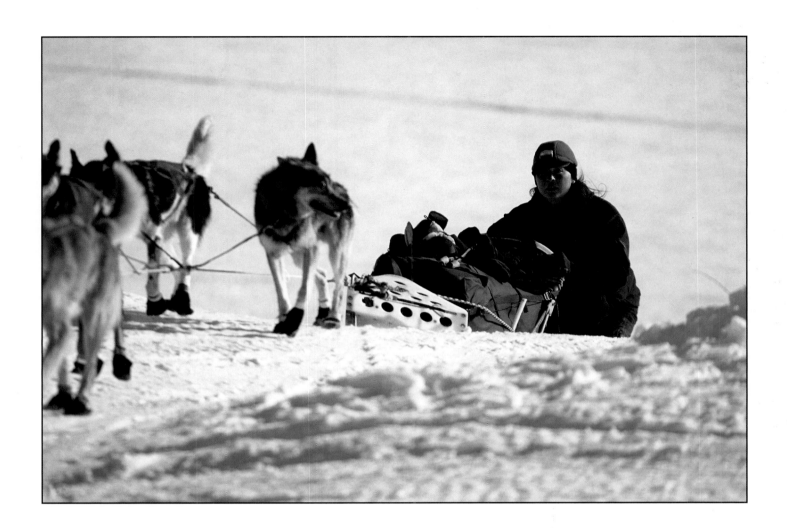

▲ Jessie Royer pushes her sled climbing the bank of the Yukon River into the Grayling
 checkpoint. Most mushers give their team a hand on uphill stretches by running behind,
 or simply pushing the sled. On straight stretches, some mushers use ski poles to help
 propel the sleds.

◄ This aerial view of the village of Ruby, the first village on the Yukon River, shows Aaron Burmeister
 mushing his team up a road toward the checkpoint, where other teams rest. As in many villages along
 the race, the community hall serves as the main checkpoint, where mushers can sleep, get something
 to eat, and sometimes get water for their dogs instead of melting snow. Notice the neatly stacked
 food and gear bags awaiting mushers. Race rules require a musher to take an eight-hour break at any
 of the checkpoints along the Yukon River. Many mushers opt to take this relatively long pit stop at
 Ruby, recuperating from the often-rough 112-mile trail from Cripple.

▼ Dogs and kids, kids and dogs . . . Iditarod brings out many fans of the canine athletes. Typically, dogs get more attention than the musher, at least from the local children. Alea Robinson pets one of Mike Williams's lead dogs upon arrival in Anvik in 1999.

▲ During the 2002 race at the Galena checkpoint, official drug tester Roy Catalano catches a urine sample in a baggy from one of the many dogs volunteers test each year. Each musher's team is subject to random testing of a few dogs along the race to protect against the use of illegal performance-enhancing drugs. The drug testing, paid for by the Iditarod Committee, falls randomly during the race, but each of the Top 20 finishing teams is subject to testing in Nome.

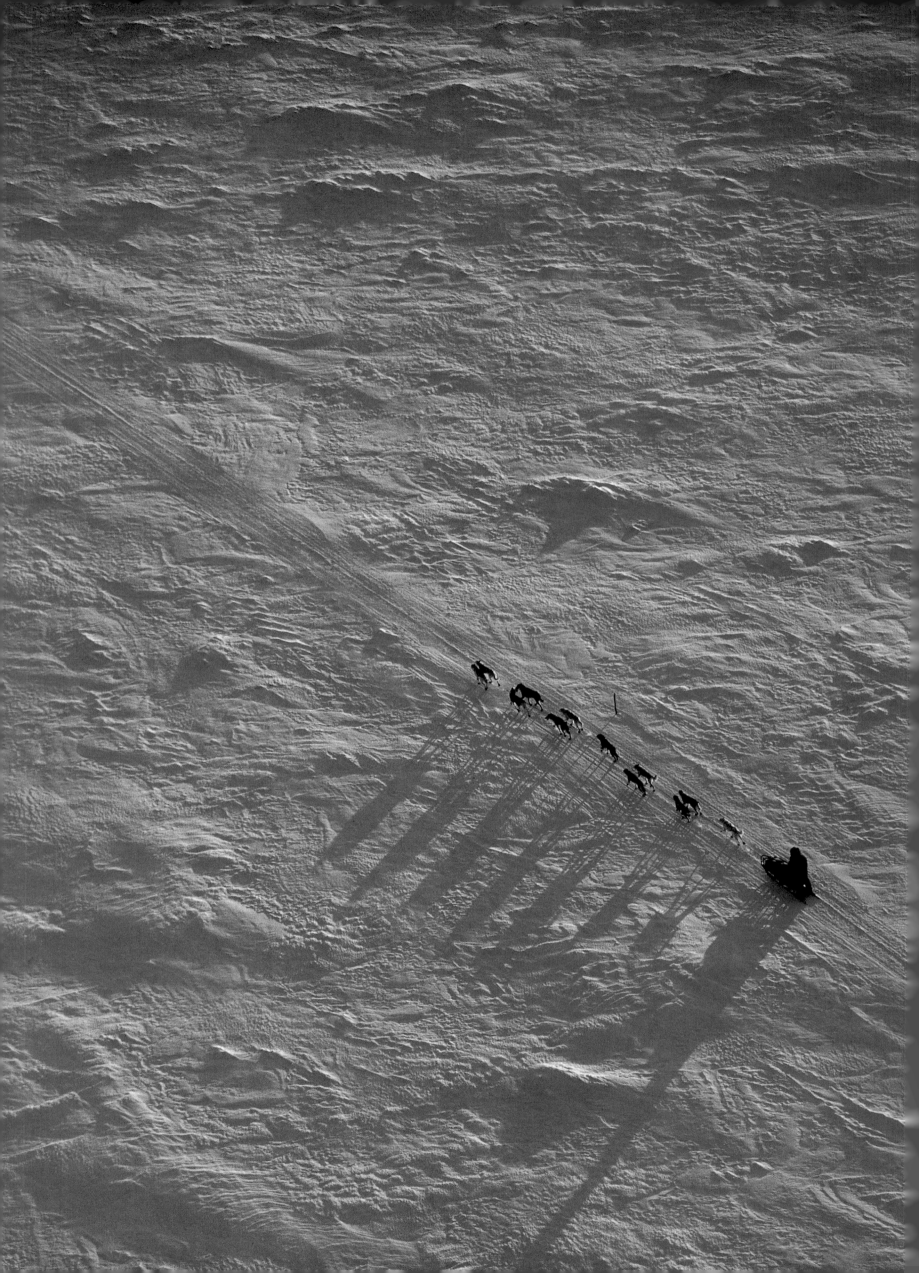

▲ As dawn just begins to break, rookie musher Randy Chappel gets instructions on where to park his team after checking in at Eagle Island in 2003. The remote checkpoint, on the Yukon River's southern end, is about mid-distance between the villages of Grayling and Kaltag. Eagle Island is not a village. It's the site of a trapper's cabin. During the race, Iditarod sets up a temporary town with two or three portable weather shelters for race volunteers.

◄ Sun crests the horizon in the early morning, creating long shadows of Bill Cotter and his team against the snow blanketing the Yukon River in 1999. Dogs perform better in colder temperatures, so mushers will manage their schedule for night, early morning, and late evening runs, reserving the warmer afternoon for resting. The wooden lathe to the right of the team is a trail marker set by one of the snowmachine-riding trail breakers, who travel a day or more in advance of Iditarod's front-runner. Over 14,000 of these lathe markers are put out along the trail every year.

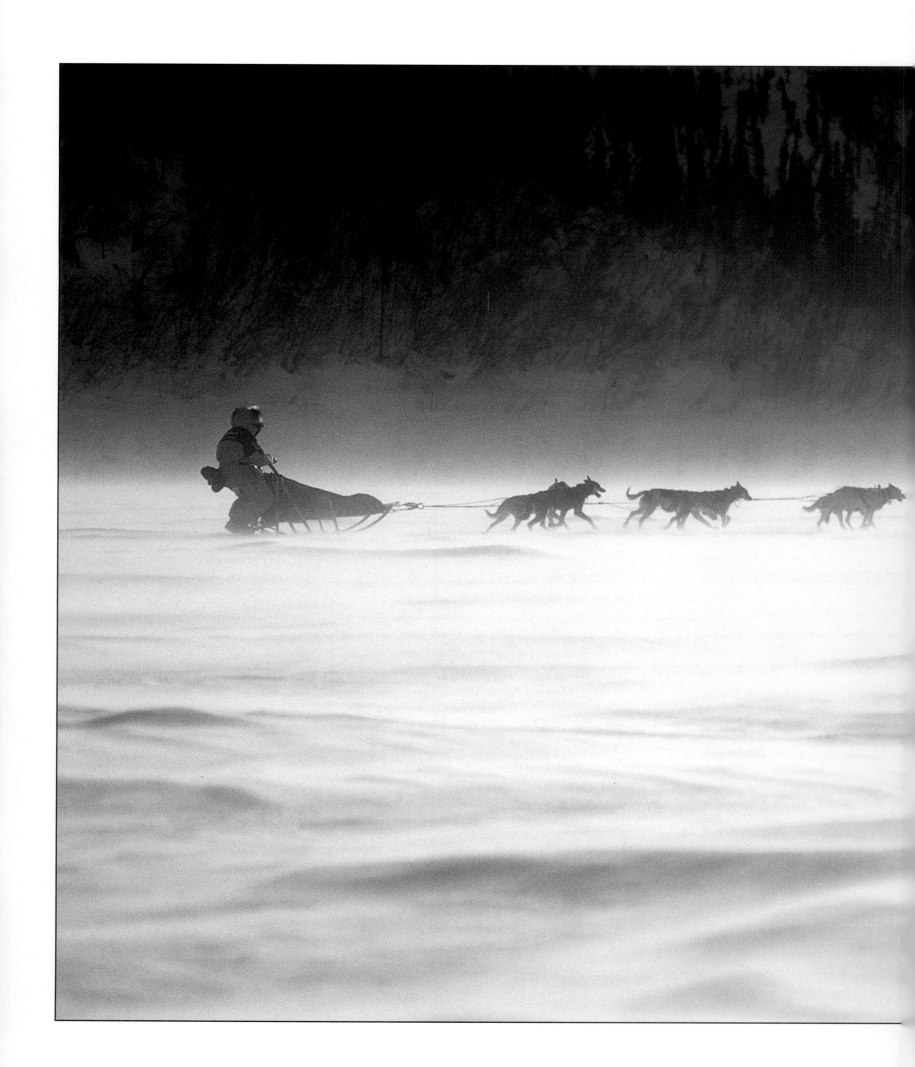

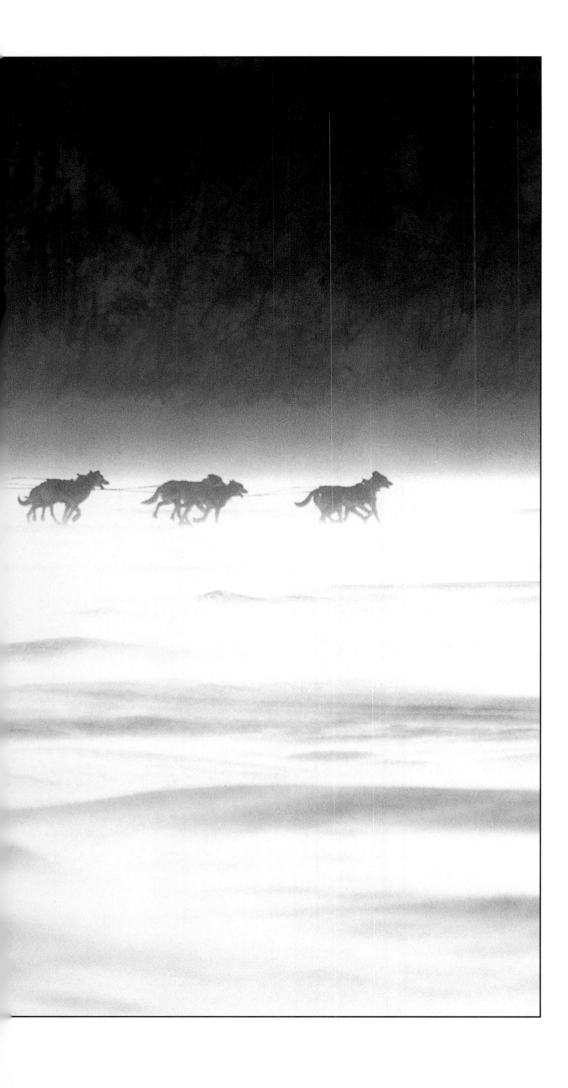

◄ On the way to the third of his four Iditarod victories, Doug Swingley and team battle wind traveling the Yukon River downstream from Ruby in 2000. A 25-mph easterly wind causes loose snow to swirl around the team, creating eerie, foglike conditions for the dogs. Just above the canines, at musher level, the air is clear. Wind at the back helps the team make better time on the 52-mile run to Galena, the next checkpoint. The 875-mile Yukon, which spans the entire width of Alaska, serves as a main transportation corridor year-round with supplies hauled by barge in summer, and by snow-machine in winter.

◀ As this sign testifies, the Iditarod Trail between Unalakleet and Kaltag has been in use since 1867, when dog teams served as the primary winter transportation.

▼ Soaked up to his knees by overflow encountered along the Kaltag-Unalakleet portage in 1999, veteran musher Mike Williams hangs up his wet clothes at the "Old Woman" shelter cabin. Natives originally built shelter cabins at strategic locations on heavily traveled routes whenever there were many miles separating villages. The original Old Woman cabin became dilapidated and was rebuilt by the Bureau of Land Management in 1990. The spread of food on the table shows the cabin is getting a lot of use by mushers in this race.

▲ Checker Randy Parent waits for a 2003 team outside his temporary headquarters at the community fire hall in Kaltag. A resident of California, Parent has been volunteering on Iditarod since 1998 and has worked in many positions including security, dog drop, checker, and "comms." He's one of many perennial volunteers who simply have Iditarod "in their blood." Volunteers like Parent pay their way each year to simply be a part of the event. Some have read books or seen TV coverage of the race, while others were invited by friends to watch, and Iditarod has simply "hooked" them. For many volunteers this once-a-year event is an adventurous highlight where they can play a small, but very significant role in making the race happen. Following 10 days of Iditarod service at other locations, Parent will now spend another week upstairs at the fire hall, bunking in cramped quarters with six or eight other volunteers, getting little rest and eating donated food—all for the "thrill of it."

► Jon Little and team skirt past snowdrifts as they come off the tundra and onto river ice within sight of the first Bering Sea coastal village of the race—Unalakleet. In the distance are the Nulato Hills.

▼ A village dog welcomes Ken Anderson's team of 9 as he drives down the main street in Kaltag in 2003. Taking care of 9 dogs is easier than 16, and larger teams are not necessarily faster. Race rules require mushers to finish with no less than 5 dogs in front of the sled crossing the finish line. The handmade wooden freight sled in the foreground is a traditional Native-style sled used to haul firewood, people, and other goods. Instead of a dog team gangline in front, this one is equipped with a snowmachine hitch. The proliferation of snowmachines in villages formerly known for dog kennels is one of the reasons that inspired the late Joe Redington Sr. to launch the Iditarod, providing new incentive for a valued way of life.

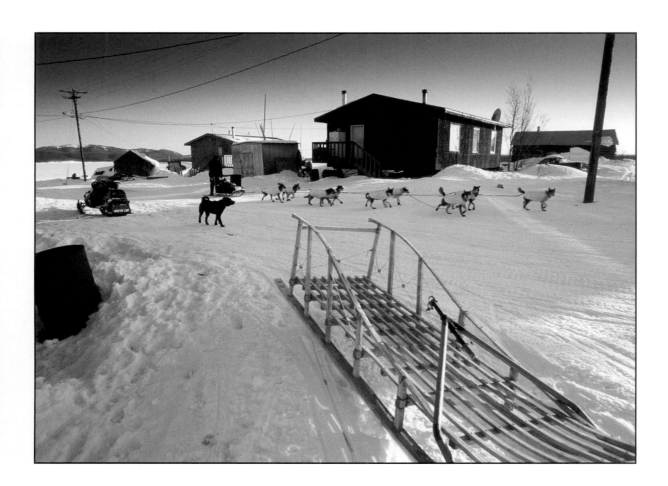

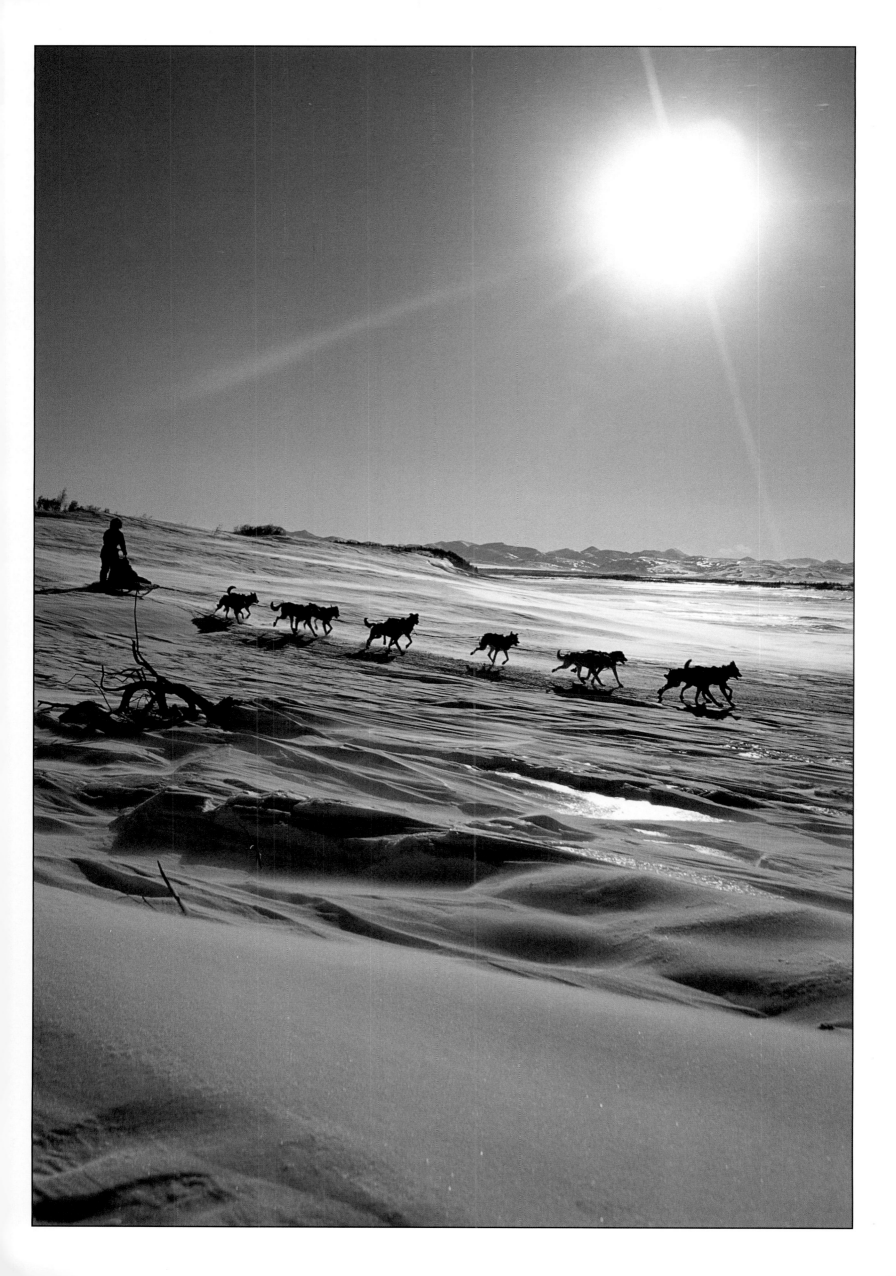

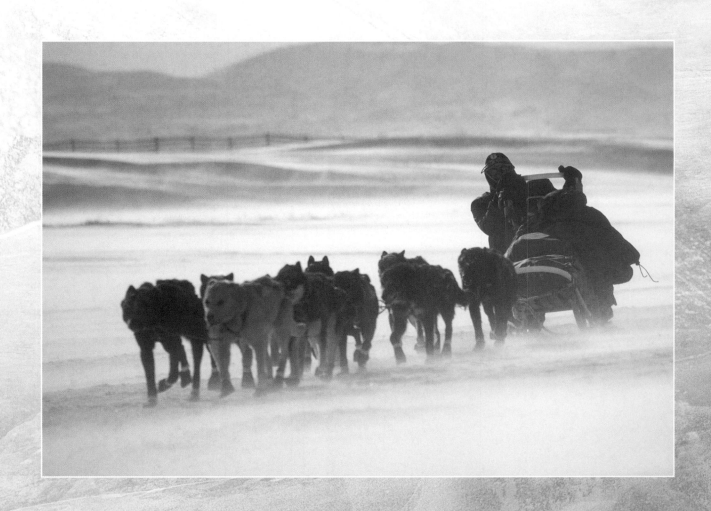

▲ John Baker crouches on the runners, diminishing the punch of a coastal storm.

Iditarod *glory*

the Gold Coast Run

▲ One of John Baker's dogs glistens with icy reminders of slumbering through a windstorm at Unalakleet. A good protective coat is one of the traits that a musher looks for in a sled dog. Proper fur consists of a soft, downy, warm undercoat and "guard hairs" that shed snow and water; such a coat will shield a dog against the cold and deflect snow driven by the wind.

▼ As the sun rises in Unalakleet during the 2003 race, Amberlin, one of Ken Anderson's dogs, rests comfortably on his bed of straw. The "36P" tag on his collar is a special number only Amberlin will wear on the trail. At the prerace banquet, when a musher's starting position bib number is announced, each musher is given a set of dog tags. Each of these tags has the musher's bib number followed by an alphabet letter. Having a unique tag on every dog makes it quick and easy for veterinarians to identify them during checkpoint field exams, or if they are dropped at a checkpoint. Each Iditarod dog also carries a coded microchip implanted in its neck for identification.

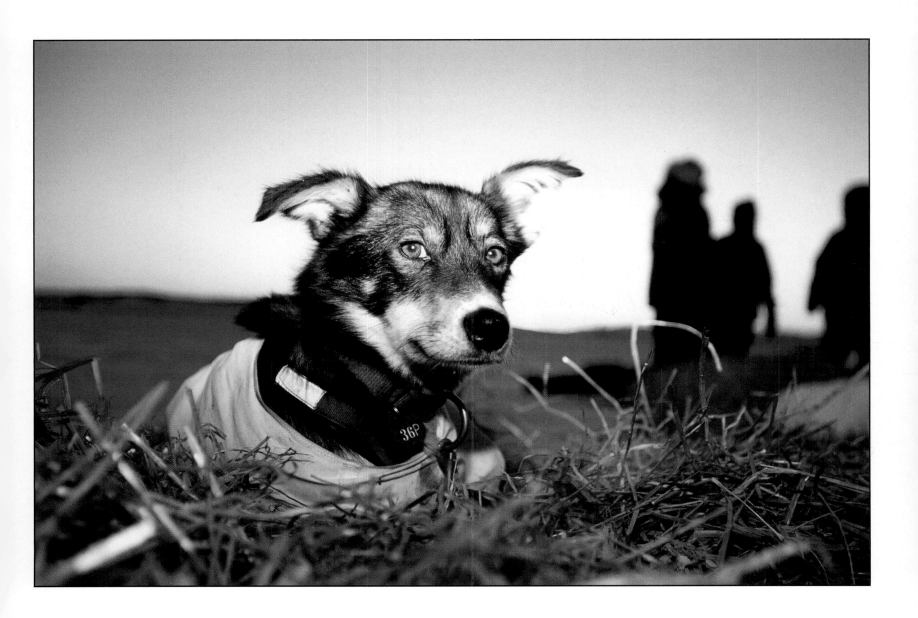

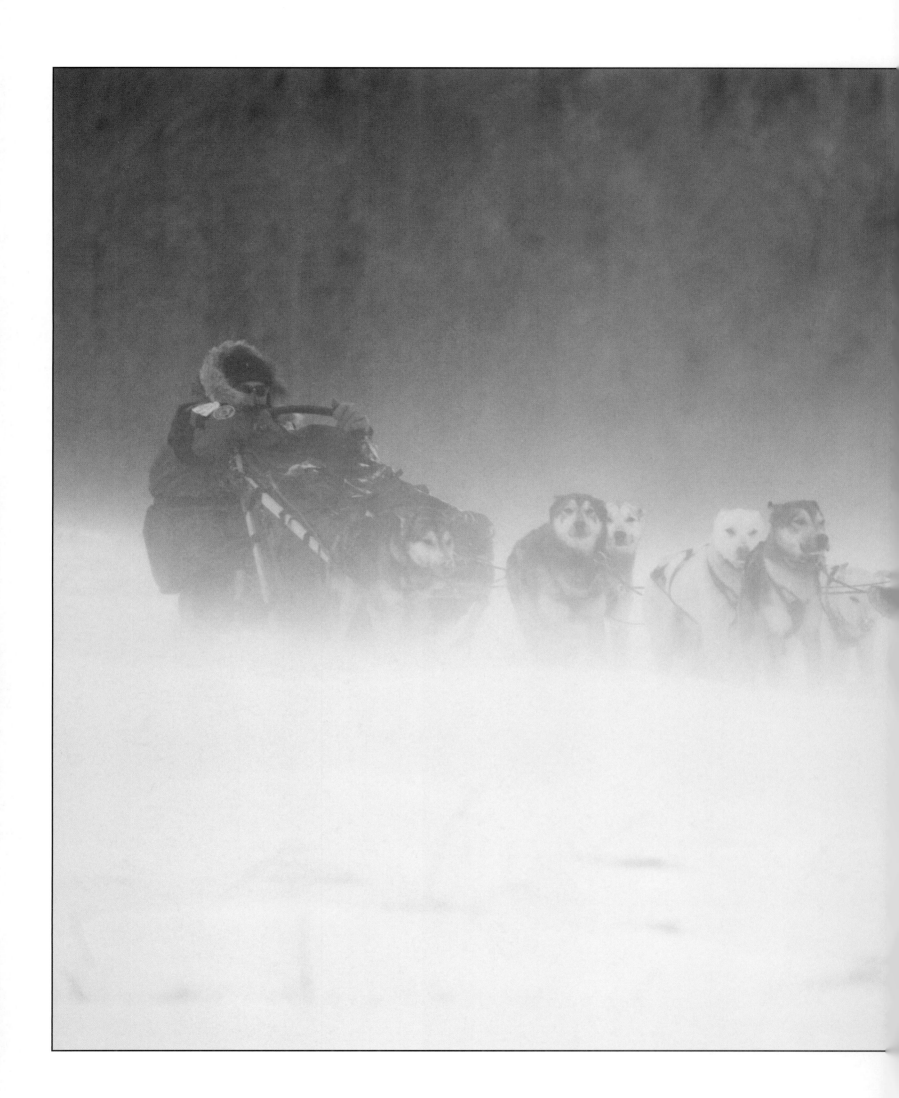

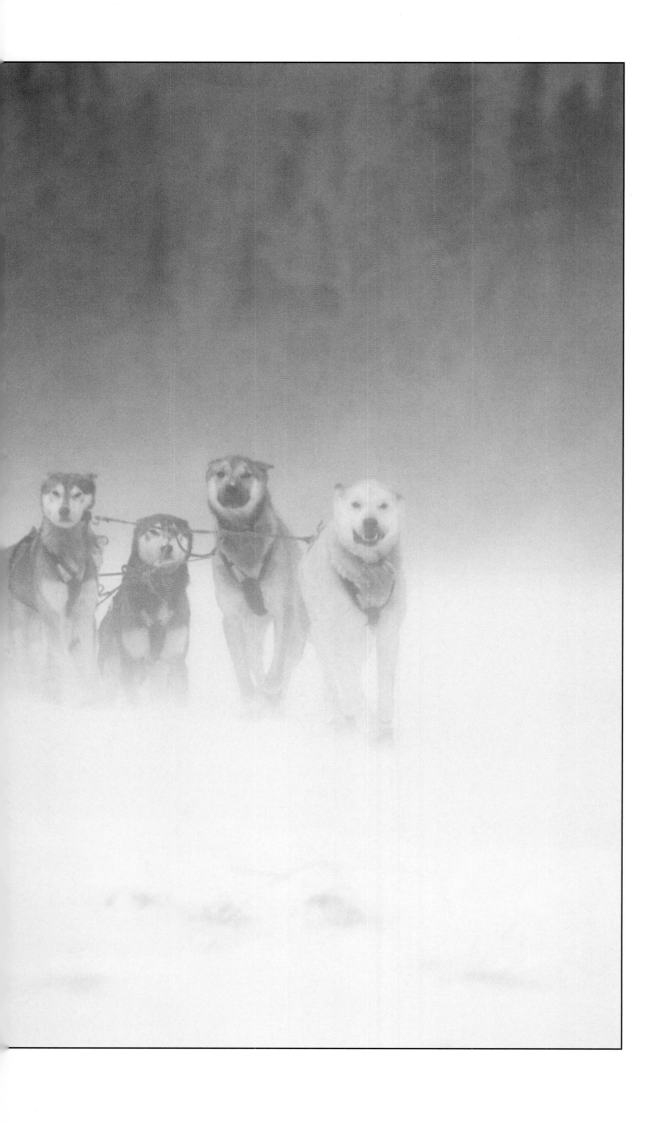

◀ Paul Gebhardt squats behind his sled in 2005, seeking to shield himself from the 30-mile-per-hour wind he and his team are encountering near Egavik on the run from Unalakleet to Shaktoolik.

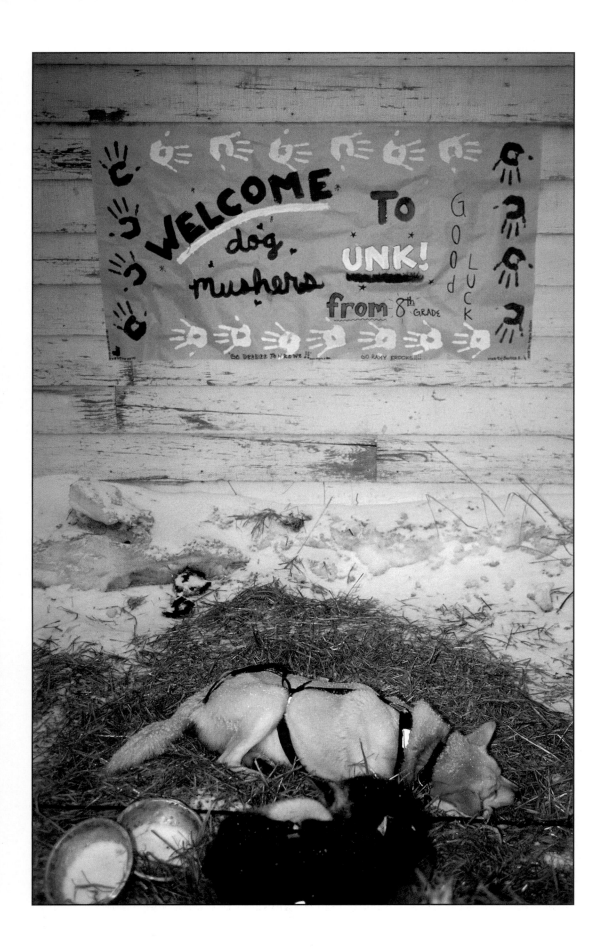

▲ Two of Zack Steer's dogs rest during his 1998 layover in Unalakleet. Colorful and cheerful signs like this, made by schoolchildren, are found at nearly all the village checkpoints, encouraging mushers throughout the race.

▼ DeeDee Jonrowe grabs a quick nap on her sled at the Unalakleet checkpoint in 1996. Because of the many chores associated with running and tending their teams, mushers get very little sleep on the trail. They take care of themselves by drinking large volumes of water, eating healthy food, and not drinking or eating foods that are stimulants such as caffeine. Top contenders learn to function with as little as two to five hours of rest per day. The more efficient a musher becomes in caring for the dogs at checkpoints, the more sleep he or she will get. Most strive to keep their mind and body occupied while mushing by thinking about race strategy, listening to music, or kicking behind the sled.

► Leaving Unalakleet in 2003, Ken Anderson and team move past a fish drying rack on the slough. Most of Anderson's dogs are wearing "dog coats" to protect against the harsh winds and cold temperatures of the wind-driven coastal area.

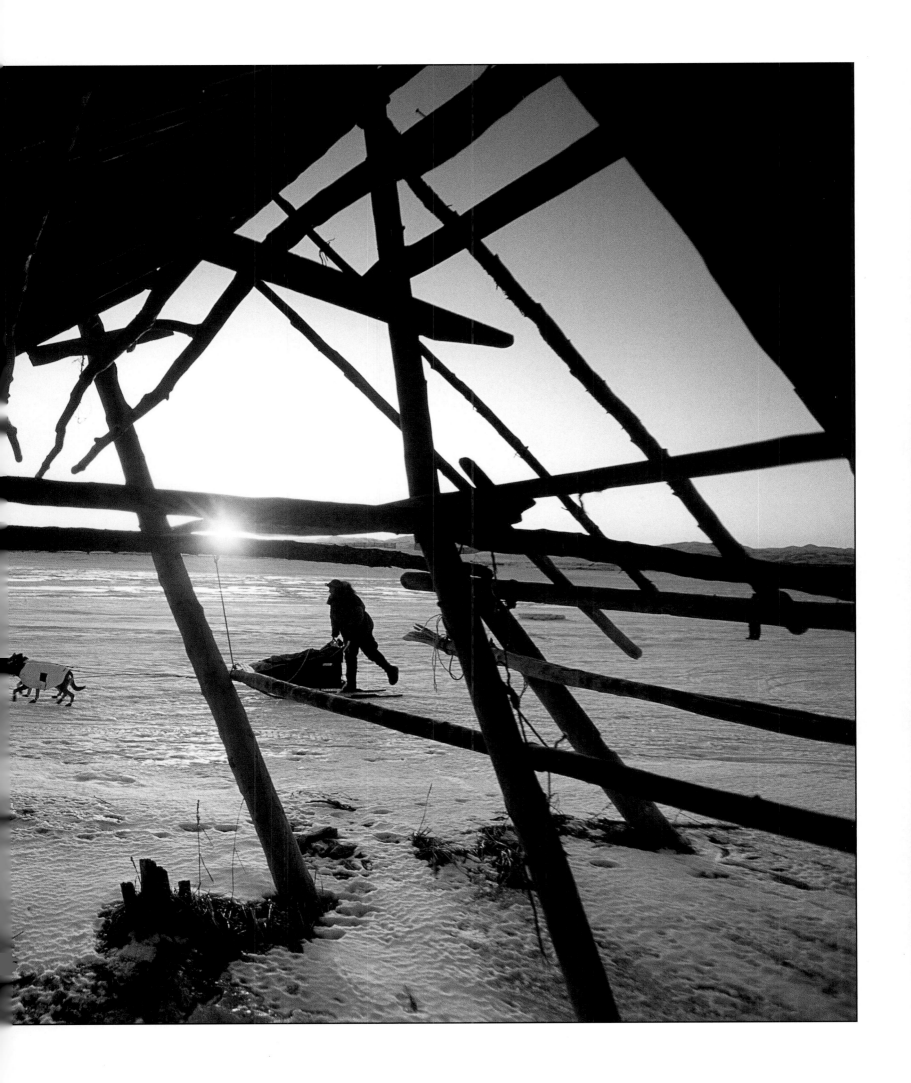

▼ There's always a large crowd on hand to greet the No. 1 musher into Unalakleet, the first checkpoint on the Bering Sea coast. When Norwegian musher Robert Sørlie arrived in 2003, it was no exception. Sørlie, who completed his rookie Iditarod the year before, held on to win the 2003 race, becoming the first European to do so.

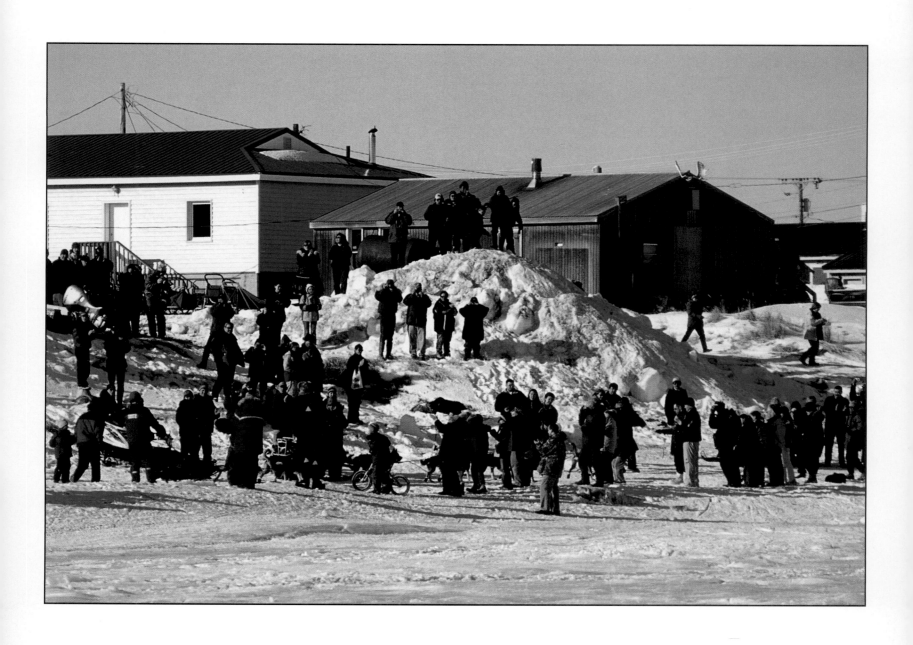

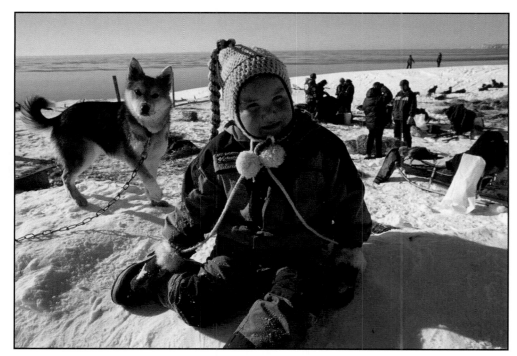

◄ Young Desiree Rock and a friendly local village husky pose for the camera from a knoll at Shaktoolik with the Iditarod dogs resting in the background in 2002. The coastal village is known for harsh winds, but this day was calm. Mushers and dogs rest comfortably in the sun.

◄ Five-time champion Rick Swenson leads Vern Halter in the 1998 race by mere seconds as they pull in from the slough entering the coastal village of Shaktoolik. A National Guard armory, seen in this aerial photo as the shiny silver building on the left side middle area, serves as checkpoint in Shaktoolik, an Eskimo village with a population of 230.

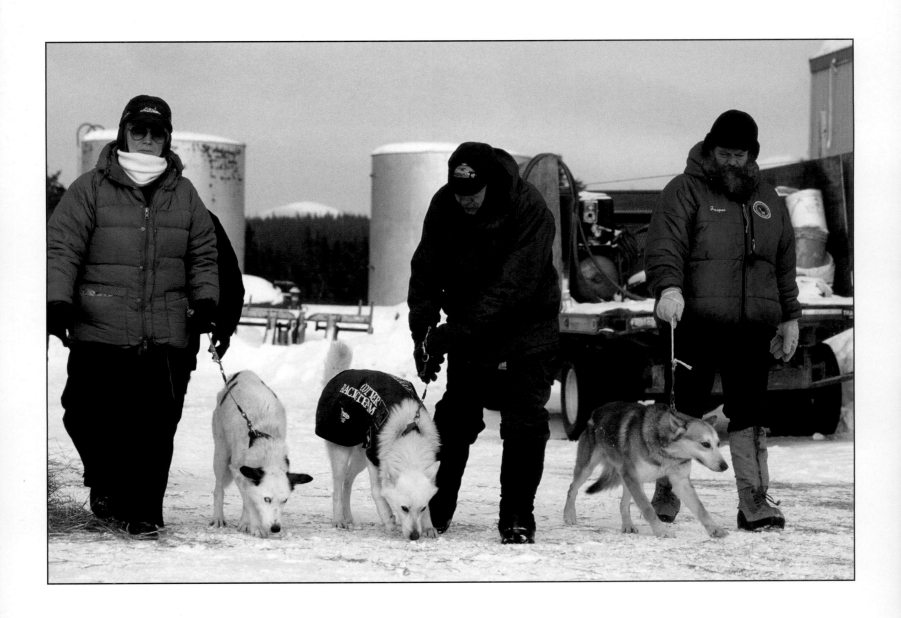

▲ All volunteers, plane-load coordinator Hannelore Kelliher, pilot Kenn Moon, and checker Jasper Bond each walk a dropped dog from the Elim checkpoint area to the airport for the 100-mile flight to Nome. Many volunteers, these three included, have Iditarod in their blood. Members of this trio have volunteered for more than 10 years.

▶ Perennial crowd favorite Charlie Boulding sits on a foldable seat as he passes by windblown snow patterns on the trail between Unalakleet and Shaktoolik in 1997.

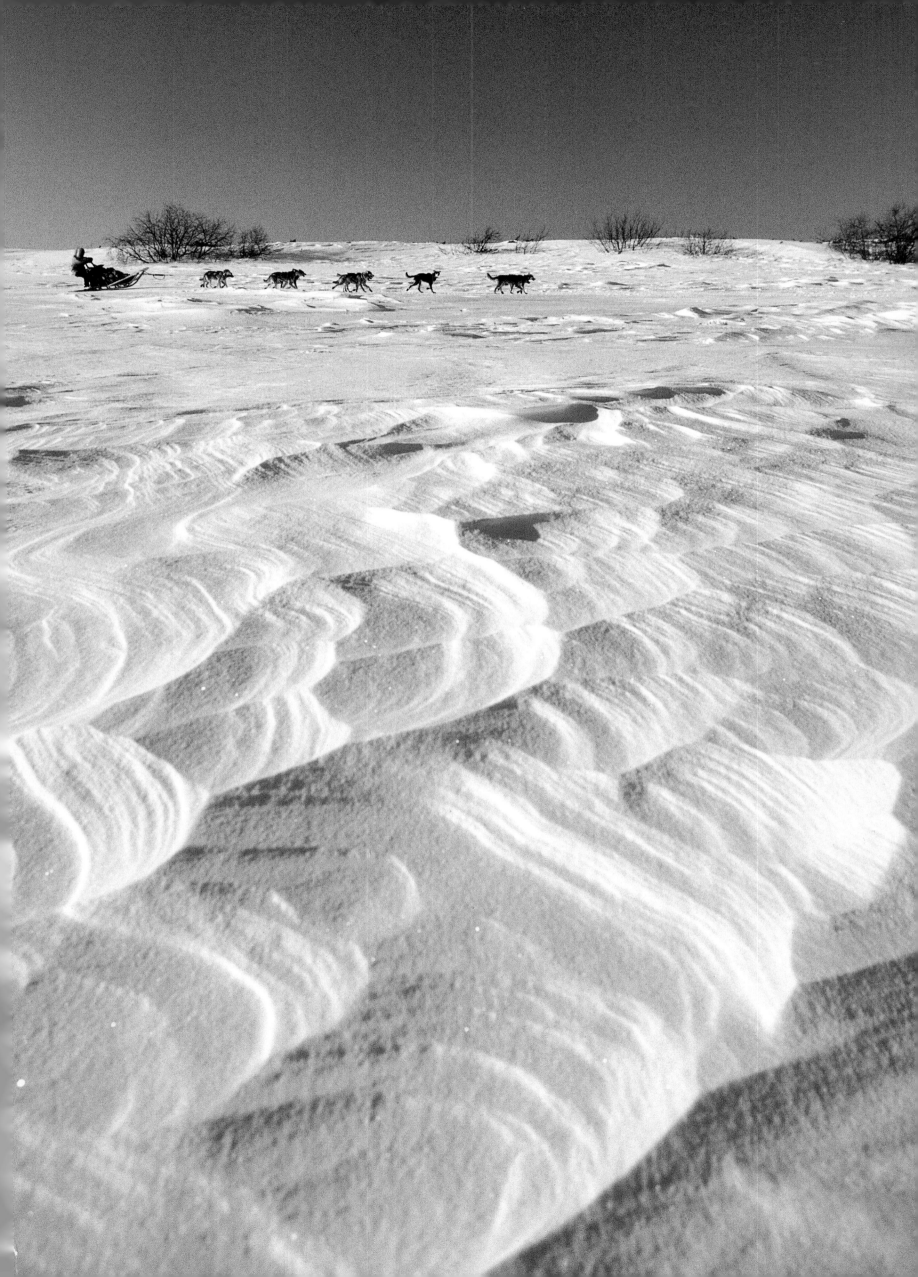

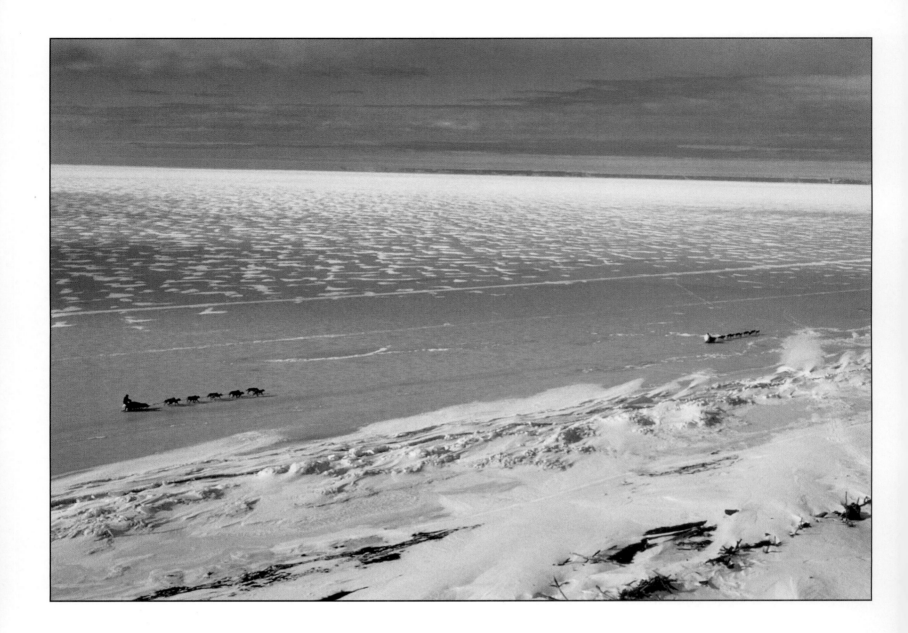

▲ Always strong contenders, Doug Swingley and Martin Buser travel just off the driftwood-
strewn shore on the Bering Sea ice on their way to Shaktoolik in 1998. The actual
marked trail is inland, which is less subject to obstacles and considered safer than the
sea ice. Buser decided to run along the brackish sea ice because he feels it helps the
dogs' feet. Swingley, running shortly behind Buser, followed his lead. Race rules do not
prohibit a team from straying from the trail provided they check in at each checkpoint.

▶ One of Bill Cotter's dropped dogs waits to board volunteer pilot Kenn Moon's plane at
the Elim checkpoint for a ride back to Nome. Opportunities to spread a sponsor's name
during Iditarod are few. Cotter's backer, Eastern Mountain Sports, uses his dog coats to
promote its involvement.

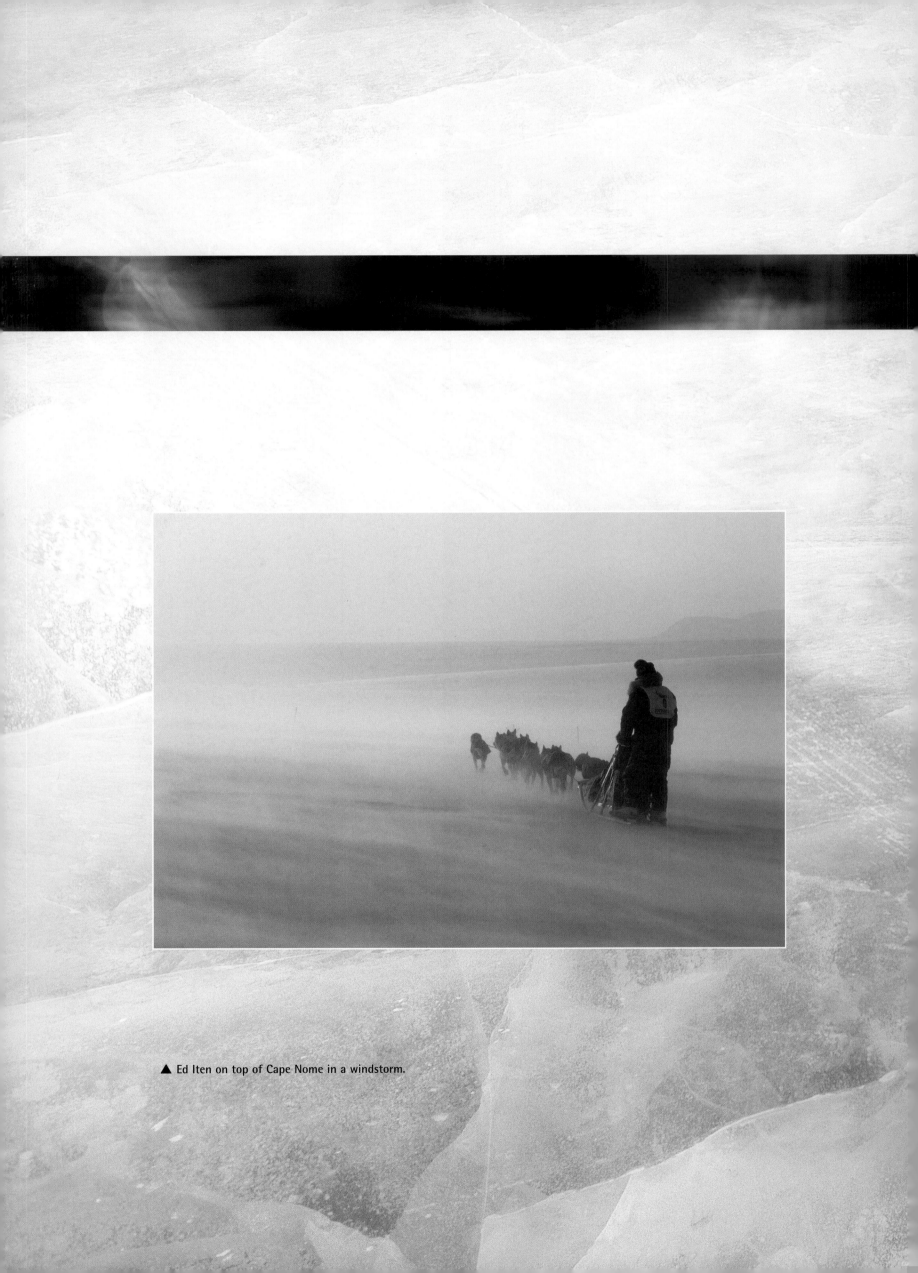

▲ Ed Iten on top of Cape Nome in a windstorm.

Iditarod *glory*
the Final Stretch

► Small dog team. **Big** landscape. The size of Jeff King and his team against the Norton Sound and Topkok Hill helps put the Iditarod Trail into perspective. The trail from White Mountain to Topkok meanders through valleys of small forests, crosses a number of streams, and continues over hills before spilling out onto the tundra and coast of Norton Sound. Between Topkok and the final checkpoint of Safety is a stretch known as "the blow hole," a nasty stretch of featureless trail. When the wind is blowing, snow can whip up in a way that leaves travelers feeling like they are inside a milk bottle with no sort of reference. A dangerous place to be.

▼ Martin Buser, the second 1999 musher to check in at White Mountain, the last village checkpoint on the trail, signs autographs for the local children. Known as one of the friendliest villages on the race and only 77 miles from the finish line, White Mountain is a mandatory eight-hour stop. Barring unusual circumstances, such as a bad trail, stormy weather, or getting lost, a musher who arrives at White Mountain leading by two hours or more has the race all but won.

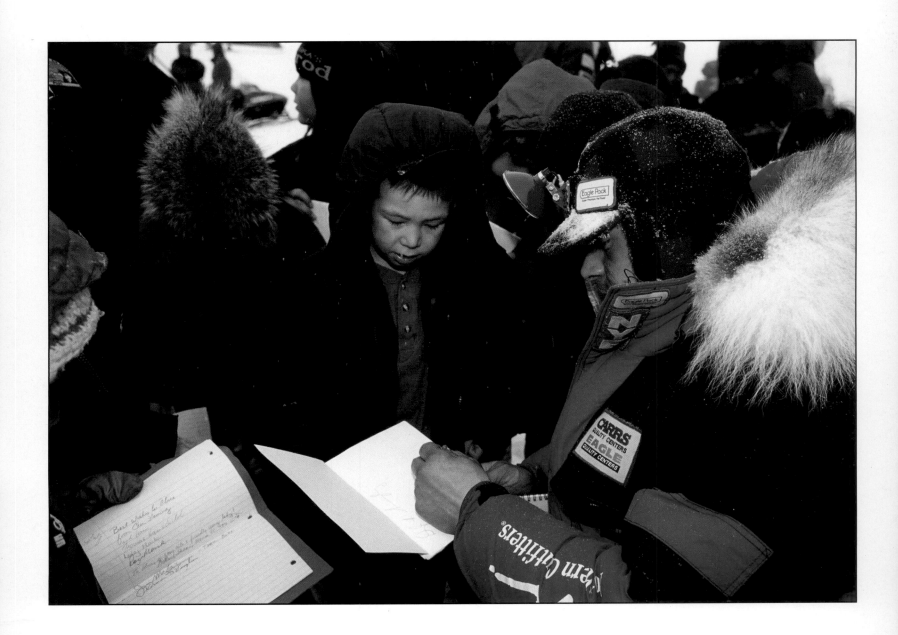

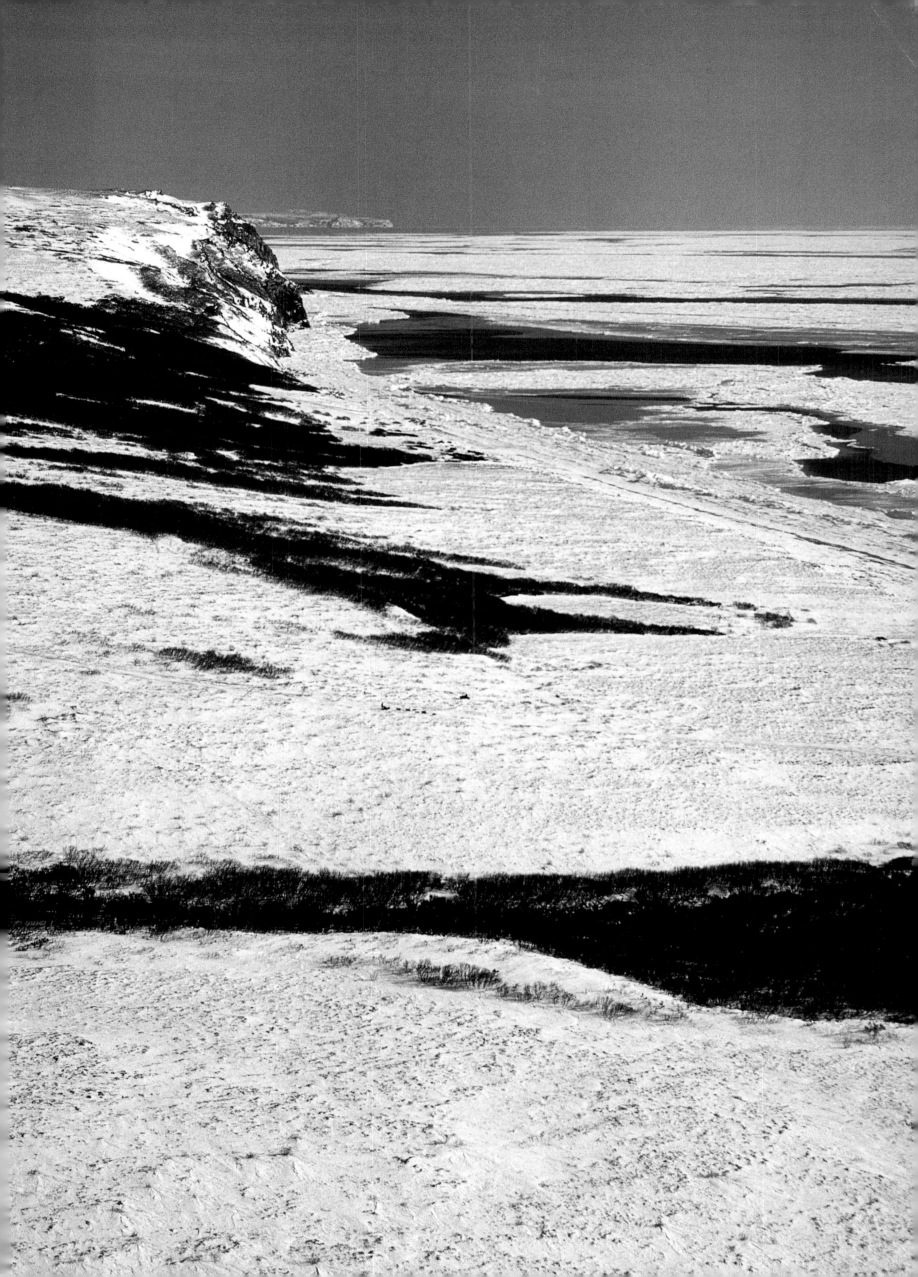

◄ Seventy-four-year-old White Mountain checker Howard Lincoln takes a break during the 2001 race. Lincoln has been a checker in White Mountain since the 1987 race when he took over the position because his brother-in-law was not feeling well that year. As with most other checkpoint checkers, Howard and his helper, Nora Brown, do more than simply check teams in. A typical race will find them and others hauling wood, cleaning up garbage, finding housing or bedding for other volunteers, cooking, providing snowmachine rides to the airport, and keeping the water hole from freezing.

▼ As teams rest in the sun at White Mountain during the 2001 race, communications volunteer Dr. Dan Stephenson splits wood to heat the wall tent he and other race officials use working the checkpoint.

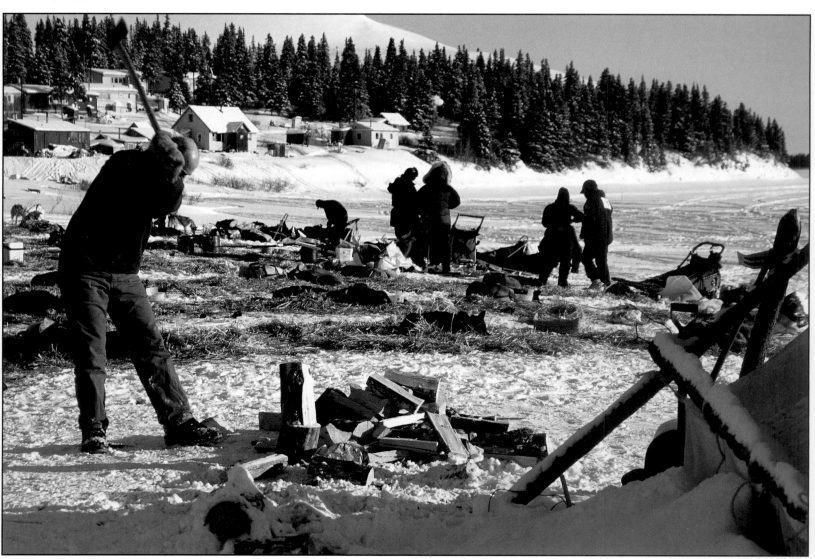

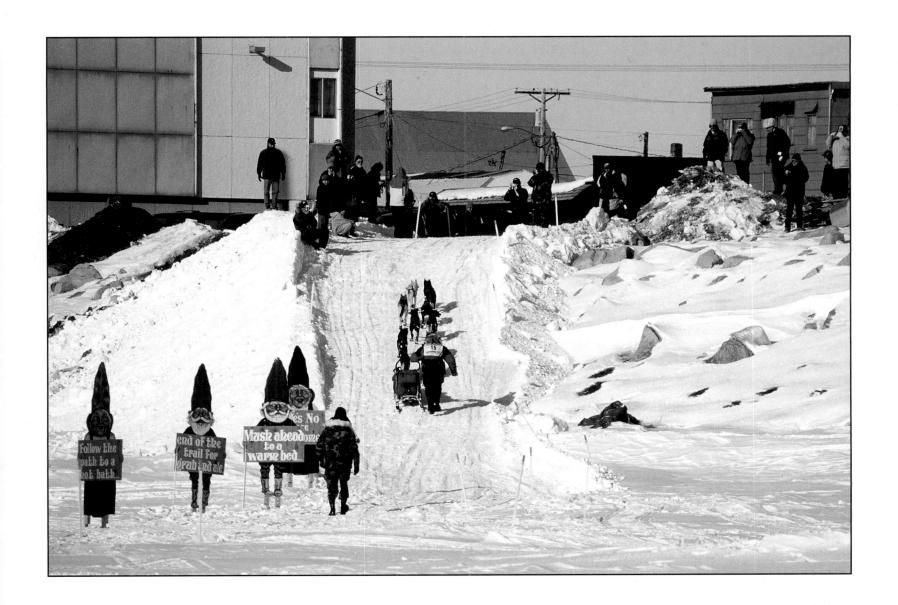

▲ After passing a menagerie of gnome welcome signs, Martin Buser runs behind his team as he mushes up the breakwater ramp from the Bering Sea into the city of Nome to a fourth–place 2003 finish. Visitors and Nomeites alike welcome the mushers completing their 1,150-mile adventure.

▶ Charlie Boulding inches his way closer to the Nome finish line and a fifth-place finish as he passes the Ft. Davis area at sunset during the 1999 race. Fort Davis is only two and one-half miles from the finish line. This stretch of the trail tends to be wide and hard from all the snowmachine traffic it receives. The driftwood tripod is a permanent trail marker of the sort found throughout the trail in areas where there are no trees or other natural features to mark the trail. These are especially necessary along the final stretch of the trail. These markers can stay up all year even in the fiercest winds.

▼ Passing the infamous Swanberg's dredge, Jeff King is within the Nome city limits and only one mile from the finish. Day or night, when a musher reaches this landmark, Nome sounds its town fire siren, which can be heard all over the city, alerting everyone that a musher is about 20 minutes from the finish line. The dredge was used in the 1940s to mine gold and has remained in this spot ever since.

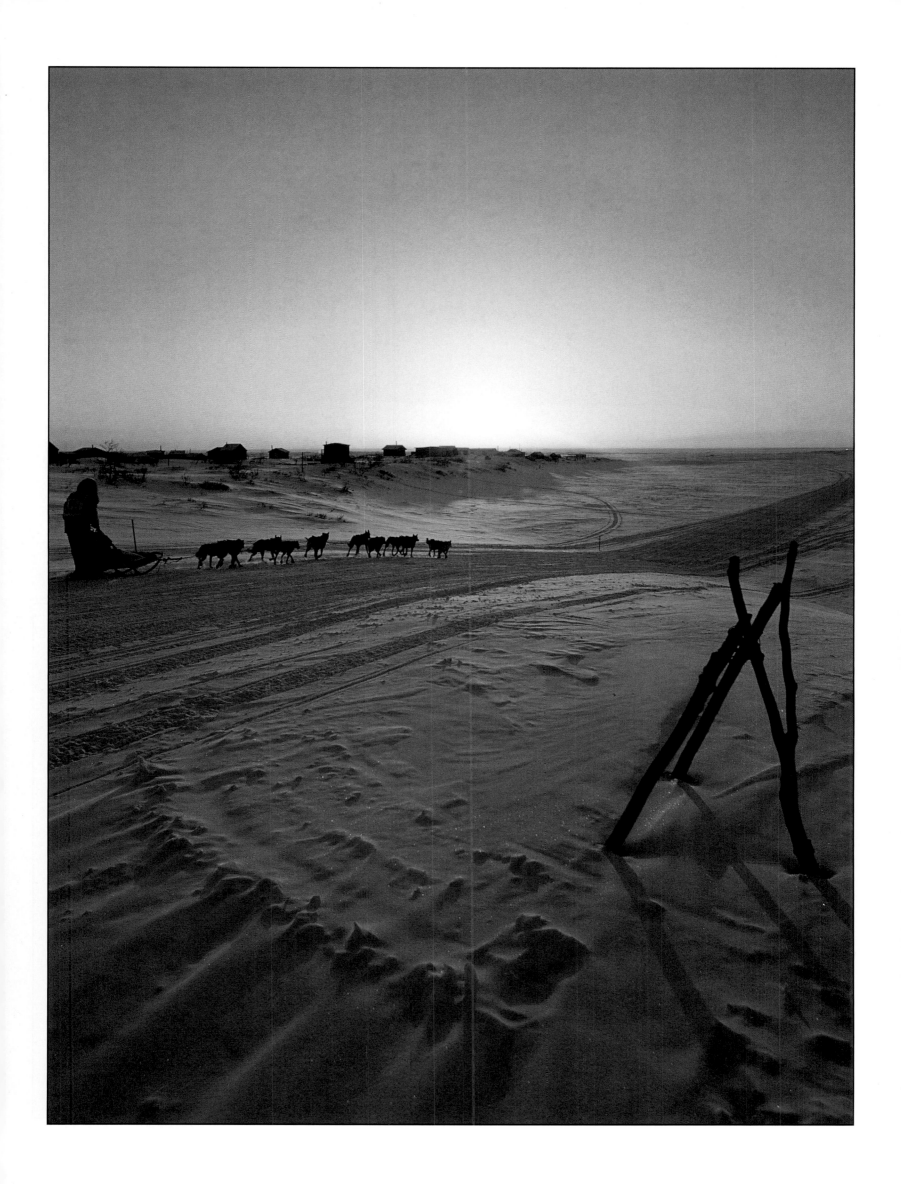

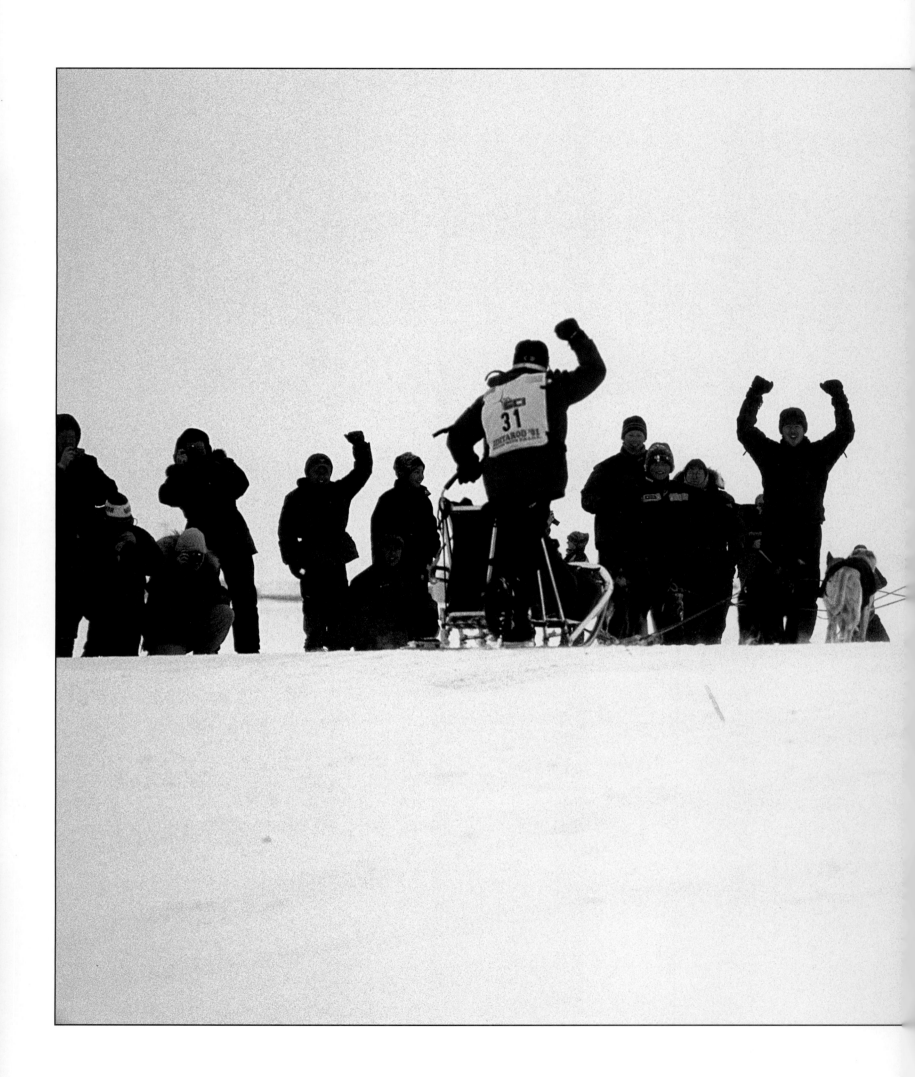

◄ Having never placed higher than eighth in 12 previous Iditarods, Linwood Fiedler gives a "right-on" fist to his arm-waving son, Dalton, and other well-wishers a few miles from the finish line. Fiedler owned second place in the 2001 race.

◀ In clear skies and sunny weather, Jerry Sousa and team pass summer houses at Fort Davis a few miles from the finish line in 2004. Sousa mushed team No. 16 into Nome.

▼ On the Bering Sea breakwater ramp, Cindy Gallea stops to help her team navigate the crowd lining the path to Nome's Front Street nearing the finish in the 2004 race.

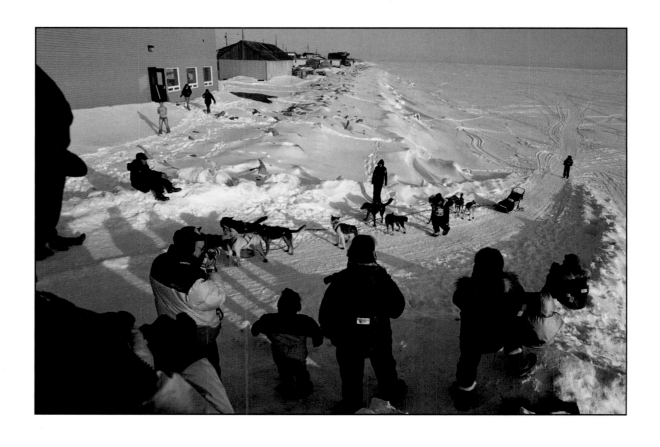

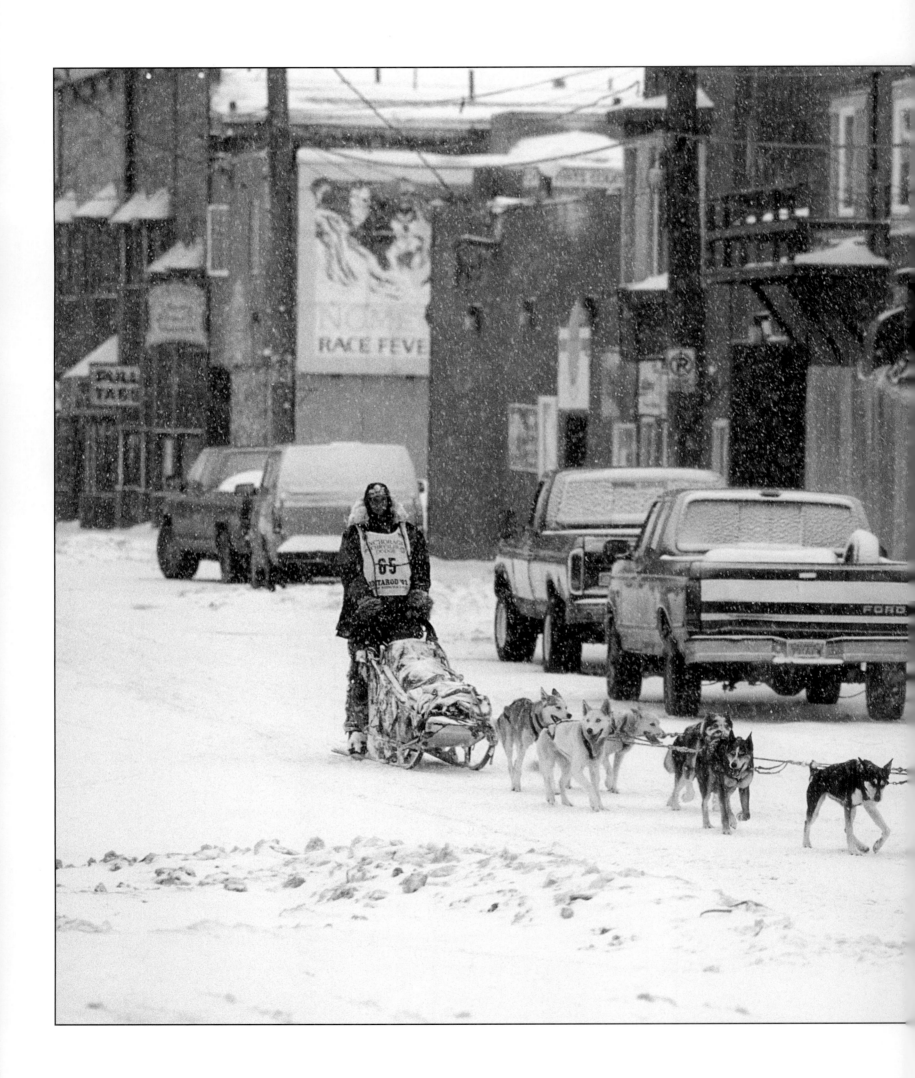

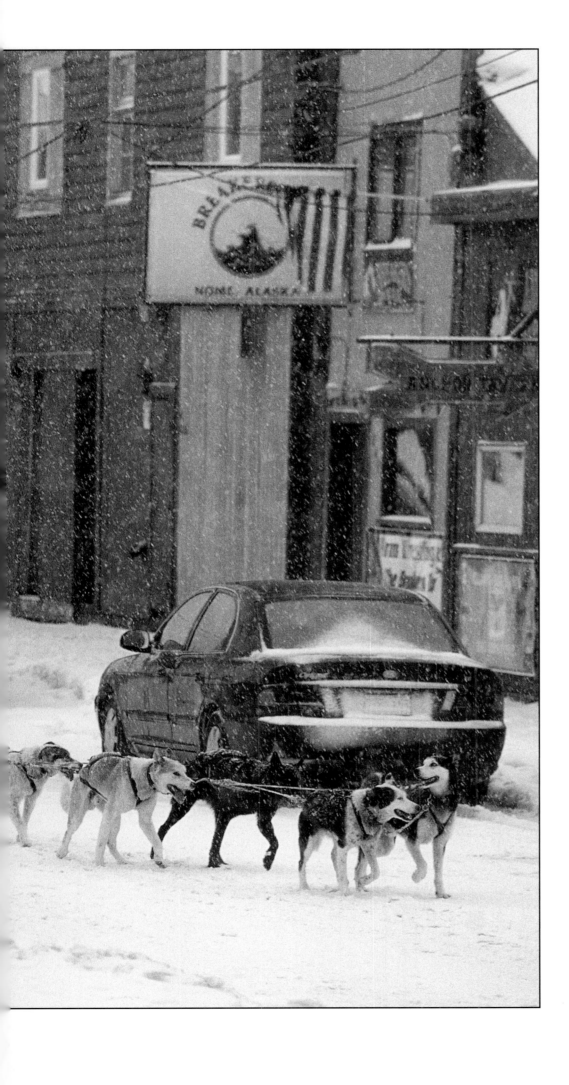

In her rookie year of 2002 and with a happy string of 11 dogs in front, Karen Land mushes down Nome's Front Street in light snow a few hundred yards from the finish. Land crossed under the burled arch in 49th place in just under 14 days. Like the start of the race in Anchorage, the Nome finish has mushers arriving on the busiest street in town, Front Street.

▲ The late Joe Redington Sr., always known most affectionately as the "Father of the Iditarod," is shown in this 1997 portrait taken at the Nome finish line shortly after completing his 19th and final Iditarod at 80 years of age. Redington's overall Iditarod record is impressive, especially considering his age throughout. He missed the inaugural race because he was raising money for the purse. But Redington five times placed fifth in the race he founded and entered each year from 1974 to 1992, skipping only the '83 race because of an injury from a moose attack. Always a promoter, in 1993 he began offering guided sled dog trips to Nome, which took place during the race. He called it the "Iditarod Challenge." For $15,000, a novice received training, dogs to run their own team, all supplies, and guided support the entire way to Nome. All by the man who started the Last Great Race.

▼ Wayne Curtis and his team of registered Siberian huskies is greeted by a huge crowd as he enters the finish chute in 1997 destined to cross under the burl arch in 37th place. Normally there is not such a large crowd to receive lower place finishers, but this group was on hand to welcome the 36th place finisher, Joe Redington Sr., just a few minutes before. Hanging from the left side of the arch is the "widow's lamp," kept lit from the time the first musher leaves Anchorage, until the last place, "Red Lantern winner," crosses the finish line.

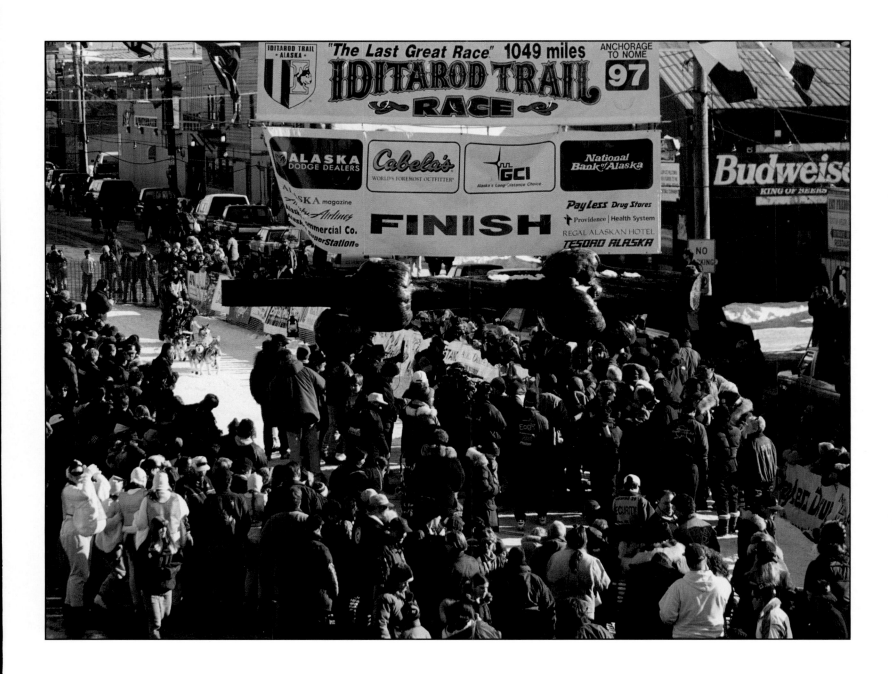

▲ As always, the dogs get top treatment during Iditarod. Dropped dogs ferried into town by Iditarod "air force" flyers are delivered to the Nome dog lot by Dick Rudy, a perennial volunteer from Cincinnati. Rudy and many other unpaid helpers wind up in Nome after working the entire race in various roles.

▼ After completing the 1,150-mile race in 2004, one of Rick Swenson's dogs sleeps in a bread box converted into a makeshift doghouse at the Nome dog lot. The annual arrival of Iditarod teams represents a busy time for Alaska Airlines, one of the race's main sponsors. All but a handful of local teams will be flown back to Anchorage by the commercial airliner. This is done using special "igloo" transportation containers, which are delivered to the dog lot by the airlines' employee "dog squad."

▲ After scratching in his two previous tries, David Straub finishes the 2002 race and proudly raises his "Red Lantern," last-place trophy while mushing down the final stretch on Nome's Front Street. Finishing the Iditarod is no easy feat for the human athlete. It took Straub 14 days, 5 hours, to make his way to Nome in 55th position. Still, an entire 6 days faster than Dick Wilmarth, the winner of the first Iditarod in 1973.

DATE DUE